ADVANCE PRAISE FOR

Saved from Oblivion

"*Saved from Oblivion* is an intellectually ambitious and theoretically sophisticated contribution to a growing field of interest in media and its relation to place.... Its theoretical sophistication and intriguing project of linking a certain media practice across concepts of material place in differing media will make it a significant contribution to media studies and theory."

<div align="right">

Jeffrey Sconce, Department of Radio/Television/Film,
Northwestern University

</div>

Saved from Oblivion

Digital Formations

Steve Jones
General Editor

Vol. 11

PETER LANG
New York • Washington, D.C./Baltimore • Bern
Frankfurt am Main • Berlin • Brussels • Vienna • Oxford

Andreas Kitzmann

Saved from Oblivion

Documenting the Daily from Diaries to Web Cams

PETER LANG
New York • Washington, D.C./Baltimore • Bern
Frankfurt am Main • Berlin • Brussels • Vienna • Oxford

Library of Congress Cataloging-in-Publication Data

Kitzmann, Andreas.
Saved from oblivion: documenting the daily from diaries to web cams /
Andreas Kitzmann.
p. cm. — (Digital formations; vol. 11)
Includes bibliographical references and index.
1. Mass media—Authorship. I. Title. II. Series.
P96.A86K58 808'.066302—dc22 2004010420
ISBN 0-8204-6195-4
ISSN 1526-3169

Bibliographic information published by **Die Deutsche Bibliothek**.
Die Deutsche Bibliothek lists this publication in the "Deutsche
Nationalbibliografie"; detailed bibliographic data is available
on the Internet at http://dnb.ddb.de/.

Cover design by Lisa Barfield
Cover photo by Harry Kitzmann

The paper in this book meets the guidelines for permanence and durability
of the Committee on Production Guidelines for Book Longevity
of the Council of Library Resources.

© 2004 Peter Lang Publishing, Inc., New York
275 Seventh Avenue, 28th Floor, New York, NY 10001
www.peterlangusa.com

All rights reserved.
Reprint or reproduction, even partially, in all forms such as microfilm,
xerography, microfiche, microcard, and offset strictly prohibited.

Printed in the United States of America

For Kirsten

TABLE OF CONTENTS

Acknowledgments .. ix

Introduction ... 1

Part One: Media Place
1. Posture One ... 21
2. The Place of the Page .. 27
3. The Place of the Camera .. 35
4. The Place of the Network ... 53

Part Two: Private Place
5. Posture Two ... 63
6. Pure Privacy ... 69
7. Public Privacy .. 79
8. Connected Privacy ... 89

Part Three: Real Place
9. Posture Three .. 99
10. Positive Reality .. 101
11. Negative Reality .. 111
12. Returned Reality ... 115

Part Four: Time Place
13. Posture Four ... 129
14. Still Time ... 133
15. Future Time .. 139
16. Real Time ... 155

Epilogue: Last Place .. 171

Notes ... 179
Works Cited ... 189
Index ... 201

ACKNOWLEDGMENTS

Books are a cumulative and collaborative process—a fact often belied by the single name that normally appears on the title page. This book is no exception. While my name may indeed be the only one on the cover, I could not have written this work without the input, inspiration, and support from a host of friends, colleagues, students, and random acquaintances. To name them all would be a Sisyphean task that would be without end. Yet a few names stand out. To begin with, this book was made possible by the support of my colleagues in Media and Communications at the University of Karlstad. Special thanks go out to Robert Burnett, whose support, both moral and financial, allowed me the time to develop this project and, as well, to sow the seeds for a few more. I must also thank Mia Ohlsson for the administrative gymnastics that were required to create a workable balance between research and teaching. Thanks as well to the CMIT Research Group, Karlstad University, and the Swedish Knowledge Foundation for providing the resources to fund my research leave. In addition, I would like to thank Steve Jones for his initial faith in the project and for providing me the opportunity to bring it to publication. Thanks also go out to Christopher Myers and Damon Zucca at Peter Lang in New York for their professionalism and tolerance for my rather liberal interpretation of deadlines. And naturally, I must thank my "family network"—Harry, Ursula, Beatrix, Brent, Markus, Rolf, and Marlene—for just about everything. Finally, a very special thanks to Kirsten Yri, whose love and unrelenting support has made it all possible and worthwhile.

INTRODUCTION

Imagine the following scenario: late one night you are sitting alone in a nearly empty subway car. Having failed to bring along any suitable reading material you try to pass the time by scanning the ubiquitous advertisements for hair removal or distance education. After a while you notice a notebook on an empty seat not far from you. Curious, you reach for it and examine its cover. "My Diary," it reads. The notebook is well worn, and as you flip through it you can see that there are indeed entries for each date for what seems to be an entire month. The odd phrase or detail catches your eye. "And then I knew I no longer loved him." Or, "Bought two shirts today. One on sale and the other overpriced but worth it." Nervously you look up to check if the writer of this diary is anywhere to be seen. Reassured of your anonymity you continue, scanning, flipping, reading—at times enthralled and at others bored by numbing and irrelevant detail. After what seems to be a few minutes you look up. Your stop has long since passed. Cursing, you get off, still firmly clutching the journal.

This imaginary but not unimaginable scene marks the origins of this book, which during the initial phases of its conception sparked a number of seemingly obvious questions. Among the first is the question of why anyone would feel the need to rigorously document the thoughts and deeds of everyday life. And more curiously, why anyone would want to spend time going over such material. Such questions are not limited to the chance discovery of diaries in subway cars. At any given point someone somewhere is using a pen, a camera, a web-cam, or a computer to document, in varying degrees of detail, personal thoughts, observations, or glimpses of private space and life. And for each of these, there is usually at least one person reading, watching, or even responding. There is always an audience, implied, eventual, or in real time.

It is this ubiquity of what can be termed the act of self-documentation that has led me to a set of less obvious but no less compelling questions and concerns. Chief among these is the question regarding our relationship to the technologies we use to represent and express ourselves. In other words, how different would our imagined scenario be if one had discovered a spool of Super-8 film instead of a dog-eared notebook or, in an altogether different scenario, never left the house in the first place but instead encountered the diary online? Clearly the experience would be very different, not only for the receiver of such material, but also for those creating it. As Marshall McLuhan and others have pointed out, a given medium, such as the page or the camera, is more than just a tool or conduit for the transfer of "content"; it's also an integral component of the message itself. Equally clear is the observation that specific media environments engender different adaptations and practices on the part of users and receivers, which, in turn, lead to a concomitant set of media-specific genres and rituals.

I am thus led to the following questions regarding the various acts of "self-documentation," the term I am using to broadly identify autobiographical uses of media technology: Where do we document ourselves? What is the nature of the place or the environment within which a given individual chooses to document him- or herself? Are the differences between the place of the diary page and the place of the home movie crucial enough to comment upon? Do the differences bear any relation to the forms of identity constructed and expressed within?

These questions do more than just illuminate the curious but persistent phenomena of self-documentation; they represent as well what I will call the "place of media," which is to say the actual physical, material, and experiential conditions of a particular media technology. In this respect, a diary, for example, is imagined as a place that one enters for the purpose of enacting a particular form of self-representation whose characteristics are, in part, directly related to the material and experiential conditions of the diary form itself—the particular requirements for using a pen, the conventions of writing in silence and solitude, the confessional character of the

narrative, the limited physical space of the page itself, and so forth. The same can be said of the place of the home movie or the web-cam. All three demand a certain form of adaptation on the part of users (and receivers), a literal positioning of human and technological agents and artifacts.

It is important to acknowledge that such positionings are not restricted to the technological or media age but rather have been consistently persistent for millennia. Archaeological records speak of many attempts to keep oblivion at bay in the form of markers, objects, talismans, monuments, gravestones, and memorials. Such sites of memory, to evoke the work of Pierre Nora, are artifacts or practices "where memory crystallizes and secretes itself," with one of the goals being "to stop time, to block the work of forgetting" (Nora, 7, 9). For Nora, the role of memorials is especially telling in that they represent a deliberate attempt to construct a particular version of the past and thus speak to preferred visions rather than to authentic truths. Such visions can be described as a form of "prospective memory" in the sense that monuments or memorials are directed as much toward the future as they are to the past (Holtorf, 1996, 120–23). "The monument is an erected sign which encodes a message in a permanent way for communicating with people that are (possibly) millennia away: a monument is what is designed to survive the present and to enable cultural communication with the distant future" (Holtorf, 2003).[1] Such "erected signs" can take on a number of forms and run the gamut from imposing monoliths such as those erected to commemorate the two world wars to commemorative plaques or getting one's name on a university building. For the purposes of this volume, what is informative here is the manner in which such efforts testify to humanity's longstanding desire to preserve records of the present, especially the presence of being, via artifacts or avatars of remembrance. While not autobiographical—or self-documenting—in the modern sense of the term, the practices of "prospective memory" point toward the consistent appeal and need for saving oneself from the amnesia that oblivion brings.

The aim of this book is to probe a selection of contemporary forms of self-documentation in order to better understand the relationships

between media topologies and the material and experiential conditions encountered within. Such an exploration will not only illuminate the nature of self-documentation itself but, as well, provide a means with which to consider broader questions regarding the relationship between media technology and material and embodied existence and experience. In this respect, the question of media is not limited to the identification of discursive constructions, which tends to be a normative critical practice, but also includes considerations of the manner in which specific media technologies contribute to or "complexify" life itself. Here I am echoing the theoretical sentiments of critics such as Mark Hansen, who in his lucid work *Embodying Technesis: Technology beyond Writing* argues that the interaction between humans and technology is better understood on the basis of physiology rather than on the basis of linguistic constructions. Language is not the only medium for cultural analysis, and technology does more than just influence modes of representation. Rather, as Hansen asserts, "technology impacts our experience first and foremost through its infrastructural role" and thus "informs our basic ways of seeing the world" (3). Technology, then, is an interwoven part of human culture itself, a dynamic part of the whole experiential realm of the human condition and thus not separate, not explainable in terms of purely discursive "statements."

Such concerns take on particular significance with respect to so-called "new" media such as the World Wide Web and other forms of computer-mediated communication. As the various boosters of the Information Age have repeatedly intoned, the places of new media are revolutionary places, cyber- and virtual places that render equally new forms of experience and identity (Negroponte; Kelly). In fact it has become commonplace to assume that new media is, in one form or another, an equally new place that accordingly demands and engenders new social, cultural, and creative practices and human-technology relationships. Admittedly, discursive constructions do play a major role here, which will certainly be addressed in this volume. However, what will be particularly emphasized in the following pages is precisely this question or assumption of "new" human-technology relationships and the infrastructural changes that

alter and inform our "basic ways of seeing (*and living in*) the world" (Hansen, 3). As a means of narrowing this wide area of concern, I will employ self-documentation as the primary exemplar with which to probe such issues. While other forms of media-technology practices could have been selected, self-documentation offers a particularly appropriate area given its highly personalized nature and its frequent inclusion in the rhythms of everyday life.

At this juncture I could be accused of two things. The first is that my book is not really "about" its proclaimed subject matter in the sense of providing its readers with an exhaustive account of self-documentation throughout the ages. It is, rather (and this is where the second accusation comes in), a purely theoretical exercise in which the primary aim is to privilege a specific taxonomy of conceptual frameworks and paradigms. Consequently, the subject matter could be almost anything—architectural trends, shopping habits, narrative conventions. You name it and my "theory" will explain it.

There is something to these accusations. This project is intended as a theoretical investigation into what Hansen has identified as the physiology of media technology and what I am terming the "place of media." Indeed, the primary motivation is to foreground the contention that the study and analysis of media technologies and practices could benefit from an increased emphasis on how the temporal, material, and spatial qualities of given media environments interact with and contribute to the temporal, material, and spatial nature of the "universe" itself. In other words media, and more generally technology, have become a part of what we know and experience as the world in a manner that is increasingly inseparable. Such an assertion requires a move from content to experience or a move from methodologies that foreground discursive inventions and conventions to those that highlight shifts in the experience of and relationship between human and technological agents.[2]

This book *will not* provide a concise narrative of technological evolution that will take the reader from written diaries to the webcam. Indeed, it is important to stress that this book is not a history of self-documentation per se, nor is it a comparative ethnography in the

sense of providing an exhaustive account of either past or present forms of self-documentation. That said, however, both history and accounts of specific practices do play an instrumental role in terms of providing the context in which to conceptualize and thus better understand the dynamics of temporal, material, and spatial movements within mediated communication.

As indicated above, the overall structure of the book will be created via the figure or metaphor of "place." In this respect "place" can be understood literally as the surface or object upon or within which the act of self-documentation is inscribed. This place could be physical, as in the case of the writing surface like a piece of paper, or virtual, as in the case of the World Wide Web, or something in between, as in the case of film or video. What all have in common is the manner in which each demands a certain negotiation between the (physical) user and the place in question. This negotiation or adjustment has a number of very "real" consequences or effects, which relate not only to content but also to the manner in which individuals construct and live out their identities. Place, therefore, matters, and, moreover, matters specifically and experientially. This latter point is an important distinction, at least in terms of better articulating the nature of this critical project. Place is not something to be "read," or deciphered; it is not something to be examined via discourses that approach place as a static and abstracted object to which pre existing theoretical constructs can be "applied," as in the case of many linguistically informed cultural critiques.[3] Thus, for me place is not a text, it is not reducible to a sign system, it is not something that can be observed from above with a ready-made toolbox of analytical tools and precepts. For the purposes of this book, place is something that is experienced, lived, negotiated, and constantly in flux and thus better approached as a temporary zone of stability that owes its existence to a dynamic system of flows and flux.

Before moving on to the summary of the book's contents and structure, one last caveat is in order. This book relies on a deliberately constructed taxonomy that may strike readers as being too tidy for its own good and, moreover, in contradiction of the statements made in

the preceding paragraph. My response to such an accusation moves in two directions. The first is the familiar postmodern turn that, with a visible wink, acknowledges that all claims of objectivity and methodological rigor are housed in paradigms and ideological casings that determine their subject matter as much as they may or may not illuminate it. Thus, one might as well announce their constructions right from the beginning and add some extra ornamentation and artifice for good measure. Stated less glibly, this entire book is in part an exercise in structure and material/expressive place, and thus a portion of my intention is to create a resonance between the content and the discursive and ideographic terrain of these very pages. Message and form, so to speak, follow and contribute to each other. My second response, which is admittedly more defensible and less shrouded in theoretical contortions, is that the taxonomy described below is motivated by the simple desire to limit my subject matter. Self-documentation is an enormous field, both in terms of practice and the methods employed to study it. Ranging from autobiography and life-writing through to the myriad of representations that are possible via visual media, self-documentation as a topic is as unwieldy as it is fascinating. Hence the need to construct a temporary zone of stability, a deliberately structured artifice of order and categorization. Such a construction, which admittedly shapes as much as it explains, is intended to provide the reader (and the author) with a cognitive map—or better yet a methodological and theoretical corral—in which to group and with which to guide this book's particular concern with the material and spatial dynamics of mediated self-documentation.

Each of the major sections of this book is devoted to a particular treatment of place as it applies to the practices of self-documentation. These "places" are, to follow in part the tactics of Gaston Bachelard, "poetic" and "thematic" in nature, in the sense that, like Bachelard's use of the home, the various places discussed below engender physical as well as mental habits and circumstances. "Over and beyond our memories, the house we were born in is physically inscribed in us. It is a group of organic habits....We are the diagram of the functions of inhabiting that particular house, and all the other

houses are but variations on a fundamental theme" (quoted in Casey, 291). The places explored here—Media Place, Private Place, Real Place, and Time Place—are similarly conceived *topoi* of "physical topography and the inner structure of inhabitation" (Casey, 294). In other words, the four "place settings" are conceived of and lived as places to inhabit and places that literally inhabit us and that inform our continuous mediation between the internal and the external. Within each of these settings, a more specific and concrete series of places will also be considered, namely those of the page, the camera, and the network. It is the material condition of the technology that is of primary interest and the manner in which a particular device, such as the web-cam, engages with the experience of, for example, Private Place and, as well, how that experience doubles back on itself in the sense of engendering the experience of the web-camera itself.

Media Place is in many ways more true to a literal understanding of place, because it is through Media Place that the primary technological exemplars of the page, the camera, and the network will be introduced and mapped. For each of these places the central concern is to identify some of the formal characteristics of each medium and to probe the manner in which these characteristics relate to the practice and experience of self-documentation. What must be stressed here is that the Media Places of the page, the camera, and the network are not to be understood as discrete entities that impose themselves on an existing state of affairs and thus bring about consequences or "revolutions." Instead, acknowledgment must be made of the larger infrastructures and movements in which the various places are dynamically embedded. Such an acknowledgment is necessary in order to avoid the comfortable trap of technological determinism and its tidy collection of linear connections and causal relationships. As noted by Mark Poster, "technical forms are never independent variables but always already inscribed in social and cultural processes" (Poster, 2001, 154). Yet at the same time, technology does, as Poster also acknowledges, "open possibilities" and "contain restraints" (154). In an effort to work through the question of technology's relationship to material and psychosocial

experience, Poster proposes four levels of what he terms "technological inscription":

1. The constraints of the medium, its material limits
2. The pretechnological conditions for the introduction of the medium; perceived needs that inspire innovations
3. The general cultural determinations of the medium; for example, the difference between the introduction of print in Europe and in China
4. The determinations of the medium through practices; that is, how people symbolize their experience with the medium. (154)

To this I would add a fifth level that addresses the question of the medium as a place. Such a level highlights the medium as a temporal and material environment in which human beings live out various experiences or forms of being—in other words a "place to be" and a "place to do." Like any other place, a given Media Place is better suited for certain practices or modes of being than another. For example, the written diary is an agreeable place in which to engage in sustained expressions of introspection and confession. The home movie is arguably less suited for such modes of representation, favoring instead more performative, visual, and embodied forms of expression.

Once again, it is important to recall that the places of the page, the camera, and the network are constructions of convenience on my part. First identifying and naming them as such and then separating them into three subsections is in effect a reductive act and thus in contradiction to the theories of dynamic complexity that I refer to and argue for in the course of this book. However, such a reduction is primarily a matter of presentation and style that, to take a cue from Manuel Delanda, should not necessarily be taken as an indication of content (Delanda, 15). Instead, one should look upon the various places identified in this book as convenient artifices or iconic markers that can be employed to generate a relatively consistent set of inquiries and concepts regarding the experiential nature of self-

documentation and the places within which it is conventionally practiced.

The first set of these iconic markers is to be explored under the general heading of Media Place and, as has been stated above, will concentrate on the equally general subheadings of the page, the camera, and the network. Once again, the aim here is to emphasize the physiological and experiential nature of such places with respect to self-documentation and to probe them in relation to a larger host of flows and dynamics. Equally important, however, is to provide some emphasis on discursive constructions (despite previous statements to the contrary), both in terms of the volume of material associated with each general form and in terms of the critical discourses thus engendered. In other words, each of the three Media Places has generated a number of key discursive areas, particularly with respect to issues of identity, representation, and influence. In the case of the page, the critical assessment of writing and the technologies associated with it (with the book being the prime exemplar) has focused primarily on the issue of subject formation and thus explores writing in terms of its relationship to the emergence of the modern individual. The camera, in turn, has also been employed as a vehicle for exploring the subject but with the added emphasis on important shifts in perception and representation. With the advent of so-called digital culture, a number of critical fusions have occurred, but again one can generalize by stating that issues of subjectivity and the articulation of identity have remained an important preoccupation (Haraway; Turkle, 1995, Levy). Yet it is the experience and materiality of such subjectivities and identities within the context of self-documentation that will receive the most attention, especially with respect to lived reality, or, to take a cue from Heidegger, the experience of being in the world of either the page, the camera, or the network.

The next three sections focus on the material and experiential conditions of a number of key concepts central to the practices of self-documentation. Again, the concept of place is used as a way to "de-abstract" the discussion and to direct our attention to the interplay between individual experiences of self-documentation and the

material infrastructures to which they are bound. The first of these sections, "Private Place," explores the culturally important but often contradictory constructions of the private and the public and the manner in which these constructions assist in the organization of a host of physical and nonphysical spaces. Given the focus of this book, the ensuing discussion focuses primarily on the dynamics between the public and the private within the context of specific forms and practices of self-documentation. The concepts of the public and the private are in themselves problematic in the sense that the distinctions between the two cannot be fully represented by a simple binary opposition. As a cultural practice, self-documentation has often blurred the neat boundaries that attempt to separate the two spheres and thus offers a means with which to further develop our understanding of the public-private mix within social, cultural, and technological contexts. To be addressed are three focal areas that parallel the historical and discursive trajectory set up in the first section, which is to say the movement from the dynamics and historical conditions of written documentation to those associated by the equally broad category of the network. Thus the first subsection, "Pure Privacy," looks at the conventions of privacy as they apply to conceptions of personal or intimate forms of self-documentation, such as the convention of the "secret" personal diary. The act of detailing one's thoughts and daily activities is a mainstay in the overall history of self-documentation and one that is often assessed in terms of its confirmation or rejection of emergent conventions. The practices of "Pure Privacy" will thus be explored within the context of specific Media Places, again following the pattern established in the first section, which takes the reader through the places of the page, the camera, and the network.

The second subsection of "Private Place," titled "Public Privacy," probes the ways in which contemporary media culture has influenced the various practices of self-documentation. In recent years the act of making the personal public has become familiar enough, especially within societies that have well-developed media cultures. Among the examples discussed is the relationship between the home movies of the 1950s and the aesthetic and ideological codes of mainstream

Hollywood cinema. Of particular note is the consideration of how privacy has been integrated into the public domain in a manner that is largely connected to the infrastructures of commercial media and consumer culture. In this way, both public place and private place have been fused within a complex and ongoing dynamic among economic, technological, and sociocultural factors.

The Internet and the World Wide Web have, to a significant degree, altered and challenged the conceptions and practices of the public and the private. In addition to concerns over threats to the private domain, digital information technology has in general provided new means for reconfiguring public and private place. In the third and final subsection of "Private Place" I explore the influence of web-based media technology on the cultural practices of the public and the private. In many cases, the changes wrought by Internet technology parallel, enhance, or continue the directions of previous technologies and media. Yet at the same time a host of new configurations are being created—in this context, new places of the private and the public and the intersections between them. Among the prime examples here are the voyeuristic world of web-cams as well as the seemingly less provocative and more normative universe of web-diaries and journals.[4]

From private place we move to the place of the real, as indicated by the title of the third section, "Real Place." Of concern here are the constructs of authenticity and reality, which are often central to practices of self-documentation, autobiography, and media in general. Philippe Lejeune, for example, has stated that one of the implied conditions of any "autobiographical" utterance (however specifically or broadly defined) is the notion that the assumed author is at least writing under the pretence of telling the truth. What makes a diary, autobiography, or even a web-cam "real" or true is the faith that what one is reading or seeing is somehow the product of truth and not fiction. To betray this assumption is, as Lejeune notes, to break the "contract" of autobiography or, more generally, self-documentation (Lejeune, 14). This contract or pact is central to the whole enterprise of self-documentation. "Real Place" thus explores the function of the real in the common media places of self-

documentation. Among the questions addressed are: How are the practices of truth and fiction, for example, played out in the respective places? Also, how have the specific technologies of a given Media Place affected the nature of the real? Such questions are addressed via three subsections, which once again traverse the material and discursive expanse between print and the network

The first of these subsections, "Positive Reality," explores the role of specific Media Places in the construction and representation of the real, especially as they apply to the self-document. Among the most revolutionary is the camera, which in its early days was heralded as a means by which people could finally capture reality in a wholly objective and truthful manner. While this early optimism has been seriously compromised and challenged over the decades, the camera is still held as one of the most reliable mechanisms with which to capture, preserve, and access the real. Of course the camera is not the only vehicle here. Print and writing are also tied to a culture of "real positivism," in the sense of aiding in the construction of cultural codes of verification, documentation, and accountability. In this manner, the concern and fetishization of the real represent an important paradigm that needs to be worked through, especially within the context of digital media, which are frequently associated with the rise of the virtual and the hyper-real.

The second subsection, "Negative Reality," centers around a common argument that often falls under the general banner of postmodernism, which claims that the real no longer matters in the same way—or at least it is not primarily based on the distinctions between the simulated and the authentic, as simulated or virtual experiences are often as "real" as the real itself. In this section I explore the extent to which specific Media Places have challenged or otherwise "de-realized" the real within the context of selected practices of self-documentation and the media in which they occur. What is particularly noteworthy is the extent to which such de-realization is often connected to the place of media itself, especially in terms of altering the experiences of articulation and perception.

While questions regarding the role and impact of virtuality or de-realization have been raised in reference to media such as print or

photography, it is, of course, digital media technology that has been the primary focus of such discussions in recent years. Indeed, many of the arguments regarding the effects of digital media on society have been popularized to the extent that they are now part of media culture itself, as testified by such films as *The Matrix* and *Simone*. Thus, to speak of the virtual or the hyper-real is to speak of the digital despite the fact that many of the ideas associated with these terms can be applied to earlier media forms.[5]

What then, is the fate of the self-document within the general material and discursive constructions of the virtual? The responses to such a question are, as usual, mixed and at times paradoxical. From the perspective of external theoretical contemplation and critique, artifacts such as web-cam sites are entirely virtual and ephemeral phenomena, tempting one to conclude that the unreal or virtual has indeed triumphed and that humanity is, to echo Baudrillard, living within the desert of the real—a place of empty signs and lifeless virtuality and illusion. However, for those engaged in the various forms of virtual self-documentation as either viewers or producers, the experience is often very real and meaningful in a manner that challenges the conventional boundaries between the real and the simulated and, as well, the often negative assessment of the virtual as a legitimate place for social and cultural interaction. In this sense virtual reality undergoes a curious but not entirely consistent reversal that both confirms and negates that which we know and "feel" as real, true, and authentic. The real, therefore, becomes negative in the "electrical" sense. It still matters and still retains its powers of accumulation and relevance. What has changed is the direction—the polarity, so to speak.

The final subsection, "Returned Reality," draws from the debates outlined above but takes things several steps further. The real is back and it is better than ever. In this subsection, I argue that the real takes on an important and contentious role in today's digital media age. The real does matter and, in fact, has become a fetish or consumer item, at least if the current trend of reality programs is any indication. One central argument here is thus about a revitalization of the real—but a revitalization that is informed primarily by the tropes of

the entertainment industry. This is the real as media object or the "mediatization" of the real—the real as product and brand name, the real as a concept. In the course of this section, the nature and function of the place of the real are again charted through a number of examples drawn from contemporary forms of self-documentation, especially those within the environments of the World Wide Web. Attention will also be given to the manner in which consumer technology such as cameras and video and digital equipment is marketed with respect to practices of self-documentation. As the corporate slogans "Think different" and "Go create" imply, do-it-yourself representation and creativity is as much a road to big business as it is to self-fulfillment and empowerment.[6]

The final section of the book, "Time Place," has a familiar saying as its premise: "time is of the essence." Time is, without exaggeration, one of the most central aspects of human existence. Time is something that we all have and then, at any given moment, cease to have at all. With respect to the media we use to inscribe ourselves and our thoughts and observations, time plays a no less important role. The task of representation is in many ways a temporal process in the sense that it literally inscribes a moment or series of moments into some kind of static or at least contained medium. Thus, to read a diary from a hundred years ago or to look at the Super-8 movies taken by one's father is not only to embark on a kind of time travel but also to experience an encapsulated form of time itself—time that is contained in such a manner that it can be consumed and revisited on a continuous basis. In this final section I examine the relationship between the social construction of time and the various Media Places used to enact self-documentation.

The first of the now familiar pattern of three subsections is that of "Still Time." Conventional wisdom describes the written page as a place of contemplation, of solitude and sustained introspection and reflection. The text, as many hypertext scholars have repeatedly argued, is static and unchanging (Coover; Nelson; Landow). Once inscribed, it remains solid and unaffected by repeated visitations and re-readings. In particular, I examine the place of time as it applies to the medium of print, especially conventional diary and journal

writing. My aim is to explore the extent to which the general mandate of self-reflection and still time inherent within the diary form can be extended in order to better understand the temporal dynamics of the other media of self-documentation. One major contention is that the notion and practice of still time remains an essential component of self-representation and constitutes an influential part of its material and experiential repertoire.

What follows is the matter of "Future Time." The future lies at the heart of the modern condition and arguably continues to provide postmodernity with a regular beat. As has been well documented, the discourses of modernity, whether cultural, social, or ideological, are infused with a general commitment to the march of progress and continual change. Time, as such, is always in forward motion. To be modern is not to look back but to look always and resolutely ahead. In the context of our discussion, so-called modern (and postmodern) forms of self-documentation can also be depicted as having fallen under the spell of the future. Technological advances in photographic and cinema technology have engendered forms of self-documentation appropriate for a future-oriented society. Specific attention is given to the practices of self-documentation in terms of how they construct temporal environments that define and qualify the past and present in terms of their ability to serve the future, either in a purely archival sense or as a means of creating a kind of endowment with which to preserve and prolong the present.

Finally there is "Real Time," the title and subject of the final subsection. Real time is immediate time, the time of the now and the time in which there are no gaps between the moment of occurrence and the moment or representation and perception. What you see is what there is right now.

The relationship between media and real time is, by many accounts, a natural one. Indeed, immediacy has long been a kind of Holy Grail of media practice and technology in the sense of constructing devices and an infrastructure for which time does not matter or, at least, causes no delays or barriers between reality and the perception thereof. Related projects are those of media transparency—making the interface disappear—and of creating

representational environments in which there is no window or screen but only experience. This is one of the dreams of virtual reality, with perhaps the famous "holodeck" on *Star Trek* being the most popular version of this ideal. Reality and representation thus become one. You are suddenly in the world that is being told.

With respect to self-documentation, the lure of real-time mediation takes on a special relevance. The great promise is that of being able to get one's self (whether inner or outer) onto a particular medium as seamlessly and as quickly as possible, and the less reliant this process is on interpretation or translation the better. Such a promise appears almost fulfilled within the domains of web-based forms of self-documentation, particularly the web-cam phenomenon, which is heralded and fetishized as a medium that is as immediate as it is real. The final section will draw from web-cams and web-diaries as a means of probing the manner in which the temporal environment of real time engenders practices and experiences that are distinct from those experienced within the "time zones" of earlier media.

PART ONE
Media Place

CHAPTER 1
Posture One

I have a chair that I love. It is a reproduction of the now classic Le Corbusier Chaise Lounge designed in 1929. Like most good designs, the construction is simple and seductively straightforward—a chromed steel frame that follows the lines of the body at rest, a supple leather casing, a cylindrical pillow that supports the neck, and a sturdy base upon which the chair can be positioned at various angles. It is the kind of chair that one has a relationship with: sitting in it involves a process of mutual adaptation. Clearly the chair was designed with the human form in mind, something that is more than evident as soon as I lower myself into it. Yet at the same time, the body curves with the chair, working with its construction in an effort to create both comfort and an aesthetic ensemble that is in keeping with the modernist vision of Le Corbusier. Form and function follow each other in this case.

Naturally I am overdramatizing things here. My chair is, after all, just a chair. Yet it affords a convenient (and one might add comfortable) entry into my use of the term *place* as a means of reflecting on the material and experiential relationship between human beings and their media environments, specifically the media environments used for purposes of self-documentation. As outlined in the introduction, place is being used here as a way to focus attention on the material and physiological nature of our media environments and interactions. In this sense a media place is literally that—a place that one enters in order to engage in a process or practice of mediation, of communication, representation, and expression. As one enters such a place, a level of adaptation is necessary on the part of both the medium and those using it. Without such adaptation the human-medium relationship would not function.

At this juncture I cannot help but think of Marshall McLuhan, whose particular and some might say peculiar contribution to communications theory is to a large extent the result of what could be termed a spatial model of communication (Cavell, 1). Drawing from the work of Harold Innis, McLuhan's notion of communication as spatial can be related to his overriding concern for the context rather than the content of communication. In contrast to the Shannon and Weaver model and its reliance on transport metaphors, McLuhan's conception emphasizes the "power of any medium to impose its own spatial assumptions and strictures" (Cavell, 5). Thus the medium itself structures and defines the content to a significant degree in a manner that creates a specific and identifiable space of experience. "All of our senses created spaces peculiar of themselves" (Cavell, 6). What is notable here is that such "peculiarity" is far from static in the sense of particular media spaces as being rigidly defined by the boundaries of their territories. Rather, McLuhan's media spaces are highly dynamic and in fact, better understood as environments that provide a context for complex and ever-changing interrelationships. "Environments...are imperceptible. But environments are not mere containers. They are active and pervasive processes" (Cavell, 6).

Space, however, is not the same as place, and it is the difference between the two that captures an important departure from McLuhan's spatial model, which arguably informs later concepts of virtual and cyberspaces.[1] Place, according to Edward Casey's reading of the neoplatonic philosopher Philoponus, is that in which extensions occur, especially bodily extension. "Bodily extension is equivalent to the particular place occupied by a given physical body. It is the room taken up by the matter of that body" (Casey, 94). Space, on the other hand, is more like a void, a place in which there is literally nothing. "Rather than being a room *of* a body, it gives room *for* a body," which means that space can, in fact, be empty until occupied by a body (Casey, 94).

The distinction is important for our purposes inasmuch as it positions place—in this instance media place—in relation to a body. More specifically, it is that body's ability to extend itself, to literally take up place, that distinguishes place from space. Thus, for example,

the place of the page, which is discussed below, is that in which both the writer and the reader take up room. Without the presence of either the writer or the reader there would be no place of the page. There would be a page, of course. The actual object or artifact would continue to exist. But without a body, without the agency and sheer presence of the reader or writer, the page becomes more like a space—that which gives room *for* a body—and therefore something akin to a void, a zone of pure potential, an expanse ready and able to be occupied but nevertheless infinitely empty.

Extended or taking up room within the place of the page, the body of the reader or writer, especially but not limited to the present context of self-documentation, takes part in what could be called an "autotopographic" experience. Used by Deirdre Heddon to signal "the location of a particular individual in actual space" while engaged in various forms of "autobiographical production," the term can be further appropriated as a means of identifying the type of action and experience that occurs within the place of the page (Heddon, 1).[2] So placed, the body of the self-documenter encounters an environment that initiates a process of mutual adaptation and complexification. In other words, the place and the bodies within it are altered in ways that cannot be reduced to any one element.

A type of repertoire is created by such adaptations—a repertoire of habits, of bodily positions, of aids and implements, of styles, forms, and genres that taken together form the identifiable characteristics of writing, reading, photography, and typing, to name but a few "media postures." In other words, when one thinks of a particular media practice, such as writing, one invariably conjures up an image of the writer writing, and the physical and material conditions of sitting at a desk, of holding a pen, of bending over to get close to a page. Indeed it is the physical conditions and the positioning required of the body that make media use actually happen in the most literal sense possible. For example, in order to make a home movie one must get behind the camera, squint through the viewfinder, hold oneself in a certain way, and so on. Without such necessary adaptations, as minor as they may seem, home movie making would simply not happen. In other words, media posture is an essential component of media use. It

marks the place of media with the human form and vice versa, much like an imprint in the sand and the corresponding sand between the toes. Both sides of the interaction are affected and potentially altered.

Yet what can be made of such a seemingly commonsensical statement regarding media posture? For one, it corresponds to my general aim of downplaying the role of language and discourse and focusing instead on what Hansen describes as a "post-linguistic form of mimesis," or better yet a "corporeal mimeticism," that acknowledges and addresses our "embodied contact with the cosmos" (Hansen, 247–62). As such, Lacan's doctrine—"we are structured in language"—can be slightly rewritten: we are structured in place and in body. In other words, our placement with respect to material and environmental conditions is integral to any mediated experience, especially self-documentation, for any form of self-documentation necessitates a particular and identifiable posture both physically and in terms of the formal and aesthetic conditions peculiar to the medium in question. I have selected three main exemplars with which to explore and contrast the practices and conventions of self-documentation, which are, in brief, the page, the camera, and the World Wide Web. This triad is not intended to be all-inclusive or definitive, but rather an indication of culturally dominant modes of mediated place. Thus, each exemplar serves as an indicator of a particular modality of mimetic experience and practice—that is, a posture, with the page indicating written language, the camera indicating visual representation, and the web indicating the hybrid and "remediated" places of computer-driven networks (Bolter and Grusin). As I will argue below, each of these places carries with it a range of identifiable practices and conventions, which are as interrelated as they are distinct. These practices and conventions in turn point to various postures or clusters of material conditions and experiences that are connected to flows of culture and history that, in theory at least, can be momentarily spotted, marked, and probed.

Having said this, however, a word of warning is in order. Like the Le Corbusier chair, my theoretical and discursive apparatus similarly initiates a relationship of mutual adaptation, this time between theory and subject matter. One result is a certain measure of comfort on my

part—nothing pleases a theorist more than when a given set of paradigms fits snugly around a particular topic. Yet another and arguably more useful consequence is the achievement of a temporary measure of stability and order in which the usual tumult of a topic as complex and vast as self-documentation can be momentarily (and, yes, artificially) stayed for purposes of pointed reflection and exploration.

CHAPTER 2
The Place of the Page

Imagine the writer writing—not in terms of content but in terms of position: the position of sitting, the position of the hand, the head, the spine, the position of the desk, the chair, the pen and page. In other words, the things to pay attention to here are the material and embodied nature of the writing experience and the demands that the activity of writing puts on the human figure or subject: the posture of writing. One of the aims of this section is to investigate the extent to which these demands can be used to probe the experiential and material relationships within the history and practice of written or text-based self-documentation. Some of these relationships can be tentatively connected to genre, such as the "modern" practice of autobiography and its association with physical isolation and introspection. Similarly, reading can also be related to experiences of silence, isolation, introspection, and internalized thought. Another way to put this is to think about the place and position of both the reader and the writer in relation to the actual place of the page, which, in most cases, is either a book or an individual sheet of paper.

It is these basic elements of written self-documentation—the page or the book—that merit some initial attention, especially in terms of comparisons to earlier forms of self-representation. If considered as a kind of generic marker, the page represents one of the most defining surfaces with respect to written expression. In historical terms, the page is of course not the starting point of written language. One could go much further back. However, for the purposes of this volume the page serves as a convenient exemplar with which to begin the exploration of the experiential nature of self-documentation. One reason for such a starting point is familiarity. In terms of the contemporary imagination, the page serves as perhaps *the* generic

referent to self-expression. Indeed, one may think of it as the primal place of sustained self-reflection itself, the place that first greets the writer with its barren emptiness, with its smooth unmarked surface of endless possibility. Second, the page constitutes the individual units of the book, which in its turn is yet another generic marker. The book, in fact, figures strongly in discussions regarding the impact of new technologies, such as hypertext, on the nature of self-expression and, for that matter, on the nature of identity itself. The book is also a cultural landmark—an icon of the modern age, of knowledge and humanity's expressive voice. Lastly, the very practice of self-documentation, whether we call it life-writing or autobiography or diary writing, is a relatively recent phenomenon and one that arguably begins on the page and within the historical and cultural contexts of modern print culture (Mascuch; Eakin; Olney). In short, the page marks the physical and metaphorical points of entry into the modern practice of inscribing thought and language and thus strongly informs the experiential nature of the self-document and the mimetic and corporeal conventions upon which it relies.

As a means of isolating some of the experiences and materialities that are specific to the place of the page, it is useful to consider the differences between purely oral forms of expression and those of the written and printed word. We can therefore consider first the imaginary zone in which humans made the transition between oral and scribal culture. I say "imaginary" because it is actually impossible to specifically locate the moment of transition and its primary agents. However, for rhetorical and exploratory purposes, such demarcations can be useful in that they highlight contemporary constructions of what we understand as our past. In this instance, the "orality" stage can be conceived as one in which the postures of both producers and receivers are positioned within a general environment of performance. The key word *performance* is used to indicate some of the major differences between oral and literate forms of expression and reception. As Walter Ong has famously noted, orality's primary agent is that of memory, and thereby requires a host of mnemonic engines to maintain itself, such as formulas, rhetorical rules, poetic devices, and other memory aids (34–36). Consequently, oral

narratives are said to lack the originality of literate expression, due to their reliance on repetition, redundancy, patterns, tradition, and a general lack of analytical reasoning. In terms of posture, the orator is imagined as a performer, one who weaves his texts in front of an audience that, in turn, assists in the construction of the actual "text" by way of continuous feedback and input. Thus the orator stands, she or he gesticulates and moves and positions her- or himself within an actual space of both a material and social nature. In turn, the audience is also active, also situated in a place that is congruous with that of the orator. Everything is in sync—the speaker, the text, the listener. All take their place in the same continuity of instances. All are bound by time, as Harold Innis might say.[1]

In contrast, literacy is often described as a cultural practice that positions both writers and readers in isolated and immobile places of production and reception. Think back to the conventional representation of the writer outlined above. The writer writes alone and the reader reads alone. As well, both are reduced to immobility and it is the text that is in fact freed from its moorings, as it is capable of "traveling" without the benefit of its original author. Yet the written text is frequently represented as being on a higher evolutionary level than the oral in the sense that it resonates with modern life and being. Text is permanent, authoritative, stable, linear, organized, analytical, mobile, detailed, and less reliant on convention and formula. It is, in fact, common to summarize the key differences between literary and orality via a series of binary oppositions: performance versus self-reflection, public versus private, exterior versus interior, dialogue versus monologue, temporary versus permanent, and so forth (Ong). Such contrasts are often incorporated into the definitions of modern subjectivity, and thereby identify the written word as one of the major "carriers" of the conventions and practices of selfhood. As discussed by J. David Bolter, one result of such an identification is to construct a particular definition of human identity, an identity that is based on the ability to express reasoned discourse in writing.

> Memory and reason become a special and indeed privileged form of writing. The memory becomes a writing space, and the writer a homunculus who

looks out at the world through our eyes and records what he sees. The homunculus translates perceptions into words and images and records them; he also puts down his inner thoughts and conclusions (Bolter, 2001, 193–94).

Yet writing, as a media place, is not without its ill effects, as McLuhan, among others, has noted. "Literacy, contrary to the popular view of the 'civilizing' process...creates people who are much less complex and diverse than those who develop in the intricate web of oral-tribal societies" (McLuhan, 242). Equally critical of the written word is of course Jacques Derrida, whose concepts of logocentrism and difference highlight the manner in which Western thought is predicated on the logic and structure of binary logic, with the opposition between speech and writing occupying a central and paradigmatic role. Among the effects of such oppositions is a form of confinement, a literal imprisonment of thought by virtue of the artificial certainty that binary logic supplies.

In terms of self-documentation, literacy and the written or printed page figure prominently. Indeed writing is often conceived as being the dominant paradigm with which human thought, memory, and intelligence are defined, represented, and evaluated. "To think is to write in the language of thought and to remember is to search the space of our memory until we find what is written there" (Bolter, 94). Within the literate imagination, the mind is a vessel—something to fill up and then turn to for withdrawals of insight and knowledge. Similarly, the written page is a place where knowledge has been deposited for the purposes of extraction at a later point in time. It follows that one's identity, one's self, can be housed within the place of the page, literally etched into the blank surface of the page through the labor of writing.

Among the most prominent forms of self-documentation is the diary, which, importantly, represents a place within which the self is both expressed and constructed. Such constructions are, of course, not done in isolation but rather in constant relationship to overall social, cultural, and material order. For example, in reflecting on the function of nineteenth-century women's diaries, Cynthia Huff notes how "space is socially and culturally constructed and reflects our

ideas about how we interact within a culture and how that culture influences us" (Bunkers and Huff, 123). For many women diary writers in nineteenth-century Britain, the place of the diary directly relates to the ordering of social space, either in confirmation or in confrontation. Of particular note is the comparison between preformatted diaries and diaries that are basically a bound volume of blank pages. In the case of preformatted diaries, with their tidy fields in which to record the day's financial transactions, keep lists of things to do, various "wise words," and comparatively small places for personal entries, the spatial dynamics actually confirm the status quo in terms of laying out "proper" concerns for a lady of means and refinement (123). Unformatted diaries, in contrast, require or at least encourage a greater degree of individual control and freedom by virtue of the fact that the blank pages necessitate individual schemes of organization and content.

The differences between preformatted diaries and diaries consisting of "pure pages" are notable in terms of how they draw attention to the role of the material or formal parameters of the place of the page. Such parameters are made visible through Huff's commentary on the diary of Marianne Brougham, who made use of both preformatted and unformatted diaries. In the case of Brougham's early diary writing as a young girl, her use of preformatted diaries generally encouraged forms of self-representation that conformed to the norms set by "proper" autobiographers. Later, as an adult, her use of "pure page" diaries allowed for more flexible and malleable forms of self-representation, although Brougham, according to Huff, still fashioned "herself as part of the body politic" and one dedicated to the "maintenance of the British Empire" (137). What is notable here is the tension that arises from Brougham's efforts to write "her diary according to her own structures" and the social and ideological norms of her time and society. In this sense Brougham "uses her diary to position herself within the space allocated by the ideological constructs of gender and class in nineteenth-century Britain" (137). As exemplified by Brougham's movement from preformatted to formatted diaries, such

positioning is significantly affected by the material changes in the place of the diary itself.

However central the diary may be to the general practices of self-documentation, it is the genre of autobiography that carries the bulk of critical discussions regarding the form and practice of writing as self-documentation. Indeed the autobiographical act is often depicted as a practice and a material space within which Western conceptions of the individual self or identity were initially formed and expressed. Thus what we today consider to be the self, the true "I" or "real me," can be hypothetically traced to the first time that someone scribbled on a page something akin to "today I woke up and thought about what is important to me." The figure of Saint Augustine is a common landmark here. As claimed, for example by Arthur Kroker, "Augustine might rightly be described as the first citizen of the modern world," in that his *Confessions* represent the expression of "directly apprehended experience, of the direct deliverance of will, nature and consciousness" (Kroker and Cook, 37). Similarly, James Olney writes, "the entire justification, validation, necessity, and indeed exemplary instance of writing one's life, of finding the words that signify the self and its history, are offered to us for the first time...in the *Confessions*" (2). What is important here is not the identification of Saint Augustine as the seed from which all forms of self-documentation sprouted, but rather the perception of what constitutes a departure from earlier forms of expression and what this departure signifies with respect to the continued development of the human condition. In this sense, writers far less illustrious than Saint Augustine could serve as equally important exemplars of the birth of modern subjectivity. Michael Mascuch employs the writings of John Dunton—a seventeenth-century author and bookseller who wrote *The Life and Errors of John Dunton*. For Mascuch, Dunton's significance lies in his being one of the first persons in England to "attempt to represent his experience in an extensive printed biographical narrative while yet alive" (130). Equally innovative was *The Athenian Mercury*, a periodical published by Dunton in which readers could write questions to the editors and have them answered without their identities being revealed. Mascuch attributes the success of the

Mercury partly to the narcissistic and voyeuristic appeal of public and secular confession. A number of these question-and-answer articles were used as the basis for fictionalized narratives in which a narrator visits various illicit persons, such as prostitutes, in order to extract often lurid and sensational confessions of their depravity. Mascuch again takes these texts as progenitors of things to come, describing the *Mercury* as a seminal text "in the history of modern autobiographical discourse: it preserves some of the earliest and most accessible examples of personal history narrated by the subjects themselves, in which individual peculiarity is appreciated for its own sake, and the beginnings of a unified structure or plot are apparent in the written narration" (150).

Depicted as such, the place of the page is a place within which to construct and implicitly celebrate the centered, enlightened, and self-aware individual. H. Porter Abbott notes that "the diary's self-reflexivity and its use of a true present…explains that the diary's expressive advantage lies in its confinement of the reader to the internal world of a single ego where the narration itself is a kind of action" (Bunkers and Huff, 3). The notion of the "internal world of a single ego" is one of the essential features of the modern condition and the "voice" it uses to express itself. One could thus make the argument that the place of the page has been culturally constructed to accommodate such an ego and that the bulk of the material and psychological conditions of writing are structured accordingly.

CHAPTER 3
The Place of the Camera

Consider the posture of the photographer. The antiquated image of the photographer hidden behind a black shroud that leaves only his legs and the legs of the tripod visible is familiar enough. More contemporary stances, however, are equally embedded within the popular imagination. The portrait photographer peering down into the viewfinder of her Hasselblad; the paparazzo brandishing his zoom lens and high-intensity flash, the tourist squinting through a disposable camera, hoping to capture the essence of a long-planned vacation; the low-resolution blur of an anonymous teenager no longer conscious of the web-cam sitting on top of the computer monitor. From the very beginning, the camera has necessitated a certain positioning, on the part of both the photographer and his or her subject matter. The stiff formality of the early daguerreotypes, for example, can be attributed as much to the unfamiliarity of the technology as to the long exposure times that would render any movement into a hazy blur. Remnants of that formality—the photographic pose, one could say—remain in the practice of studio portraiture, with its emphasis on control and composition. In such a setting the photographer is the expert arranger of light and form, rendering even the most dysfunctional of families into a static image of order and unity.

A strong sense of idealization is evident in professional photography: wedding photographs, school portraits, graduation shots are bought for the professional codification of certain private moments as exemplary, as the magical accomplishment of a perfect social conventionality (Slater, 134).

The combination of the photographic pose and the "magic" of the perfect moment is elemental to normative conceptions of the camera's

power and meaning and, moreover, offers a succinct testimony of technology's role in the shaping and complexification of material reality. Indeed the pose and the "magic" of the camera point to what Hansen, through Walter Benjamin, has identified as technology's role as a "material force of natural history" (Hansen, 234). "Benjamin furnishes...(1) an account of the real that recognizes the *presocial* role of technology as agent of material complexification and (2) a correlative account of becoming (what Benjamin calls 'innervation') that foregrounds corporeal or physiological adaptation to the *alien* rhythms of the contemporary mechanosphere" (234). In the present context of the place of the camera, such distinctions are particularly useful in terms of highlighting the manner in which the camera both acts independently of (or better yet, in spite of) human agency and is engaged within a process of *mutual adaptation* that affects the spheres of humans and machines. Thus, the place of the camera is not one that can be *fully* explained via prior discursive or social constructions, in that the properties unique to its "nature" are such that "new" or at least distinct conditions and discourses are brought into being by its existence as a material entity. To further explore such concepts, the remainder of this section will draw from selected instances or developments within the history of photography, such as the peculiarities of early photography, *cartes de visite*, and detective cameras, before moving on to more recent "camera places," such as the web-cam.

Photography owes its existence to the dedicated and at times haphazard experimentation of early pioneers such as Joseph Nicéphore Niépce and Louis Daguerre and Fox Talbot, to mention just a few of the most obvious names. This early stage, from the world's first photograph, by Niépce in 1826, to the mid-1850s, is a period dominated by "elite amateurs" who through a series of patents kept the actual practice of photography under a relative degree of control. Talbot, for example, required that anyone wishing to use his paper-based negative-positive process for profit in England had to obtain a special license (Seiberling, 2). Indeed lawsuits between rival experimenters constitute a major portion of photography's history, and in some cases photographers spent almost

as much time in the courts, protecting their patents, as they did in their laboratories or studios.[1] In many cases, such legal vigilance led to considerable financial gain, especially during the "daguerreotype craze," which swept Europe between 1840 and 1850 and lasted a few years longer in North America.

Aside from legal constraints, the limits of the technology itself were a major hurdle and furthermore are indicative of the adaptation process between the human and the machine. The cameras themselves were cumbersome and finicky instruments, which often demanded as much guesswork as expertise. The development process was equally complicated and required the knowledge of chemical processes and procedures that were far from reliable. The actual taking of the photograph was also complicated and at times uncomfortable. For instance, the excruciatingly slow exposure times meant that human subjects had to remain completely still—sometimes for as long as twenty minutes—which meant that subjects often suffered from sunburn as a result (Pollack, 70). In order to keep people from moving, their heads were secured by a specially designed vice and sitters were told to concentrate on an indicated spot or "birdie"— the process was not unlike a visit to an optometrist or dentist. Indeed one enterprising inventor modified a dentist's chair so that the "the sitter may lounge, loll, sit or stand in any of the attitudes easy to himself and familiar to his friends" (Gernsheim, 229). However, as noted by the photography historian Helmut Gernsheim, "the sitter was usually adapted to the chair, not the chair to the sitter" (229). Remnants of this required rigidity, which was initially a result of technological limits rather than aesthetic or formal preferences, still exist today. Just think back to the last time someone took your photograph. It is likely that you were told to stand still, to look into the camera, to smile, and, in not so many words, to strike a pose. A vice is no longer necessary to ensure "proper" photographic poses, but by now most of us know the repertoire and quite naturally fall into one of those poses the moment someone pulls out a camera and announces the intention to "take a picture."

The camera not only demanded certain postures of its subjects, but also required photographers themselves to adopt specific poses

and cultural and physical positioning. Among these is the pose of active experimentation and arrangement. As a dedicated pioneer, the early photographer stands as a valiant and often solitary figure within a makeshift laboratory, forever tinkering and laboring—sometimes defensively, as indicated by the aforementioned lawsuits. The stance or pose is in a sense heroic or at least resolutely positioned on a forward path. In this respect the photographer gives precedence to the object of his labor, which is the camera. Thus all must be subjected to the camera and its technological possibilities and limits. Because of early photography's slow exposure times and other technical limitations, it was necessary to arrange reality in such a way that the camera could adequately capture it. This required not only vices and converted dentist's chairs but frequently the construction of elaborate sets in which subjects could be properly positioned. It is in this respect that the posture of the early photographer can be characterized as an expert amateur, which in some sense removes him (and less frequently her) from the general public. As expert amateurs, early photographers adopted a position of implied superiority over their subject matter, literally standing behind the technology, which provided them with a certain measure of authority and status. In many cases this superiority was more than implied: expert amateurs were normally from the upper classes, because the pursuit of an art such as photography required financial resources and a significant amount of leisure time.

The era of the expert amateur, with his bulky and idiosyncratic equipment, did not last for long and quickly gave way to the overt commercialization and domestication of photography, which in turn gave rise to an expansion in the repertoire of photographic postures. Technical and legal developments were at the forefront of this expansion, creating conditions that allowed the public to employ photographic methods with greater ease and freedom from patent restrictions. In England, for instance, two events are acknowledged as furthering the expansion of photography into the public realm. In 1851 the Great Exhibition of Arts and Industry in the Crystal Palace introduced the public to photography via exhibits of prints and equipment from England, the United States, and Europe. During the

same year, Frederick Scott Archer introduced his wet plate process, or collodion, to the public without patent restrictions (Seiberling, 2). The process offered important technical advantages, such as short exposure times and more reliable and consistent results. The combination of technological advances and relaxed patent laws led to the increased commercialization of photography both in terms of professional studios and the manufacture of cameras for the wider public.

Photography's development into a normative and widely available technology can be explored via changes within the place of the camera, especially in this instance through changes associated with the production and reception of the photographic artifact and changes in the material object of the camera itself. While there is a nearly limitless variety of phenomena and innovations that could be referred to, I will restrict myself to two relatively familiar examples—*cartes de visite* and detective cameras. These two exemplars succinctly draw attention to issues around materiality, production, and reception and thus serve as convenient platforms from which to embark on further explorations into the places of self-documentation.

Adophe Disderi first made the *carte de visite* popular in 1854. The concept of the *carte de visite* is simple enough and in some ways a predecessor to the photo booths that inhabit the halls of railway stations or the corners of shopping malls. The basic concept was to take ten photographs on one glass plate, thereby reducing both the cost and time of developing multiple copies. This obviously made the cost of the photographs much cheaper, which meant that they became more accessible to the middle and lower classes. Popular legend has it that the *carte de visite* became a hit due to Napoleon III, who while en route to Italy in May 1859 stopped with his troops outside Disderi's studio to have his portrait taken. The next day Disderi was famous and all of Paris vied to have their portraits preserved on the small *cartes* (Gernsheim, 226). What is significant about the phenomenon is that it signals in a very tangible manner the emergence of a definable economy of images and the manner in which reproducible visibility became an increasingly dominant form of self-representation. This is

especially the case in terms of nineteenth-century "celebrities"—royalty, famous authors, politicians, musicians, and cultural impresarios—whose *cartes de visite* were actively traded on the open market, much like baseball or hockey cards today. The trend of "trading *cartes*" is said to have been initiated by J. E. Mayall, who published a *Royal Album* that featured *carte* portraits of the entire royal family (Gernsheim, 226). The album was a great success, and other photographers quickly followed with similar representations of well-known public figures. The phenomenon quickly became an industry, and hundreds of studios were opened up across Europe in an effort to meet and capitalize on the demand. In England alone it is estimated that between 300 million and 400 million *cartes* were sold each year in the mid1860s, and equally high figures are reported for the United States, Germany, and France (232).

The commercial success of the *carte de visite* points to a curious turn within the history of photography that is arguably continuing, if not accelerating, in the contemporary era. This turn is perhaps best explained as a matter of confluence and the layering of events and conditions within the techno-human matrix. One of the vectors within this turn takes its force from situating the general notion of self-documentation within the dynamics of the commodity form and the modern marketplace, which as identified below runs the risk of turning the individual into a "malleable commodity."

The acceptance of the carte portrait as an item of exchange, a collectable by the middle class, and the subsequent adoption of the practice by the workers themselves represent the insidious transformation of the individual into a malleable commodity. Direct human intercourse was in a sense supplemented by the interaction with a machine generated and therefore irrefutably exact alter-ego, a fabricated "other." The creation and popularization of the *carte de visite* during the Second Empire therefore represents an early step toward the simplification of complex personalities into immediately graspable and choreographed performers whose faces rather than actions win elections and whose makeup rather than morals gains public approbation (McCauley, 224).

An equally powerful vector can by identified by returning to the previous ideas of Hansen and Benjamin. The *carte de visite* phenomenon can be seen as one indication of what Hansen describes as a "post-linguistic mimesis," which identifies the "eclipse of language as the reigning vehicle of mimesis" and the correlative rise of visual, material, and sensory forms (236). As a form of technological modernization, the *carte de visite* "brokers a shift in the medium of experience, from non-sensuous linguistic correspondences to embodied and practical mimetic activity" (236). In other words, the act of sitting for the photographer, the compact nature of the images, the industrial nature of the processing, the sheer volume of potential copies, and their circulation within the general marketplace—all these conditions (and more) constitute technological nodes or contact points between humans and the world that speak of physiological, social, cultural, and material adaptations that have the potential to form the basis of new forms of social and human-machine interaction and codevelopment. Such interactions are also evident in the second development to be discussed here—the invention of so-called detective cameras. This technology was the result of the dry plate process that radically reduced exposure times so that cameras no longer had to be mounted on tripods and no longer required the "dark box" or tent in which to change film or plates. Gradually, cameras became smaller and were sometimes even disguised as handbags or parcels or designed so that they could be hidden in clothing, such as in the case of the Stirn "buttonhole" camera of 1888. Despite the term, there is little evidence that detective cameras were actually used by real-life detectives. It is more likely that the word *detective* was merely fashionable given that this was the era when fictional detectives such as Sherlock Holmes, Dr. John Thorndyke, Arsene Lupin, and Sexton Blake were all the rage (Holmes, 96). The main selling point of these cameras was that they could be used to take candid photographs. In other words, they were small enough so that they could be used without being noticed (96).

Whatever the motivations for the name, what is revealing about the detective camera phenomenon is the implied freedom that portable camera technology allowed. Integral to this freedom was the

ability to capture reality as it was happening rather than being compelled to carefully arrange it in preconceived postures. Consider, for example, this excerpt from an advertisement for the Stereoscopic Binocular Camera manufactured by W. Watson and Sons of London. The main feature of this camera was that it allowed one to take pictures at right angles, since the actual lens for the camera was located at the side of the binoculars.

> This is held to the eyes like a Binocular Glass, which in appearance it resembles but its unique feature is that the picture is taken at right angles to the direction in which the camera is ostensibly pointed and in this way it secures pictures without in any way indicating its purpose. It is an ideal Detective Camera and invaluable to travelers as it enables them to catch native subjects in perfectly natural poses, without arousing any suspicion in their minds that they are being photographed. (quoted in Holmes, 99)

The obvious colonial overtones only add weight to the belief that the camera is an intrinsically objective media capable of both representing and rendering reality. Moreover, the possibilities created by portability and concealment allow for different techniques of observation, new modes of seeing and perhaps even being. The development of detective cameras subtly demonstrates the interplay between the physical and material conditions of the technology, its perception within lived reality, and the cultural assumptions that go along with it. Again, a bifurcation has occurred here that can be explicitly traced but not limited or confined to a particular technological development. What has occurred with the introduction of a device such as the detective camera is an extension of the evolutionary matrix of the human-machine relationship—an extension that necessitates a certain level of adaptation on the part of humans to the "alien" nature of the place of the camera (Crary, 1990).

The introduction of affordable and lightweight cameras in the late nineteenth century continues the momentum of the *carte de visite* and the detective camera and arguably represents the full emergence of photography into the realm of everyday life. The most widely acknowledged instigator is of course George Eastman, who with his Kodak revolutionized the photographic industry. The first Kodak, a

so-called detective camera made available in 1888, was an exercise in simplicity. The instructions for use were as follows: "Pull the string; Point the camera; Press the button; Turn the key" (Auer, 119). Each camera contained enough film for one hundred exposures, which, after being taken, could be sent to the factory for processing. Shortly after the debut of the Kodak, the famous slogan "You press the button, we do the rest" was inaugurated, thereby popularizing photography as never before (119). The camera itself was not particularly unique for its time, but it was Eastman's combination of technology, marketing, and consumer service that effectively brought photography to the general public (Lothrop, 36). Photography thus moved out of the studios and into the hands of individuals who carried the little black boxes around with them, meaning that the practice of documenting family events, vacations, and everyday occurrences for the purposes of preserving them in a family album became a regular practice by about 1900 (Duval, 110). One consequence of this was the personalization and sentimentalization of photography—a practice that had been more or less in the hands of professionals or dedicated amateurs until the very last years of the nineteenth century. "The rise of the family album had the foreseeable effect of promoting the sentimental interpretation of photography. Just as painting moved away from descriptive realism, so photography too became more subjective and the amateur snapshot more closely identified with the subject and its emotional overtones" (110). In this sense the place of the camera became increasingly incorporated into domestic space and thus informed by the codes of bourgeois sentimentalism and culture.

The ubiquity of the camera within domestic space is considered one of the hallmarks of modernity and consumer culture. Indeed, the camera is structured as a consumer good, which, as suggested by Don Slater, renders the means of representation in such a way as to "produce and exploit profitable social relations and activities in domestic life" (130). The dominant place of such "exploitation" is within the coordinates of leisure time, which encompasses a broad range of activities and spaces from birthday celebrations to summer at the cottage to graduation ceremonies and dinners with out-of-town

guests, to name but a few. In this respect the place of the camera is coupled with the places of leisure, which in turn are subsumed within the general terrain of capitalism and commercialized consumption (Rojek; Braverman). Among the most pervasive yet contradictory practices is that of the family album. Almost every household has one, at least if we are not too literal about the term *album* and include such repositories as old shoeboxes, desk drawers, and the envelopes from the photo finishers.

The matter of the shoebox signals an interesting footnote with respect to the consumption of photographs themselves and points to what Slater has identified as an indication that the use of photographs and other domestically created images has not yet been fully structured into an accepted leisure event in and of itself (Slater, 140). The key phrase here is "fully structured," which indicates that the consumption of snapshots, slides, and home movies is somewhat incomplete when compared to the consumption practices of actually taking pictures. In other words, the camera is a near constant presence and often an essential tool for the success of any given family event. Yet once the photographs come back from the developer, they are often given only a cursory glance, most frequently in the car just after having picked up the photographs from the developer. Selected photographs are commonly placed within albums or put on display, such as within frames, which are then hung on the wall or propped up on the mantelpiece. Others are merely taped or tacked onto bulletin boards or the sides of computer screens and other such haphazard zones of display. Of course such seemingly random and careless consumption could also be interpreted as the "structure" of photographic consumption itself in a manner that does not diminish the emotional or cultural importance of having photographs "around," whether carefully arranged in an album or stuck in a drawer somewhere.

Yet, however incomplete, such an assertion acts as a useful counterpoint to recent trends in digital imaging, which arguably points to a possible change or at least an acceleration of the consumption patterns of images and their integration into the structures of everyday life. Given digital technology's ability to

converge media formats into a single technological environment (that is, the computer), consumers are increasingly able to function as "production centers" in their own right. In other words, the entire process—from taking the pictures or movie, to "developing" and editing it—can be accomplished by most users, at ever-decreasing costs and with little more than a few mouse clicks. Added to this is the ability to "publish" or distribute one's creations via the global network of the World Wide Web. Together, such developments are arguably unprecedented, although one may certainly argue about their value or significance on the basis of taste or cultural import. Yet what *is* significant and worthy of note here is the level of control that individual consumers have over the entire production process with respect to their works of self-documentation—a process that also includes its "distribution" via the web, for example. On one level the increased control could be interpreted as leading to a potential increase in creative and expressive agency. On another level the increased control is actually market driven, thereby signaling the extent to which the actual consumption of "self-documents" and other forms of consumer-created media "objects" is now firmly codified within the overall matrix of the media-technology-consumer complex. One need only think of the "Go create" campaign by Sony or the "Think different" campaign by Apple, both of which encourage the active use of consumer media technology in a manner that gives almost equal weight to the use of the material as to its capture or encoding. What could be said here is that the use of domestic images (after the fact of their initial capture) is rendered into a creative activity that requires the purchase of specific equipment. Thus one can "go create" and "think different" or otherwise follow the numerous slogans that emphasize individual creative activity. In this manner the place of image consumption dissolves the spectacle into a continuous zone of individual effort and production, which is arguably in keeping with the ethos of utilitarian leisure preferred by the contemporary consumer society. Thus one does not passively consume images but rather actively interacts with them in an increasingly complex and technologically dependent manner. Consumption has become "productive," giving rise to a new breed of

consumer—the "prosumer" or the productive consumer who, in this case, creates his or her own spectacles. Moreover, the inclusion of these "homemade spectacles" into the general media and entertainment stream—which starts with the web and progresses to such phenomena as reality TV—has become commonplace. Again, tropes of production and commercialism are at work here—a type of DIY approach to personal expression and promotion.

There are of course precedents here that, if confined to camera technology, go as far back as the first marketing campaigns of the photographic era. "You press the button, we do the rest." The twin engines of capitalism and modernity have been fueled by the combined forces of the spectacle; the dreams of consumption and codes of organization and progress since at least the nineteenth century (Crary, 1990; Buck-Morrs, 1989, 2000). Thus the phenomena represented by Sony's call to "go create" is nothing very new but rather representative of the longstanding tradition to create new markets by creating new needs—in this case the need for creative expression and control. However, what is potentially different is the level of acceleration and increasingly seamless convergence of technologies, media, society, and users. Thus we work, we shop, we film, we express, we record, we edit, and we display—and then we watch others do the same. And around and through us capital continues to circulate and expand.

As a means of reflecting further on this, a combination of Michel Maffesoli's concept of "neo-tribalism" and Katherine Hayles's identification of "liberal post-humanism" offers some intriguing insight. In the first case, neo-tribalism is used by Maffesoli to refer to the nature of social cohesion and attachment in postmodern society, which is said to be the result of emotional and symbolic groupings that lack any form of permanence. "Tribal groupings cohere on the basis of their own minor values, and…attract and collide with each other in an endless dance, forming themselves into a constellation whose vague boundaries are perfectly fluid" (12). Sporting events, rock festivals, and raves are among the more obvious examples. Equally exemplary are the more symbolic groupings such as those represented by brand loyalty and the "bonds" created by following a

popular television program. In either case, what is significant for Maffesoli is the manner in which such temporary groupings create meaningful bonds between often-disparate individuals.

> In contrast to the stability induced by classical tribalism, neo-tribalism is characterized by fluidity, occasional gatherings and dispersal. Thus we can describe the street scene of modern megalopolises: the amateurs of jogging, punk or retro fashions, preppies and street performers invite us to a traveling road show. Through successive redirection, an aesthetic ambience...is contrived. It is within such an ambience that we occasionally see "instantaneous condensations," which are fragile but for that very instant the object of significant emotional investment. (76)

Such "aesthetic ambience," with its potential to "accentuate the sensational, tactile dimension of social existence," resonates with Hayles's observations regarding the state of the post-human in contemporary society. Briefly, Hayles's concept of "liberal posthumanism" can be paraphrased via her exemplar of Hans Moravec, the computer engineer and theorist who excitedly envisions the day when human consciousness can be successfully downloaded into the computer (1). Equally representative is Kevin Warwick, who in response to the "frequently asked question" of whether or not humanity is obligated to change itself because it has the power to states: "Humanity can change itself but hopefully it will be an individual choice. Those who want to stay human can and those who want to evolve into something much more powerful with greater capabilities can. There is no way I want to stay a mere human."[2] Both Moravec and Warwick display what Hayles identifies as the dangerous "grafting of the posthuman onto a liberal humanist view of the self." Hayles explains, "when Moravec imagines 'you' choosing to download yourself into a computer, thereby obtaining through technological mastery the ultimate privilege of immortality, he is not abandoning the autonomous liberal subject but is expanding its prerogatives into the realm of the posthuman" (287). Similarly, the seamless convergence of technologies, media, society, and users referred to above serves the dual purpose of creating temporary (neo-tribal) zones of interaction, solidarity, and community and the

necessary illusion of an empowered "liberal humanist consumer" who can shop and create as he or she pleases. In this respect, the place of the digital camera becomes a hyperconnected place that is representative of a social-media-technological complex that is ideally suited to the neo-tribal liberal humanist post-human subject—a mouthful if ever there was one.

At this juncture another set of questions arises: What happens when the images begin to move? How different are the places of the movie, video, and web-cam? What are the dynamics of adaptation between the machine and the human and to what extent is the material and social world further complexified by the introduction of motion into the practices of self-documentation?

The responses to such questions start with the home movie camera. As early 1923 Kodak's 16mm Cine Kodak was available to the general public, at least those with deep pockets.[3] The phenomenon of the "home movie" began in earnest, however, in the mid-1930s with the introduction of 8mm cameras and film. As a tool, the home movie camera significantly enhanced the nature of self-documentation with its ability to record larger slices of time than those offered by still photography. The possibility of recording a small segment documenting the movement of time allowed for a greater degree of reality, or at least such is the perception inasmuch as the ability to capture "moving time" is associated with greater reality and objectivity. Such "naïve empiricism," as Richard Chalfen terms it, generates or at least implies a kind of hierarchy of mimetic experience. "Color pictures do it better than black and white ones, motion pictures improve on still photography, and when color movement and sound are all included, you really have the best chance to duplicate, experience, and, indeed, re-live life" (Chalfen, 1998, 162).

The place of the home movie camera is thus conceivably a place in closer proximity to the real and the immediate, a feature often proclaimed in advertising campaigns. In terms of content, however, "changes in technology did not significantly change the images themselves; home moviemakers generally photographed the same things that snapshooters did" (Citron, 3). As such, the home movie

camera remained a place for the generic intimacies of family and everyday life and, as such, quickly became regular accompaniments to the rituals of leisure and consumer culture in a manner comparable to that of the still camera.

However generic in terms of familiarity, the home movie camera arguably adds a layer of complexity to the dynamic between those behind and in front of the camera. As Michel Citron identifies, "home movies represent how the person behind the camera chooses to film the way the person in front of the camera presents his or her 'self'" (13). As such, home movies render the place of documentation into a more volatile environment in which "directorial control," for lack of a better term, meshes with the increased need or impetus to "perform." This volatility can be partly attributed to a number of increased intensities—intensities of time, of mediation, of space, and of the materialization of media engagement. The place of the movie camera "lasts longer" and takes up more room—it has a greater level of intrusion into personal space and thus stretches the actual moment of mediation from a part of a second to several minutes or more. The place of the movie camera is larger and offers a greater space within which the body can extend itself, at least in terms of visual (and later aural) representation and expression.

Such observations would appear to be even more tenable in the case of the video camera, which began to be available with the introduction of the Sony Portapak in 1965. The initial high price restricted the technology to more or less professional circles, such as filmmakers, journalists, and a new breed of artists working in video. However, it did not take long for video technology to become a staple on the consumer market, with videocassette recorders being relatively common by the late 1970s (Cubitt). On a general level, the use of the home video camera paralleled that of the film camera, with a number of notable exceptions. Compared to film, the cost of videotape was remarkably low, and tape had the added advantage of being reusable by recording over previous material. Thus, the documentation of everyday life was enhanced in terms of quantity. Instead of three-minute reels, videotapes allowed for hours of recording time. The temporal shift is significant in terms of creating

50 *Saved from Oblivion*

the potential of "real-time" visual documentation both in terms of a closed-circuit television setup and via the potential for continuous recording thanks to the low price and reusability of videotape. The place of time, as I will explore in a later chapter, is changed in important ways.

Equally notable is what could be termed the material presence of the video camera—in other words, the manner in which the video camera has become an omnipresent media technology whose boundaries are increasingly being expanded. Video monitoring and surveillance is an integral part of most contemporary societies, either in the name of security, news, or, increasingly, entertainment (Lyon). Thus, to enter the place of the video camera is to enter a "mediatized" place, a place that functions under the pretense of being potentially connected to the infrastructures of mainstream news and entertainment media. Indeed, the promise of media coverage is increasingly a material part of everyday life to the extent that the practice of performing for the media, however broadly defined, becomes naturalized. Particularly notable is the expansion of the terrain initially marked out by the still camera. The place of the camera is literally extended, thereby creating a larger place within which the subject can perform. Implied by the concept of expansion are not only increases in size or intensity but also the evolutionary changes brought on by moving into "new" media territories. In this respect there is more going on here than just ubiquity—the idea that the camera is everywhere. Here we see the emergence of a more complex environment that can partly be linked to the presence of the camera and our ever-increasing interaction with and adaptation to its materiality.

The place of the web-cam is a curious one. One the one hand it can be seen as furthering the forces of "camera ubiquity" mediatization and the expanding territories of media technology. Yet on the other hand the web-cam is a distinct place in a number of ways and thus leads to a number of important points of departure. One important difference is with respect to the physical archive and the practices associated with collecting, sorting, storing, and viewing images. Web-cam images are transient and fleeting. While some

measure of archiving is possible (and indeed practiced), for the most part web-cam images are destined for real-time representation and consumption. Thus as a "record" or artifact their role is curtailed and as such the images represent a significant departure from the material dynamics of earlier forms of self-documentation, such as the diary or the photograph. Much of this has to do with the virtual nature of the medium and the fact that web-cams are primarily utilized as means for real-time image capture.

The web-cam is not without its distinct postures. On the consumption side, web-cam images are normally watched by individuals rather than groups and thereby position the user within the static restlessness of the "web surf." One watches, and waits for something to happen, rather than encountering images that have already been selected or contrived on the basis of significance of entertainment value—or at least such is the pretence or assumption. The attraction of the "totally live" web-cam is precisely the possibility of being within the moment of representation itself. For a brief instance, the consumer is relocated to the "there" of the web-cam in a manner that is literally in sync with the time and place of representation.

The posture of the web-cam operator, if such a term can be used, is a curious one. To begin with, the web-cam is a rather independent medium: web-cams are not generally brought to family events, for example, but are rather set up in locations where events might happen, such as at home or in the town square. This means that unlike still, movie, or video cameras, web-cams are not ceremonial instruments (in the same way that a movie camera is at a wedding, for example). Instead, web-cams form part of the material and informational infrastructure and thus bear some comparison to the telephone or even electricity. Web-cams are always there, always on, and thus part of the background, the very structure and experience of the environment itself. Added to such a posture or positioning is an emphasis on control, security, and surveillance, as indicated, for example, by the marketing efforts of web-cam manufacturers:

> Biromsoft WebCam is efficient, dependable and low-cost surveillance software solution for home and business use. This great software features

live streaming right away just by giving out your IP address to your friends. You may use this software to keep an eye on your kids or pets, or use it to make sure your house is safe when you are gone. WebCam allows you to either keep the surveillance images private or make it available for everybody on the Internet.[4]

For Biromsoft and its many competitors, the web-cam is assigned the role of a comforting presence, a benign and self-created "big brother" who watches over one's household and loved ones. It is arguable, in fact, that the web-cam represents a kind of embodiment or internalization of the camera in the sense of its increasing inclusion in all forms of material life. Among the notable examples is the wrist-cam developed by Casio and the self-proclaimed cyborg Steve Mann, who has a web-cam literally wired to his body.[5] In both cases the camera becomes a literal prosthetic, rather than just a portable medium or tool. The place of the camera thus undergoes a radical relocation as a consequence of its becoming a "natural" and increasingly internalized component of one's body or life world.

CHAPTER 4
The Place of the Network

The place of the network is a place of hyperbole and relentless speculation. Indeed, the network has become a type of paradigm with which to characterize a wide range of phenomena, whether electronic, social, or biological. We speak of network cultures, neural networks, and economic networks, with Manuel Castells serving as one of the leading gurus of the network age, claiming as he does in his monumental three-volume study that "for the first time in history the basic unit of economic organization is not a subject, or collective" but rather a "network" (Castells, 2000, *Network Society*, 214). By obvious extension, the network also encompasses the various environments of digital media, with the Internet, the World Wide Web, and virtual reality serving as the major points of reference. Here again, metaphors and overstatement abound: consensual hallucination, mind machines, collective intelligence, connected intelligence, virtual realism, being digital, cyberspace, and hyperreality, to name only a few.

As a place, the network is not quite as ephemeral as it may at first seem, at least in terms of its effects and application to existing human and material environments. Seen in relation to the social structures of human societies, the network—or, more specifically, the "Network Society"—is representative of very real changes in the spatial and temporal conditions of human society. However, as Castells reminds us, the network as a general category of human organization is not particularly new:

> What is new in our age is a new set of information technologies which has created a new paradigm. What is characteristic of this technological paradigm is the use of knowledge-based, information technologies to enhance and accelerate the production of knowledge and information, in a

self-expanding, virtuous circle. Because information processing is at the source of life, and of social action, every domain of our eco-social system is thereby transformed. (3)

Much has been made of the transformative potential of information technology, especially in the early heady days of the "IT Revolution" when even the sky was too much of a limitation (Katz, 1978; Negroponte). The excited rhetoric of Derrick de Kerckhove offers a representative example:

Digitization is smashing everything to bits and placing the rebuilding of matter, life, and reality in the hands of people like you and me....Together, interactivity, hypertextuality, and connectedness constitute the basis for the planetization of ordinary people as well as organizations, nations, and continents, by a permanent, self-updating synergy of local computers, global networks, and satellites. (xxiv–xxv)

However, the "planetization" made possible by "digitization" is, in reality, accessible to only a relatively small and elite section of the world's population. For example, the United Nations *Human Development Report*, published in 2001, states that "79% of Internet users live in OECD countries, which contain only 14% of the world's people" (UN, 42). The Digital Divide Network makes similar assertions, claiming that "only six percent of the world's entire population" is online and that the "United States has more computers than the rest of the world combined."[1] Both the utopian and dystopian discourses around the effects of information technology seem at best overblown and at worst sadly isolated from the realities faced by the majority of the world's population. Yet despite such sobering statistics, the network still retains its paradigmatic force.

What, then, are some of the major features of the place of the network, especially as they inform the practices of self-documentation? The first part of this question can be discussed by considering the following traits, which are in themselves compiled from similar "lists" of major features and paradigms (de Kerchhove; Jones):

1. The compression and extension of space;
2. The virtualization of time;
3. Ubiquitous pluralism; and
4. The virtualization of direct interaction.

The first trait, the compression and extension of space, is familiar to the point of being obvious and, moreover, applies to other technologies such as the telegraph or the locomotive. The network, as rendered under the influence of computer communications technology, radically alters the experience and relevance of space, distance, and time (Robinson). As countless commentators have remarked, geography is irrelevant on the net, given that one can be anywhere (and anyone) at any time. Michael Heim notes a common sentiment (which he later problematizes): "The computer network appears as a godsend in providing forums for people to gather in surprisingly personal proximity...without the physical limitations of geography, time zones, or conspicuous social status" (quoted in Benedikt, 73). Space and place are thus compressed into a single moment of access, rendering a condition of simultaneity or immediacy that is essentially flat, immaterial, and malleable (Slevin, 71). Everything is possible, mainly because the virtual worlds of the Internet and similar technologies are imagined and presented as "unreal," and thereby separated from the conditions of the real world and the real body.[2]

Yet as Vivian Sobchack has noted, the "technologies of the screen" each demand very different ways of "being in the world," and thus involve all of us in equally different structures of material investment and experience (138): "Just as the photograph did in the last century, so in this one, cinematic and electronic screens differently demand and shape our 'presence' to the world and our representation in it. Each differently and objectively alters our subjectivity while each invites our complicity in formulating space, time, and bodily investment as significant personal and social experience" (138). As a virtual reality, the network is "exceedingly material" and thus "dependent on human bodies, technologically as well as symbolically" (Sunden, 24). The place of the network is not one that

can be removed from the material world but rather one that should be perceived as an extension of it. Among the results of such "extension" is a literal increase in places to "inhabit" and, more significantly the creation of a kind of hierarchy for "real" geographic places vis-à-vis their ability to be connected to the network. The United Nations, for example, ranks individual nations in terms of their level and intensity of connectivity, dividing nations into categories of "leaders, potential leaders, dynamic adopters and marginalized" (UN, 45). The bigger the hub or node, the higher the country's ranking and the greater its relevance.

The inability to be connected or to be able to do so only via a very small bandwidth effectively banishes a given geographical place to the veritable backwaters of economic, technological, and social relevance. To again quote Castells, "By definition, a network has no center. It works on a binary logic: inclusion/exclusion. All there is in the network is useful and necessary for the existence of the network. What is not in the network does not exist from the network's perspective, and must be either ignored or eliminated" (Castells, 2000, "Materials," 6). Such a sentiment is echoed throughout the network's discursive matrix that ranges from advertisements to the day-to-day "connection anxieties" of web users.

The second aspect, what I call the virtualization of time, is comparable to Castell's notion of "timeless time" or the more general concept of immediacy. In either case, what is being identified is the manner in which information technology attempts to compress time to the extent that there is nothing but the present. For Paul Virilio, such compression signals nothing less than a fundamental and global transformation in which everyone and everything is subjugated to the "tyranny of real time" (Virilio, 1997, 18).

> To gain real time over delayed time is thus to commit to a quick way of physically eliminating the object and the subject and exclusively promoting the journey. But a journey without a trajectory and hence fundamentally uncontrollable.
>
> The real-time interface then once and for all replaces the interval that once constituted and organized the history and geography of human societies, winding up in a true culture of the paradox in which everything arrives not

only without needing physically to move from one place to another, but more particularly, without having to leave. (19)

Again, what matters is the moment of access, which effectively jumbles the past, present, and future into a "de-linearized" hypertext of available moments and experiences. Any moment—or better yet, any moment belonging to a particular individual who exists in time—can be accessed or connected to. Time, of course, still matters in the conventional sense, given that the network, digital or otherwise, has yet to do away with the looming certainties of old age and death. In addition, the communication network is in a constant race against a kind of self-created obsolescence. The inability or refusal to update one's equipment or software will very quickly cast one into an outdated and eventually inaccessible abyss of incompatibility.

Ubiquitous pluralism highlights the hypertextual nature of the network. As a place, the network is by definition in a constant state of change and mutation. The network cannot be static, nor can it be contained or comprehensively mapped unless copied in its entirety on a continuous basis. It is thus "hyper" in all ways possible, thereby engendering a temporal-spatial environment in which there is only plurality—plurality of time, plurality of experience, plurality of space, plurality of contact, and so on. As Michael Joyce has remarked about hypertext, "every reading [of hypertext] becomes a new text" (Joyce, 1995, 193). More recently, and more directed toward the network, Joyce writes that "network culture is an othermindedness, a murky sense of a newly evolving consciousness and cognition alike, lingering like a fog on the lowlands after the sweep of light has cleared the higher prospects" (Joyce, 2000, 1). Joyce's evocative comment captures not only the sense that there is indeed something different about "network culture," but also that it is in a constant state of evolution, of "othering," that keeps it within a dynamic state of growth and change. The efforts to map the Internet offer an interesting example. Often striking aesthetic objects in and of themselves, Internet maps, such as those collected at cybergeography.org, attempt to render in visual form the topography

of the Internet itself—a Sisyphean task if ever there was one.[3] Like Borges's well-known and oft-cited story, the only way in which to properly map the Internet is to make the map identical to the Internet itself—to perfectly reproduce the ubiquitous sprawl of its relentless diversity, growth, and dynamism.

The final feature is really a hybrid form that encompasses those mentioned above. The virtualization of direct interaction is meant to indicate the manner in which communication networks such as the web allow one to effect direct and often immediate contact or interaction outside of the parameters imposed the life of an individual situated within a physical or geographic place. The Internet and the web are, of course, not the only instance of such forms of interaction, nor is all electronically mediated interaction the same in terms of interactivity (Ryan, 2001). Nevertheless, the information network, with the web being my primary exemplar here, is distinctive in terms of how it has created places for human interaction that are indeed virtual, if by virtual we mean "a second order reality in which to play with or practice upon the first order" (Poster, 2001, 129). Among the consequences and manifestations of this second-order reality with respect to human interaction and experience are newly identified forms of engagement and subjectivity—virtual communities, multiple selves, global connectivity, and cybersex, to name but a few.

As a place of self-documentation, the network is both a confirmation and a departure from existing conventions and practices. In the former case, the network, specifically the World Wide Web, can be seen as an extension of earlier media forms such as the diary and the camera. The web functions as a type of communication channel or even a generic medium in which to transmit and store personal thoughts and images. The individual's home page, as such, becomes an extension or alternative to the family album, with a few added bells and whistles, simultaneous and nongeographically dependent access being the prime feature. Distant relatives and friends can view the arrival of a new baby, the awkward formality of prom night, or the hectic calm of a family beach vacation from anywhere and at any time. The use of the web as a place to store

one's diary is similarly unremarkable in that from a purely functional perspective they appear to be no different from the diaries of one's childhood, with their flimsy locks and imitation leather covers. The only difference is that instead of being stuffed in a drawer, they exist on the web.

However, this difference matters. Despite many functional similarities, the web provides a place for self-documentation that is unlike anything else that has preceded it. At the forefront, as will be discussed in the following chapter, is the manner in which the web paradoxically blurs and maintains the conventional distinctions between the public and the private. Thus one can be both private and public within the place of the network in a manner that preserves *and* disrupts the integrity and relevance of both categories. The phenomenon of web-cams represents uncharted territory to a greater degree, in the sense that web-cams introduce a radical form of simultaneity and immediacy into the self-documentation mix. Temporal and spatial contexts are subjected to a type of virtual velocity that renders the web-cam as a place of both collapse and extension—the collapse of former distinctions such as those of privacy, the home, the individual, the public, the private, the me, the you, the past, the present, *and the extension of the very same*. Thus, once again, the binary modes of the either/or are replaced by the hypertextual litany of the and/and. Such is the place of the network. It is a place that renders the experience of "being there" into a paradoxical mix of fleeting ephemera and concrete experiences of life and meaning.

PART TWO
Private Place

CHAPTER 5
Posture Two

At first glance the distinction between private and public seems straightforward enough—private is private and public is public. Everyone knows what the terms mean, so what more is there to say?

Yet nothing is ever quite what it appears to be, and in the case of the private/public distinction there is indeed much that is left to say. To begin with, the very definition of what constitutes the limits of privacy is open to considerable fluctuation as one moves from one social context to another. An example from my own experience comes to mind here. Several years ago I began a new job as a university lecturer in Sweden. In addition to an office and a cornucopia of office supplies I was assigned my very own pigeonhole in which I could receive my mail. As the mail began to arrive, I noticed something that sent waves of paranoia up my spine. Someone was opening my mail. In fact, there was not even any attempt to hide the fact. Every envelope with the exception of junk mail bore the scars of a rather dull letter opener. Concerned and feeling somewhat violated, I began to question my colleagues, who seemed rather surprised at my level of concern. Of course my mail was being opened, as was everyone else's. As an employee of a public university I was technically working for the state and under the rules of Sweden's "public access" all my correspondence, including e-mail, was officially a part of public record. For this reason, all incoming mail was logged and identified by its sender and the general category of its content. Accordingly, every citizen has the right to read the mail of any public servant up to and including that of the prime minister, as long as state secrets were not being compromised.[1]

Given my upbringing in Canada, where, like in the United States, mail is considered to be among the most sacrosanct of private spaces,

Sweden's public access policy took a little getting used to. Indeed, in telling fellow North Americans about the practice, reactions of shock and indignation were often the result: How could I stand for such invasion of privacy? Is there no such thing as privacy? In response I often confused matters even more by telling people that surveillance cameras were illegal in Sweden with the exception of very limited locations such as banks and airports. The reason? The use of surveillance cameras constitutes a violation of privacy and thus should be avoided as much as possible.

What is made clear through my experience is that privacy is not a concept that travels well and that its meaning and realization are often fluid and subject to change as one moves from one country to another. Thus what constitutes acceptable public behavior in one culture is potentially a grievous moral or legal lapse in another. Yet one does not need to travel in order to run into problems with working out the distinction between public and private. Most scholars working with the concepts in such fields as law, sociology, history, or anthropology note that the task of establishing lasting definitions is a slippery one. Jeffrey Weintraub, for example, notes that "despite widespread use of public and private as organizing categories," the terms are "usually not informed by a careful consideration of meaning and implications" (Weintraub, 2). One need look no further than the dictionary to get a sense of the multiple layers that lie behind the words *public* and *private*, as Patricia Boling has done in her study of the politics of private life (43–48). Derived from the Latin *privatus* (to bereave, deprive, dispossess, rob), the term *private* signifies a withdrawal from public life, and to be deprived of public office. Dictionary entries for the word *private*, when used as an adjective, indicate at least five major different meanings, including: a person who does not hold public office or have rank, distinction, or official position; a person who is retiring, secluded, secretive, or reticent; that which belongs to or is the property of a particular individual; by one's self, alone, without the presence of anyone else; and a place that is unfrequented, secluded. Via her "ordinary language analysis," which I will not detail here, Boling reveals that the meaning of the word *private* cannot be limited to one that is

locked within a binary opposition. In other words, public and private are not always in contrast to one another.

> It does not pay to assume that a word must have an opposite, or one opposite. For example, we commonly find that practices or institutions, such as the closing of large plants or gender relations within the family, are private in some respects, public in others. We need to be alert to differing meanings and senses of private and public, and conscious of the temptation to cut the world into two dichotomized spaces. (Boling, 49)

This is not to say, of course, that the task of defining the public and the private is impossible or meaningless. Definitions are not only possible, but also necessary for ensuring a level of congruence between formal definitions of public and private life and the manner in which such definitions are practiced and lived. That said, a number of attempts to define the terms can be considered.

At its most basic, privacy can been seen from the perspective of personal control and as such can be defined as "the measure of control an individual has over 1) information about himself, 2) intimacies of personal identity or 3) who has sensory access to him" (Schoeman, 2). Similarly, Alan Westin identifies four basic functions of individual privacy: "personal autonomy, emotional release, self-evaluation, and limited and protected communication" (quoted in Jagodzinski, 4). In this sense privacy is essentially an issue of access whereby to be private entails the ability to control or regulate the level of access that the "outside world" has to one's personal property, body, or thoughts. It is perhaps such a concept of the private that constitutes the most general understanding of the term, especially in legal matters or issues around access to personal information on the world's numerous databases (Poster, 1990). Thus to be private is to have control over one's information and property.

On a more macro level, Weintraub proposes that the distinctions between public and private for the purposes of social and political analysis are generally drawn from four broad schemes. The first of these is the "liberal-economistic model," which defines the distinction between public and private mainly on the basis of the "distinction between state administration and the market economy" (7). This is

the kind of public/private distinction that we hear about most often in everyday political discourse in which the market, as a champion of all things private, is frequently hailed or demonized as a means of ushering in a new social and economic order. Debates regarding the privatization of public organizations, such as health care, are one example. Next in Weintraub's scheme is the "republican-virtue approach," in which the public realm is seen in terms of political community and citizenship, which is "analytically distinct from both the market and the administrative state." Such an approach can be employed to probe the early enthusiasm regarding the prospects of the Internet as a means of creating utopian communities of vibrant political spirit, democracy, and activism as championed, for instance, by Jon Katz: "Where conventional politics is suffused with ideology, the digital world is obsessed with facts. Where our current political system is irrational, awash in hypocritical god-and-values talk, the Digital nation points the way toward a more rational, less dogmatic approach to politics. The world's information is being liberated, and so, as a consequence, are we" (50). Somewhat less hyperbolic would be the example of public radio, which is also frequently cited as a means of organizing broadcasting based on community values and participation rather than market forces (Aufderheide; Barlow; Carey). The third category depicts the public realm "as a sphere of fluid and polymorphous sociability" where many of the normative boundaries and constructions that dictate "material" life such as those of social status, kinship, or religious affiliation are potentially open to reconfiguration or outright invention.[2] Lastly, the distinction between public and private can be conceived of in terms of the difference between the family or domestic life and the larger political, social, and economic order. This distinction has been instrumental to much feminist criticism and scholarship that has shown that the demarcation of the private as the domestic has been used primarily as a means of limiting and confining the lives and potential of women in society. Under such a scheme, the public world is the world of serious pursuit and one accessible primarily to men. This is the world of politics, of business, of war and technology and industry. The private world, in contrast, is in the background, consisting mainly of family

intimacies and the comforts of a good home and is, as such, the domain of women (Massey). There is more than just an implied value judgment going on under such a model. To be at home, in private, is somehow less important than being out in the world, being a man of the people, of the public.

The various practices of self-documentation take on a particular resonance within the ambiguous gray area that constitutes the public/private distinction. From one perspective, an activity such as diary writing would appear to characterize the essence of privacy itself, with its conditions of isolation, personal control, intimacy, and the assumed lack of public readership. Yet from another view, self-documentation appears to be ultimately exhibitionist, where even the lone diary writer is scribbling for the sake of posterity and a readership beyond the grave. More contemporary practices such as digital video, web-cams, and online diaries go even further in terms of catapulting the individual self-documenter into the public spotlight.

In an effort to bring some structure into my investigation, I propose three meta-categories in which to slot both past and present forms of self-documentation in terms of how they navigate between the private and the public. These are pure privacy, public privacy, and connected privacy, which, like the other "trios" employed throughout the course of this book, broadly correspond to the historical periods that move us from the emerging modern world through to mature modernity and end up in our current state of postmodern, global, network culture. In keeping with my concern for the materiality of the practices of self-documentation, the categories of pure, public, and connected privacy are intended to draw attention to the experiential conditions of privacy within particular environments or places of self-documentation. It should be noted, however, that the categories of pure, public, and connected privacy are not mutually exclusive, nor are they tied to any one historical moment. Instead, they should be seen as conceptual markers that allow one to temporarily isolate specific moments or experiences of the public and the private within the practices of self-documentation.

CHAPTER 6
Pure Privacy

Pure privacy represents what is likely the most normative definition and condition of privacy, at least in terms of popular use. This is the privacy of isolation and the personal control described earlier, in which privacy is achieved by virtue of an individual being able to control the access that others have to his or her personal space, whether physical or psychological. It also corresponds to the concept of private property, which in essence is also a matter of controlled access and the establishment of rigid and clearly defined boundaries that are further grounded within stated rights and responsibilities. Pure privacy can be further characterized as one of the major constituents of the material and experiential conditions of modern capitalism. Under such conditions, the older premodern public realm of polymorphous sociability has been divided into increasingly separate spheres, with privacy representing intimacy and emotionality and the public representing instrumental, functional, and impersonal space and activity (Weintraub, 20). As has been well discussed by Aries, Elias, and Foucault, for example, the family and the home have emerged as the central realm of private space and are often represented as a refuge from the alienating experiences and consequences of industrial capitalism (Aries). Among the major factors is the conventional separation between work and home—a separation born from the division of labor itself, within which labor and life became independent entities. "Just as capitalist development gave rise to the idea of the family as a separate realm from the economy," argues Eli Zaretsky, "so it created a separate sphere of personal life, seemingly divorced from the mode of production" (14). This separate sphere includes not only the family and the physical space of the home itself, but also a highly individualized form of

subjectivity. As such, meaning is to be found within individual experience and consciousness, encouraging a form of introspection by which "people sought in themselves the only coherence, consistency and unity capable of reconciling the fragmentation of social life" (49). Ferdinand Schoeman argues that "the emergence of privacy norms are correlated with the emergence of the individual as the basic social unit replacing the kin group" (121). Private space, which in industrial cultures is most often the place of the home and family, becomes the place in which individuality can be ideally expressed, enacted, and explored (Anderson, 58).

To engage with the self, to examine and develop it intensely, is thus best pursued within the exclusivity of a purely private place, whether the home or the blank pages of a well-hidden diary or, by extension, the mind. Or at least such is the convention by which self-documentation has been predominantly practiced within modern Western cultures. The practice of reading itself, especially as enhanced via the spread of printed matter, is frequently associated with the rise of not only individuality but also conventional notions of privacy. Indeed the "individual" is predicated on the availability of the "ownership of self" and a defined and controllable level of solitude. "Essential to the nurturing of privacy is the idea of solitude," writes Cecile M. Jagodzinski in his *Privacy and Print*, which develops the argument that the experience of reading is directly related to "the emergence of privacy as a personal right, as the very core of individuality" (1). Of course the book is but one contributing factor among a host of cultural, economic, and technological contexts, as Jagodzinski acknowledges at the very beginning of his study. But it is an important and notable factor all the same.

> It was not simply that more people could read (recall the familiar notion that the Protestant reform encouraged literacy as a duty). Rather, the establishment of an English publishing industry, the growth of a merchant class with leisure time, increased opportunities for education for most classes, and the social, religious, and political upheavals of the late sixteenth and seventeenth centuries contributed to a new way of thinking about the individual person. (2)

The practice of diary writing can also be associated with this "new way of thinking" and furthermore literalizes the notion of the page as a privileged environment for both personal reflection and expression. As a practice, diary writing can be characterized by fairly defined material demarcations, again both literally and metaphorically. For one to engage in the activity of diary writing, a number of conditions are *ideally* necessary. One must achieve a certain measure of isolation. One must mark out a particular territory within which the inscriptions can occur. This territory must have a certain measure of stability and limited access, ideally only to the diary writer him- or herself. Most important, the place of the private diary must be understood as a situation in which one's personal thoughts, no matter how trivial or intimate, can be recorded without the perceptible intervention by outsiders. In other words, to maintain the coherence of the introspective individual genuinely exploring him- or herself, the place of introspection (in this case the diary) must be perceived as a purely private place, as a place where no other can intervene, at least at the moment of inscription. This last distinction is important. Introspection, at least in its conventional understanding, is an activity that demands a high degree of exclusion—it is by definition a solitary act, an act of pure privacy (Martin-Fusier). To engage in it, one must be alone, one must be in control over every word, image, or gesture. Or at least this is what must be believed.

The combined discourses of the family, the home, and private property figure prominently in twentieth-century practices of self-documentation. As discussed earlier, the conventional written diary, complete with its brass lock and imitation leather cover, makes for an archetypal example of the purely private. Perhaps less obvious are the seemingly more public rituals of family snapshots and home movies, which, while characteristic of what I call public privacy, discussed later, also retain elements of the purely private. In the case of home movies, what is most evident is the manner in which they represent what Patricia Zimmermann calls "familialism"—"the transference of the idea of the integrated family unit as a logical structure onto other activities" (122). In other words, the family functions as a type of cultural and ideological template for a range of

social activities and organizations, with the technology of home movies (and later videos) serving as just one method with which to secure such a template within the popular imagination. A major effect of such an affirmation is the emphasis on the family as one of the primary avenues for personal development and meaning: "Popular ideology resurrected the family as an invention signifying the quest for fulfillment of subjective needs and the satisfaction of desires for meaningful social interactions. The popularized notion of togetherness epitomized this ideology of the family as an emotional lifeboat in an automated, efficient, and distant society" (133).

The family lifeboat is thus separated from the public world at large and positioned as a stable refuge in which to retreat from the stresses of contemporary life. Images of such an idealized family, as in the case of home movies, are generally those of a harmonious social unit caught in a continuous loop of birthday celebrations, vacations, humorous moments, and memorable events. Discord is rarely, if ever, recorded, thereby rendering the private world of the home in an almost utopian light. The purely private, in this respect, becomes thus purely perfect as well, depicting intimacy and the private seclusion of the home as the most effective and morally preferred means of achieving emotional satisfaction and pleasure.

Home movies thereby become statements rather than depictions or reflections of family life: they represent ideals rather than actualities. Perhaps it is for this reason that we tend to look upon home movies, whether they are of our own families or those of strangers, with a certain sense of nostalgia and loss. For what is being represented is something never quite attainable, something that can only be imagined and hoped for rather than actualized in reality. Perhaps it is for this reason that home movies are often used in television and movie productions as a means of evoking exactly such feelings—nostalgic longings for simpler times, small capsules of authentic family bonding, of a privacy that is pure and uncorrupted by the outside world of public vice and ambition.[1]

Within the context of the current discussion, the key to understanding the function of home movies in relation to conceptions of privacy is to approach them as testaments of intimacy, as literal

representations of what private family life should look like. Michele Citron uses the phrase "necessary fictions" to express the manner in which home movies are primarily psychological documents that are "simultaneously acts of self revelation, self-deception, and self-conception" (19). They become "necessary," in the sense of fulfilling our need for personal spaces that we can control and maintain. Citron's description of her own films is informative: "But these films also served a more subtle function of self-definition....My films gave me a presence in the world. Through them I became authorized, that is, they gave me the authority to become the author of my life, the protagonist in my own narrative" (46).

What I see as being emphasized here is the importance of control, in this case the control of a very private and subjective view of the world that employs the trope of family intimacy and unity as a primary structural device. As noted by Fred Camper in a special issue on home movies in the *Journal of Film and Video*, home travel movies are not actually about the places visited but rather about how the "participants see themselves, each other and the external world" (12). The world becomes only a background to a self-image (or image of the family) that remains curiously the same, no matter the context. Again, the sanctity of the purely private—the intimacies of the home and family—remain intact and unaffected by anything external to it. Or at least such is the illusion, the necessary fiction that sustains our belief that our home is really our castle in which we can be safe and ourselves.

Equally pertinent to the place of the purely private is what one might call the degree of "media autonomy," or the degree to which a given medium can function independently of direct user input or control. With respect to camera technology, a simple hierarchy of such autonomy can be constructed with the still camera "least autonomous" and the web-cam "most autonomous." The still camera demands that the user interact with it at all times, at least if photographs are to be taken. Indeed, each individual moment of "capture," which is today only a fraction of a second, must be initiated by the photographer. Conversely, the web-cam can just run itself continuously and independently, which means that the images

or moments that it captures are done so via its own accord, so to speak. Between these two dichotomies are the home film camera and the video camera. In the first instance, the 8mm or Super-8 home movie camera is somewhat more autonomous than the still camera, in the sense that the span of its documentation runs in the minutes instead of less than a second. While still controlled by the user to a high degree, the increase in the length of documentation allows for a greater level of "chance" with respect to content. Thus, once the camera is running the chance of recording unplanned or unposed content is more probable and slightly less within the direct control of the individual photographer. The video camera takes this autonomy a bit further by virtue of the fact that videotape is both much cheaper and longer in duration than film stock. The video maker can just let the camera run for comparatively long lengths of time, meaning that it is capable of intruding much further into the places of everyday life, thereby increasing the chances of accidental or "candid" documentation. Also significant is a decrease in the level of selectivity on the part of the filmmaker given the low costs of accumulating raw footage. One can literally film everything in the hope that something important or meaningful will happen while the camera is running.

Web-cams and digital video technology take this even further. After the initial setup, the camera does not "require" the active presence of the user, with one result being that private life can be fully captured on a twenty-four-hour basis. In terms of pure privacy there are two ways to look at this development. On the one hand, the constructed privacy, the necessary fiction of the intimate, unified, and secure home, is threatened by virtue of the fact that the autonomous, all-seeing web-cam "corrupts" the integrity of the purely private by resituating it within the public domain of the web. Yet on the other hand, the web-cam paradoxically accentuates or highlights the purely private by turning it into a fetishistic experience. The notion of the fetish takes on a peculiar resonance here, and, as Slavoj Zizek has noted, there are several ways in which the fetish can be approached. One of these is via the more conventional understanding of the fetish, as articulated by Marx in his conception of the commodity fetish. "A commodity is, in the first place, an object outside of us, a thing that by

its properties satisfies human wants of some sort or another." As Zizek observes, such a definition of the fetish "relies on a clear common-sense distinction between what the object is 'in itself,' in its external material reality, and the externally imposed fetishistic aura, the 'spiritual' dimension, which adheres to it" (96). Thus, to follow Marx's lead, my Le Corbusier chair, which I referred to earlier, satisfies the rather basic human need of having a comfortable place to sit or, in this case, to recline. Yet the chair is much more than that, as my homage to it has demonstrated. It is a fetish item in the sense of being very much a bearer of value—the value of good taste, of "superior" design, of bourgeois sensibilities regarding the well-honed object with which to demonstrate advanced literacy in high-end consumerism.

Yet Zizek also asks his reader to consider the fetish from the perspectives of German idealism and "radical versions of Hegelian Marxism" such as that developed by Georg Lukacs.

> From this perspective, the very notion of the object's external material being, directly identical to itself ("the way things really are"), is the ultimate fetish beneath which the critical-transcendental analysis should recognize its subjective mediation/production. The fetish is thus at one and the same time the false appearance of In-itself, and the imposition on this In-itself of some spiritual dimension foreign to it. (Zizek, 97)

Such thoughts offer some assistance in understanding the peculiar and seemingly contradictory appeal of the web-cam in terms of its ability to provide entry into the "spiritual" dimension of pure privacy while at the same time preserving its essential integrity. For one, Zizek's comments regarding the "idealist" conception of the commodity fetish make one aware that perhaps the "real appeal" of the web-cam's representation of the purely private is this dual "false appearance of In-itself," the perceived construction of a pure privacy whose very impossibility in terms of being actual or real is exactly that which makes it so appealing. Thus as a fetish, the pure privacy of the web-cam achieves its "aura" by creating an experience for the user that is literally magical in the sense of projecting an "aura" of a materially unattainable purity of form and experience.

Consider, for example, the livingroomcam—a rather established representative in the circle of so-called family cams.[2] As its name implies, the livingroomcam offers its viewers the opportunity to peek into an ordinary suburban living room, and thereby provides a form of access to one of the central locations for family intimacy and privacy. The site has been running at least since 1995, which makes it somewhat of a pioneer within the history of the web-cam.[3] In addition to the camera in the living room, the site also offers a "kitchencam," a "studycam," and video footage of family Christmases, celebrated, naturally, in the living room, for the past eight years. A recent addition is a simple interface that allows site visitors to control one light in each of the rooms equipped with a web-cam. Discursively, the site is a celebration of family values and a down-to-earth lifestyle and as such documents the everyday activities of a middle-class family in the United States, including video footage of Christmas Eve and numerous vacation snapshots and anecdotes. The pretense of the site is essentially that there is none. What you see is what there is—a deliberate construction of the normal: "A camera in our living room, a capture board, an Internet connection, a little software and what do you get? A family's home on the Web! Welcome to our living room. People seem to show up in the evening. Send us email and enjoy relaxing at our house."[4]

Visitors to the site may find that the living room is generally empty, given that during the day everyone is at work or at school. During the evenings, fleeting images of activity can be seen, but given the lack of any kind of narrative or commentary there is no structure to the experience. What is being witnessed is only the purity of private life at its most regular and mundane, which means that if one wants to see something, one must be willing to watch as long as possible. In this sense the livingroomcam captures the essence of the web-cam as an autonomous recording medium that requires little in the way of intervention and direction and is thus able to become a permanent and transparent fixture of the private home. The livingroomcam also underscores the fetishism discussed above in a manner that is as intense as (if not more intense than) more "obviously" fetishistic web-cams, such as the plethora of sites that

feature young women in carefully articulated moments of apparently random disclosure. What is accomplished via the livingroomcam is a type of ontological paradox that, to follow Zizek once again, subverts "the standard opposition of 'subjective' and 'objective.'"

> Of course, fantasy is by definition not "objective" (in the naïve sense of "existing independently of the subject's perceptions"); however, it is not "subjective" either (in the sense of being reducible to the subject's consciously experienced intuitions). Fantasy, rather, belongs to the bizarre category of the objectively subjective—the way things actually, objectively seem to you even if they don't seem that way to you. (119)

The experience of pure privacy, as rendered by the spectacle of the livingroomcam, falls into such a "bizarre category" by virtue of being able to straddle the two "essences" of the private and the public without unsettling the experiential "purity" of the family living room. In this way, we the viewers can simultaneously experience the intimacy of someone's living room, kitchen, or bedroom while recognizing and taking pleasure in the knowledge that we are experiencing nothing of the kind. Therein lie the fantasy and the fetish.

Yet the contradictions continue, which is part of the point here, as well as in the pages to follow. "Family-oriented cams" such as the livingroomcam embody much of what is implied by my distinction of the purely private, at least if considered as an overt and deliberate representation and construction of the intimate spaces of private family life. By virtue of the autonomous web-cam, which sees and captures all, the purely private is curiously encoded or preserved in a type of digitized still life that continues yet extends the lineage of private self-documentation first initiated by the private diary. A bizarre experience if ever there was one.

CHAPTER 7
Public Privacy

Broadly speaking, the second category of public privacy can be associated with the maturation of modern capitalism and the development of an integrated and powerful media infrastructure. More specifically, it is photography that can be identified as a crucial agent, especially but not only in terms of self-documentation. What is seen as significant about photography in relation to capitalism is that the technology in itself corresponds with the internal logic and material predispositions of industrial culture. In other words, the medium of photography resonates with a society that embraces and practices mass production, consumerism, and the rule of the marketplace as the primary means of constructing its social and economic space. Scott McGuire argues that the "photograph corresponds to the maturing logic of commodity production in a world remade by machines." In terms of historical force, the photograph is comparable to that of the printed book, which can be seen as "one of the first serial objects of a nascent capitalism" (49). Photography thus corresponds with and further accentuates a cultural system that practices the mass production and rapid circulation of objects, signs, and discourses. Such a claim is supported in part by merely reflecting on how rapidly photography was accepted as a medium and incorporated into the rhythms of everyday life and commerce. Equally telling is the relationship between technology and the aesthetics of modernism. According to Sara Danius, the aesthetics of modernism, particularly as represented by the literary works of Mann, Proust, and Joyce, were profoundly shaped by "technologies of perception," such as photography, cinema, the telephone, and the radio, among others. "Specific technoscientific configurations and their conceptual environments

enter into and become part of the aesthetic strategies, problems, and matters they help constitute" (11). In this sense modern technology and the engines of mass production are not seen as opposing the artistic output of modernity, as, say, argued by the normative texts of the Frankfurt School, but rather as serving as important components of basic structure and orientation. Given such an assumption, it follows that photography can be portrayed as a force that ushered in a new repertoire of perception that allowed individuals to literally see the photographically. The same can be said of other technologies such as the phonograph or typewriter, which each in its own way altered the perceptual and material relationship between the individual and the larger social and physical world (Kittler). In the case of self-documentation, what is of course significant is that the camera allowed people to transpose their individual take on the world, their "camera eye," to use a phrase employed by John Dos Passos, onto the actual practice of self-representation. The effect is transformative in the sense of opening up the visual as a means for articulating subjective experience and thought. This is to go even further than Marshall McLuhan in the sense that the camera did more than just extend the eye. It also augmented and reconfigured the whole of the perceptual and subjective realm in a way that was *consistent with*, rather than a departure from, what is meant to be modern and living within the realms of industrial capitalism. "With photography, the artist's attempt to replicate nature was made scientific. It extended the human sense of sight in a way commensurate with Marx's idea in the 1844 'Economic and Philosophic Manuscripts' that the human senses in their true, anthropological (i.e. social) nature are 'nature as it comes to be through industry'" (Buck-Morrs, 1989, 132).

The camera, as one of the machines of capitalism and modernity in general, lies behind much of the impetus of what I am calling public privacy. As the term implies, public privacy indicates a blurring of the divide that separates the public from the private and also relates to the emergence and industrialization of fame or celebrity (Braudy). On the one hand, the private sphere is still suspended in the "purity" discussed above in terms of thriving under the discourses of private property and the nuclear family, which are

so essential to the cultural logic of capitalism. Yet on the other, the private realm is increasingly adapted to suit the demands of a public media machine, which thrives on the constant production and circulation of images, narratives, and momentary icons of meaning and relevance. Not only does the public enter the private home in the form of newspapers, magazines, radio, television, and so forth, but the private also becomes part of the content itself. The private lives of individuals become objects of consumption, spawning a whole subindustry of lifestyle and celebrity magazines, talk shows, call-in radio programs, and web-cams, to name only a few examples. A symbiotic relationship is thus formed between the public and the private so that everything becomes a potential media object—everything is of potential interest to the camera and the microphone and, more important, to an audience constantly in pursuit of a new spectacle (Debord).

Since the late nineteenth century, with the advent of various technological developments, public privacy has become a normative and regular commodity, accessible to an increasingly wide section of the population. While the concept of public privacy is not limited to the camera, the camera nevertheless functioned as an important catalyst in the mass production and distribution of content for purposes of consumption. In terms of the current discussion it thus serves both a literal and a metaphorical purpose. As well, the camera became a public medium very quickly and on a scale that surpasses many other mediums, at least in terms of everyday, normative use. The camera has become an accessory to modern life that is part of a vast array of social and professional contexts. All activities, whether conventionally private or conventionally public, are potentially included within the photographic apparatus and thus become subject to the "camera eye."

> Remember that the movies you'll want to have tomorrow must be shot today. So, in addition to using your camera on the special occasions that suggest movie making almost automatically...keep it busy on some of the more commonplace but, in retrospect, equally memorable ones. Take it with you on visits to the zoo, to fairs, and to amusement parks; photograph the kids learning to ride their bikes and to roller skate; shoot movies of your

boating, swimming, fishing, and golfing activities; use it whenever you go visiting or even fly a kite. As long as something's going on, there's a good potential movie. (Kodak, 1958, 27)

It is important to recognize that the private-public divide does not disappear within my conception of public privacy. Indeed the distinction is still very much at work. In other words, in order for public privacy to function within the broad contexts of a modern consumer society there must be a certain conception of privacy that can be countered with and thus employed as a resource for public scrutiny and consumption. At the same time, however, the "purity" of the purely private must be corrupted in the sense of no longer being sacrosanct; there is no moral or idealized impulse to keep it segregated and intact. Within the logic of the market, everything is for sale and everything can and will be made public if it can potentially lead to an increase in the circulation of commodities, whether physical or intellectual. Such an idea resonates with Guy Debord's well-known *Society of the Spectacle*, but with the added idea that the "market" serves also as a kind of internalized and abstracted logic that does not have to lead to the realization or creation of actual capital or profit. Sometimes pure distribution and production without any articulated thoughts as to return are reason enough, given that the "system" continues to be reaffirmed. In this respect the posture of consumption is maintained: we are always ready to shop at a moment's notice.

The modes of self-documentation that use the camera indicate a number of identifiable patterns with respect to the public/privacy distinction. Consider, for example, the nature of nineteenth-century portrait photography, which was widely practiced across the whole social spectrum. The conventional representation of portrait photography is in terms of its basic democracy—finally everyone could afford to capture and preserve an image of themselves at a cost significantly less than that of hiring even a second-rate portrait painter. This is true to a significant degree, especially if limited to purely material considerations. Photography is cheaper, faster, and less reliant on training and skill than painting, engraving, or other such prephotographic forms of image reproduction. Yet, as Suren

Lalavani has pointed out, conventional portrait photography of the nineteenth century was predicated on conforming to representational structures that affirmed certain dominant discourses regarding the body, class, modes of consumption, status, and ideology. In reference to Michel Foucault, Lalavani argues that nineteenth-century portrait photography had a certain disciplinary function in terms of making the photographed body conform to the normative postures of bourgeois ideals regarding the nation-state, the family, and the individual (Lalavani, 47). He states further that "what needs to be understood is that portraiture is always about public display, even if the photography is limited to private consumption. There is an attending to the discursive, the cultural, and the social that is implicit in the portrait" (59). Exemplary here are the actual procedures and rituals of studio portraiture at the time, which as described by Lalavani is an almost theatrical procedure. The standard upper-class portrait studio in England, for example, usually contained three major elements—a reception room, the studio, and a small factory that produced the plates and prints. The reception room was frequently decorated with iconic portraits that served as models for subsequent subjects. The actual studio resembled a stage set, with elaborate props and backdrops that would transport the subjects into worlds idealized by the bourgeois sensibility. With respect to the consumption of these images within middle-class households, an element of theatricality remained, insomuch that family albums were often carefully arranged and scripted by, as was often the case, female members of the household (Jobey).

Home movies share many of the characteristics of family and vacation photography, particularly in terms of subject matter and the discourses around which they are constructed. With respect to the public/privacy distinction, what is noteworthy is of course the moment of projection or the point at which home movies are played for an assembled audience. Most guides and instruction manuals for home movie equipment emphasize the importance of "the good show," which keeps the audience entertained and presumably wanting more. A Kodak guide for the production of sound home

movies emphasizes the importance of keeping the entertainment value of home movies in mind:

> Being a captive audience for the home movies made by a friend or relative has often been compared to "a fate worse than death"—sometimes with good reason. However, good home movies, the kind you'll be showing from now on, enhanced by available light scenes and sound are entertaining. An entire new world of home entertainment is possible. Movies of picnics, vacations, special events, and even day-to-day activities will have added interest and meaning. (Kodak, 1973, 94)

Such an emphasis on keeping the audience content with well-planned home movies parallels that of commercial media production, which is also driven by the need to capture the devoted attention of its audience. An advertisement for the Fairchild Cinephonic home movie camera entices its customer by direct comparisons to Hollywood: "Now all the resources of Hollywood can't equal what you can do with your own Cinephonic, as you film *your* family, your fun, your travels" (*Photography*, 86–87). Equally important is the ability to recognize and accommodate the needs and interests of different audiences, as noted by this extract from a guidebook on vacation photography:

> But, the corny shots, the record shots, Junior with his face covered with cotton candy, these can be saved for the Family Night slide show. Now, you can invite the grandmas, grandpas, indulgent aunts and uncles, nieces and nephews, as well as the voyagers themselves. An audience of this type can sit through hundreds of slides because those who lived through the experience really enjoy the memories evoked, and the others take pleasure in seeing their *family* in unfamiliar surroundings. (Aarons, 92)

Central to the success of any form of public display is the ability to properly organize content for purposes of defined and compartmentalized consumption. Almost from the beginnings of photography itself, the importance of employing organizational schemes that allow for the efficient showcasing of photographic material, whether family albums or home movies, was routinely practiced and encouraged (Jobey, 1996). Again, what can be discerned

from the many guidebooks and articles published over the years is a sustained emphasis on the value of creating and maintaining order, especially an order created for the purposes of individual pleasure, control, and consumption. Such an emphasis is very much in keeping with what it means to be "modern," with respect to the practical and moral legacies and consequences of rationalism, possessive individualism, and capitalism. Bruno Latour's designation of the truly modern as a commitment to "works of purification" captures some elements of the distinction being made here. Purification is described as the creation of "two entirely distinct ontological zones: that of human beings on the one hand; that of nonhumans on the other" (10). The significant result of such a distinction, at least for Latour, is the creation of "a partition between a natural world that has always been there, a society with predictable and stable interests and stakes, and a discourse that is independent of both reference and society" (11). Such a separation enforces what I would call ideal states of momentary certainty, meaning the deliberate construction of either discursive or material environments that allow for the momentary suspension of the forces of randomness and chance. Technology, again as either a discourse or an actual practice, makes for an ideal companion. Technology, writes Lorenzo Simpson, "represents our quest for security against novelty, through control and order, while presupposing the possibility of novelty....In securing ourselves we want assurances against surprises against an open and uncertain future" (54). Among the tactics employed to achieve such assurances are formalized devices of imposing order on the artifacts that represent our individual life experiences. Meaning, as Burt Murphy's *Guide to Baby and Child Photography* informs us, is achieved ideally via the twin engines of display and organization. "Please, don't be a 'squirrel' photographer! You have applied too much time, effort and expense toward accumulating photos and slides which are *meaningless*. Yes, meaningless is what they are—until you can display a print album or slide library. What you need is a personal showcase of photography" (118). The comment regarding the creation of a "personal showcase" is also indicative of the importance of cultivating a public privacy—a version of the private that is suitable

for public consumption via sanctioned and recognizable schemes of organization and control.

The notion of the "personal showcase" is literalized by the phenomenon of online self-documentation, particularly web-cams, which render the showcase into an actual "show" that is transmitted via the very public medium of the World Wide Web. Online diaries and the personal web-cams are in this sense the very embodiment of public privacy, especially in terms of how the users themselves articulate their own relationship to the broader public. "Being able to broadcast your private life to the other side of the world is quite powerful," writes "Carla," a web diarist. "I believe it is quite empowering to the individual. Until now, the average person has had very little control over what is fed to them over mass mediums."[1] The feeling of empowerment that Carla expresses is notable in terms of its emphasis on the need to directly control and sculpt a particular public image of one's self. Thus, the "average person" is now raised to the level of a cultural producer, at least potentially, and is thereby granted the ability to engage actively with the medium. Web users such as Carla are able to sculpt the public face of their private lives in a manner that arguably surpasses the technical limits of earlier media. However, the differences are largely a matter of degree rather than kind. The emphasis on control, accuracy, simplicity, and individual agency has been long established in the history of "consumer technology" such as photography. However, what is a significant departure in the case of online forms of self-documentation is the fact that the documents themselves are rendered in what is essentially a public media space as opposed to a family album or a shoebox full of snapshots in an attic somewhere. This is an important difference that directly affects the assumptions regarding readership and, moreover, the construction of a public version of the private. The following comment by the web diarist "Rick" is telling in that it criticizes the supposed limits of earlier media in terms of their inability to connect to a truly public space.

> I have started writing a personal (non-web) journal more than one time. Only once did I even get as far as a single page full of writing. The thing I couldn't get past was that there was no audience besides myself. It was like

re-capping a movie to someone that had already seen the movie! I felt ridiculous writing to myself when I already knew everything I was going to say.[2]

For the web diary writer, and indeed any web self-documenter, the audience is anticipated and real, thereby influencing and structuring the very manner in which the self-document is articulated, composed, and distributed. One effect is the rendering of web diarists and "cammers" into veritable media objects—self-styled celebrities to be distributed, evaluated, and ranked. Among the myriad of examples that can be found on the web is the Amanda cam, a combination webcam and web journal site that is deliberately coded in the languages of mass media, particularly in the case of the "covers" for the home page, which are modeled after fashion magazines.[3] "Amanda," the site's creator, produces a different cover for each month, which features her in poses drawn from the repertoire the generic "cover girl."

Equally representative of the desire to be "mediatized" is the annual awards ceremony held by diarist net, which employs categories similar to those used in the Emmys or Oscars to pay tribute to the stars of the genre.[4] In addition to the "site awards" there is also recognition for individual entries, which again mimic the Hollywood categories for excellence—best romantic entry; best comedic entry; best dramatic entry; best rant; best collaborative entry; best account of a public or news event. While more elaborate than most, "The Diarist Awards" are indicative of the common trend of displaying recognition and audience size for individual websites, whether in the form of "counters," which indicate the total number of hits or visits to date, or digital seals of approval or "awards," which users frequently assign to one another. Whatever the mechanism, its basic function appears to be the creation of a kind of economy of recognition, which often borrows from the tropes and discourses of mainstream media and the embedded discourses of control, categorization, and rationalized order. Private space thus undergoes an important mutation by virtue of being coupled with the very public spaces of performance, celebrity, and commercial media.

CHAPTER 8
Connected Privacy

The phenomenon of web-based forms of self-documentation has met with a certain amount of incredulity from the general public. The common reaction to activities such as a web-diary or web-cam is essentially one of amused disbelief and concern that something irreparable is being done to the sanctity of private space and personal integrity (Kahney; Muther). This sense of violation and the crossing of what would seem to be a necessary boundary between the private and the public are intriguing for a number of reasons. First, they represent the still lingering import of essential dualisms, in this case that of pure privacy and its clear distinctions between what is inside and what is outside. Despite the fact that our lives are increasingly integrated into the overall media environment, it is still customary to cling to the idea that such a thing as "real" privacy does and should exist. A second and less obvious source of interest is the implied contradiction or paradox in the whole activity of online self-documentation. After all, does not the act of making the private public make the private disappear altogether? Does it not simply become sheer spectacle and thus removed from the spheres of true intimacy and privacy?

The usual route through such questions is to become embroiled within issues of authenticity. What is real privacy? What is real intimacy? What is real community? What is being destroyed or threatened by this mongrel practice of online self-documentation? While interesting in their own right, such questions are, however, rather limited given that they circle in on themselves by virtue of locking one into a cycle of binary oppositions. Furthermore, there is the added danger of lapsing into a type of nostalgia for times when there supposedly were such things as real privacy, real intimacy, and

community, especially when considering the impact of new technologies and modern society in general. Within such a mindset technology is something that *happens to* a preexisting social or cultural space, thereby encouraging critical investigations that emphasize cause-and-effect relationships.

As a means of avoiding such a critical loggerhead, Mark Poster recommends that one should think of a technology such as the Internet as a country rather than as a tool. "The Internet is more like a social space than a thing, so that its effects are more like those of Germany than those of hammers; the effect of Germany upon the people within it is to make them Germans...the effect of hammers is not to make people hammers...but to force metal spikes into wood" (Poster, 2001, 176–77). Poster's contention here is that the Internet is more than just an "efficient tool of communication" that is utilized by its users for instrumental reasons but rather a social space, or, as James Slevin notes, a "medium of practical social activity" (113). The Internet is something that is made by virtue of its use rather than a technology that imposes its order on an existing set of practices.

> The Internet resists the basic conditions for asking the questions of the effects of technology. It installs a new regime of relations between humans and matter and between matter and nonmatter, reconfiguring the relation of technology to culture and thereby undermining the standpoint from within which, in the past, a discourse developed—one which appeared to be natural—about the effects of technology. (Poster, 2001, 176)

It is with such an orientation in mind that I arrive at the last "category" regarding the place of privacy, namely "connected privacy." As the term implies, there is a process of hybridization involved here, with the private and public merging into one another. More specifically, connected privacy is directly associated with the specific conditions and practices of network-based communication, notably the World Wide Web. Equally relevant are the changes in the technosocial infrastructure that are generally considered under the auspices of postmodernism and globalization. Such associations are useful not for purposes of declaring a new age or revolutionary state but rather for exploring the manner in which the private and the

public are socially practiced within the networked place of the World Wide Web.

To put it simply, connected privacy is a privacy composed, ordered, and defined by connections, by links between individuals, groups, families, and communities. It is a privacy whose space is permeable, thereby allowing for the direct input and inclusion of external agents. In this respect, connected privacy is the direct opposite of pure privacy, with the latter's conditions of defined isolation and secure boundaries. Yet at the same time, it is a privacy where private moments and places are possible and, in fact, desired. Connected privacy does not negate or eradicate moments of pure privacy, nor does it subject everyone to constant surveillance. One can still be alone in conditions of connected privacy, yet the walls can be dropped at any moment without necessarily leading to feelings of violation, exhibitionism, or disempowerment. As such, connected privacy can be characterized by a certain lack of paradox or contradiction inasmuch as the boundaries that separate the public from the private are recognized and respected but also ignored and transgressed. Thus one can experience privacy while being on a webcam 24/7 or perceive little contradiction in the act of putting one's most intimate thoughts onto a public website such as diaryland.com. Such a lack of paradox can be attributed in part to Poster's notion of the Internet as a "new regime of relations" in which the distinctions and conventions of previous "media regimes" are reconfigured in such a manner that frustrates the stability of already established critical and evaluative paradigms. Similarly, Aaron Ben-Ze'ev argues that the conflicts between privacy and emotional closeness and between privacy and openness are notably weaker on the web. Part of this weakness is attributed to the relative anonymity of Internet-based relationships and the ability for users to both limit public access while at the same time engaging in activities that increase emotional connections and intimacy (Ben-Ze'ev).

What is central to the condition of connected privacy and its deployment within online self-documentation is the discourse and practical realization of community. Without a sense of community, even at its most ill-defined state connected privacy could not function

as it does. In other words, what keeps phenomena such as web-diaries from being little more than fleeting spectacles within a culture already inundated with fabricated experiences are the social networks that are created under the broadly applied banner of community. It is community, or at least the illusion thereof, that keeps online self-documentation meaningful to its many practitioners.

Before exploring why and how this is the case, it would be useful to comment on the nature of community itself, which like privacy is a term not without its debates and disagreements. It has become common to characterize community as something that is lost, particularly as a result of contemporary technology and media (Putnam). Yet research on contemporary communities steadfastly reveals that community is still thriving and viable in the twenty-first century despite the doom mongering of the pundits and politicians. "Community," writes Barry Wellman, "has never been lost" and can be found in all human groups, in all historical periods and contexts, whether it is a medieval cloister or a web-based discussion forum (2). In this respect, to actively create and take part in a social network, a community can be considered as part of what it means to be human. For the purposes of this discussion, community can be more precisely understood as a group of people who are unified to some extent by the following conditions:

> Social interdependence and life in association with others; A social dynamic that encourages shared discussions and decision making; Feelings of commonality and shared interests, feelings, or beliefs; Social, cultural, or material conditions that encourage fellowship and active social interaction; and A sense of differentiation from the larger social whole, such as notions of cultural distinction or exclusivity. (Bellah, 333; Munon, 1)

A comparable list can also be drawn up for online or virtual communities, as Murray Turoff has done for a very early study on Internet-based communities. According to Turoff, there are four minimum technical conditions for effective online community:

Bounding: forming closed online groups;

Tracking: listing how far each participant has read in community discussions;

Archiving: maintaining accessible records of community discussions;

Warranting: ensuring stable and (most of the time) genuine participant identities. (Hilz and Turoff, 1978, quoted in Bakardjieva and Feenberg, 183)

Such a list, which as stated focuses on technical or material conditions, can be augmented with yet another list that emphasizes the import of social constructions:

The creation of personal images of other community members no matter how limited the communications channels of the medium may be:

The active appropriation of available structures and technical features in both expected and unexpected ways;

The creation of "dynamic and rich communities via new forms of expression and through interactive negotiations of meanings, norms, and values",

The designation of different and distinctive codes of conduct and normative conventions by individual communities, which are not necessarily the same for all. (Bakardjieva and Feenberg, 184)

As already stated, the practitioners of online diaries, web-cams, and other forms of online self-documentation actively employ community building as a means of achieving what I am calling connected privacy. On the broadest level, the majority of online portals for self-documentation, particularly online diaries, appear to fulfil the requirements set by the first list indicated above, meaning that deliberate mechanisms are employed by both the site administrators and individual users to actively create and sustain community. The portal opendiary.com, for example, describes itself as "the next generation of online diary communities," and for a bid at differentiation or exclusivity states that "this community will be *limited* to only 10,000 members. We are currently home to 3,048 online diarists."[1] Similarly, the extensive diarist.net, which describes itself as one of the most comprehensive sites for web-diaries, states that "online diarists are a true web community interacting with each other as well as with their respective readers. They socialize, brainstorm,

counsel and debate together in a variety of venues."[2] Livejournal.com's community section emphasizes that "LiveJournal is not just an online journal; it's an interactive community! You can meet new friends, read and comment in other journals, and interact with people from around the world who share your interests."[3]

To achieve such aims, an assemblage of "social, cultural and material conditions" is employed, such as web-rings, organizational schemes, link sharing, "sites of the day," and "daily topics." Many of these also correspond to varying degrees to the "technical conditions" outlined in the second list and the social constructions represented in the third. Web-rings or "burbs," for example, play an important role in limiting the potentially alienating and overwhelming diversity of the online diary population by "bounding" the sharing of diaries within the context of common interests, concerns, and values. Pioneered by Sage Weil in 1995, a web-ring is essentially a circle of sites dedicated to a single subject or theme that by way of a CGI script written by Weil are connected to one another into a single and stable circuit. Each ring is organized by a "ringmaster" who in addition to defining the thematic content of the ring also maintains its structure by removing dead or inappropriate links. What is significant about this arrangement is that users, once they have found a subject that interests them, are able to move to similar sites without having to return to a general search engine. Web-rings have been primarily adopted by users wishing to make personal connections and therefore function mainly as "forums for sharing poetry, personal journals, and broken hearts." As noted by Weil, a web-ring ""allows anyone to create their own little community" (McDermott, 67). Not surprisingly, web-rings have been widely adopted by creators of web-diaries and web-cams. The web-ring Open Pages, for example, describes itself as "the largest, most all-encompassing web-ring dedicated to online journals" and celebrates web-rings in general as "a decentralized, dynamic network that allows people to wander through the personal triumphs and tribulations of people scattered across the globe."[4]

The web-ring The Diaries, administrated by Jaded1970, similarly emphasizes the web-ring as a medium for creating a community

predicated on the sharing of personal "triumphs and tribulations" by describing itself as a "a webring for interesting diaries, logs or journals on the internet that are in depth and deal with love, loss, misery, hope, and all other emotions."[5] Equally influential are the various organizational schemes or settings employed by web-diary portals to provide a sense of order and also to create a sense of community "history." Among the more common examples are archives, diary search engines, surveys, link sharing, categories, statistics, questionnaires, debate topics, help guides, reader's choice, feature diaries or diary entries, and diary categories. The combined effect of such mechanisms is the creation of a relatively diverse environment for user engagement and interaction that is directed toward a broad realization of community. In this respect, web-rings fulfill an identifiable infrastructual role inasmuch as they function as technical constructions deliberately designed or at least employed as means of stimulating communities of shared interests and emotional intimacies. Privacy is thus reconceptualized in terms of connection and choice, meaning that the articulation of the private becomes a mode with which to create links or bonds with others on the basis of active selection. In this manner, online diaries are more than just dialogues with the self but also a type of "identity network" through which participants can seek out connections and discursive soapboxes from which to present themselves and their worldviews. Once again, there is an oscillation at work here—in this case the oscillation between the very personal act of exposing or representing one's private life and the very public act of showcasing that life on a veritable identity marketplace that, as in this other example from the Diarist Net Awards below, is subjected to such "professional" paradigms as "box office" success and the peer review.

> The phenomenon of the online journal has uncovered some of the most fantastic writers, storytellers, and designers on the web...often everyday people who manage to captivate readers and fans all over the world. They deserve to be recognized. And while other excellent award programs exist, The Diarist Awards—now entering their fourth year—are the most ambitious, accessible, peer-driven effort to date.[6]

Equally telling and perhaps of no surprise is the creation of JournalCon, the annual "real-life" conference that bears a striking and clearly intentional resemblance to many trade and professional conferences.[7] Complete with well-designed logos, organizing committees, keynote speakers, sponsors, luncheons, and workshops, JournalCon effectively renders the experience of private self-expression into a public display of professional camaraderie and community that is a long way from the solitary act of pouring one's heart out into the pages of a leather-bound diary. Clearly, something very different is going on here.

Part of this difference can be attributed to the "new regime of relations" engendered by the connected privacy of Internet-based forms of interaction and community. In this respect there is a notable lack of dissonance when the private meets the public within the place of the network. Thus connected privacy is not an indication that privacy is being compromised or corrupted or, to follow a common route, cast under the spell of media power and influence (Postman). Rather, connected privacy is indicative of an altered state of contact between humanity and the world *by way of technology*. As Walter Benjamin notes, "technology is not the mastery of nature but of the relation between nature and man....In technology a physis is being organized through which mankind's contact with the cosmos takes on a new and different form from that which it had in nations and families" (Benjamin, 1996, 487).

To follow Benjamin's lead, the conditions of pure privacy, public privacy, and connected privacy can be thus envisioned as particular forms of contact between humanity and the world via the *technologies* of self-documentation. In each case, the dynamics of the public-private relationship are duly articulated, complexified, and augmented by technosocial innovation and change.

PART THREE
Real Place

CHAPTER 9
Posture Three

Imagine once again the scenario of finding a diary on a nearly empty subway car. Once again you are flipping through the pages, scanning for something that will fulfill your voyeuristic expectations. As before, you look up once, twice to see if anyone is looking at you. And once more you feel that tingling rush of guilt brought on by trespassing into someone's private and personal world.

But imagine that when you get to the last page you encounter these lines: THIS IS NOT A REAL DIARY. IT IS ALL MADE UP. NOTHING HERE IS REAL!

How would you feel? How would anyone feel? Betrayed, annoyed, and taken in? Most likely. Amused and befuddled? Probably less so. You have been betrayed. Diaries are supposed to be real. That is the whole point, after all.

This chapter addresses the slippery problem of the real with respect to the various practices of self-documentation. For when it comes to self-documentation, reality constitutes a central and important place. Indeed, reality is the place that one is supposed to be able to access and enter via the self-document. To read someone's diary is to occupy, if only via fleeting gestures, the place of the authentic self.

Of course things are never quite that straightforward. Reality has a way of slipping away and multiplying itself, often at the same time. For the purpose of constructing a temporary moment of order in what otherwise would be quite an unruly affair, this chapter will segment the real into three units that, as before, correspond roughly (but not exclusively) to the material and discursive places of the page, the camera, and the network. As should be evident by now, the aim is not to create a tidy chronology or typology of "media experiences"

but rather to probe the manner in which a given experiential realm, in this case "reality," is framed, structured, expanded, and contracted by the general or archetypal modes of self-documentation featured in this study. As such, the questions become again quite straightforward: What happens to reality, as both an experience and a discourse, as we pass from the handwritten diary to the web-camera? Where does reality go? What kinds of things are said about reality? What does reality feel like? What does reality mean, and does the question even matter anymore?

Yet the asking of such questions is the easy part. More difficult but also more rewarding is the matter of crafting and putting forth a number of responses, however tentative and unstable.

CHAPTER 10
Positive Reality

We want to believe. It is not much more complicated than that. A diary, a memoir, a family photograph, or even a web-cam image all draw their power from their proximity to the real, which, ideally, should be close—very close. This is the nature of what I term the positively real: the premise of the self-document is that it is an accurate and often raw representation of the real. On the screen or through the pages of a diary we can get a glimpse of the reality of family dynamics, the depths of personal introspection, and the authenticity of candid snapshots. The assumption, the expectation, the demand, in fact, is that what you see, read, or hear is or was actually present and that artifice and fiction are kept to a bare minimum.

To follow a line of thought initiated by the literary historian Philippe Lejeune, this expectation of the real could be represented as a kind of contract between the creator and consumer of a given self-document. In his study of autobiography, Lejeune notes that the title page is of considerable import because it makes an explicit connection among the work, the author, the protagonist, and the content. This connection implies a promise of a common identity among the author, the protagonist, and the text. "The autobiographical contract is the affirmation in the text of this identity, referring in the last resort to the name of the author on the cover. The forms of the autobiographical contract are quite varied, but they all manifest an intention to honor the signature" (Lejeune, 14). In part, Lejeune is drawing on the legal context of authorship itself, which among other things links a text to its author by way of the copyright apparatus, which again takes us back to the title page. Thus the task of determining the difference between a work of fiction and an

autobiography requires no great journeys outside of the text. We need only venture toward what Lejeune refers to as the outer boundaries of the text, "this final term, the proper name of the author, which is at once textual and indubitably referential. If this reference is beyond doubt, it is because it is based on two social institutions: vital statistics (agreement internalized by each of us from early childhood) and the publishing contract; there is, then, no reason to doubt identity" (21). In the case of nonliterary self-documents, such as family snapshots, home movies, or diaries, there is of course no publisher or title page in the legal sense. Yet the broad implications of Lejeune's designation of the autobiographical contract are informative in that they point to the assumptions that accompany the practices of self-documentation. Among the key expectations on the part of viewers or readers is that of authenticity, which forms the basis of the relationship between a self-document and its audience. In other words, for the experience of self-documentation to "work," it is vital to maintain the link between the document and the reality upon which it is based.

How this link is established depends in part on the specific nature of the medium in question and the repertoire of "reality markers" (or even aesthetics of reality) associated with each media place. For handwritten diaries it is very much the object of the diary itself that testifies as to its reality. As a result, handwritten diaries become artifacts, material testimonies of a writing hand, a concrete entity that lived, breathed, and literally inscribed portions of him- or herself into a diary. The rigorous testing of Anne Frank's diary is a famous case in point. In order to put to rest any doubts regarding the diary's authenticity, the Anne Frank–Fonds[1] initiated a five-year authentication process that painstakingly analyzed every square inch of the diary's surface—everything from the handwriting to the paper and the glue used in the binding. The result was the *Definitive Edition*, published in 1989 (Frank).

Yet the diary as thing, as artifact and as a literal place for the hand, so to speak, is only part of the equation. Equally pertinent are reality markers that are embedded within the content of a given diary or, for that matter, any form of self-documentation. At the more

concrete end of the spectrum are the verifiable facts—dates, historically accurate descriptions, famous events and figures. On the other end are the indications of a "real person" writing—sincerity, honesty, spontaneity, and a general lack of formal or structural unity, which further indicate that diaries should not appear as if they have been planned. The latter was the case for the diary of Emily Hawley Gillespie, which was written between the years 1873 and 1952 and edited into a two-volume edition by Judy Lensink, a respected scholar in the field. The diary, it was discovered, was a carefully planned and edited project rather than a spontaneous reaction to daily life as it unfolded for the writer. Lensink's response to the discovery:

> Rather than an authentic text of an ordinary life, the archived manuscript diary was a subtly altered journal about an idealized past and imagined youth that rendered the older woman's unhappy journal of her subsequent brutal marriage incredibly poignant. Therefore, all that I have written about Gillespie's journal, some of which having been recently reprinted in a Gale reference as basic readings on the nonliterary diary as history and as autobiography, is based on a faux diary. I am a scholar scorned by a diary constructed to appear so ordinary that its extraordinary qualities seemed all the more luminescent. (Temple, 153)

Lensink's experience is notable for its identification of overt "ordinariness" as an accepted marker of authenticity. Indeed, it is the stamp of ordinary life, the seal of the banal that testifies to the positive reality of most forms of self-documentation. Diaries, home movies, and web-cams should be about "nothing" if by nothing one means the unstructured and familiar elements of day-to-day life as emphasized, for example, by the online diary portal The Ordinary Life:

> Sometimes life is hard, sometimes it's good, but most of the time it's just plain boring. Though it might seem boring, and you're feeling like a machine, we still do even the smallest things our own way. We all have our own way of seeing things. We are all great personalities, and this is shown in these small details of our lives. So share your life and your personality

with others. Your life is much richer than you think! *But what you write must be true.* Just share some of your ordinary life and enjoy the good read ahead.[2]

Helen M. Buss, in her study of diaries written by Canadian women in the nineteenth century, notes that diaries are not driven by narrative conventions such as those associated with the novel. Diaries "do not fulfill the novelistic assumptions of the reader" and thus "demand a different relationship with the reader" (Buss, 57). One aspect of this relationship hinges on the assumption of reality or at least the writer's sincere attempt to represent what she or he believes to be real. Lois Guarino's diary-writing guide *Writing Your Authentic Life*, for example, emphatically informs the would-be diary writer that "only accuracy, sincerity, and integrity will do" (Guarino, 22–23).

For the still camera the authenticity and "realness" of the likes of family snapshots is based primarily on the discourses and narratives constructed around them by acquaintances or family members (Chalfen, 1998). Positive reality is established because someone actually testifies as to the authenticity of a particular image. This is one way. The other is partly a matter of formal and stylistic codes, or lack of them. In other words, to be positively real within the medium of photography often means employing less than professional standards of composition and form, for example. There is a certain rawness, a certain reduction in fidelity or resolution that is expected of the amateur self-document. Of course this is not done intentionally, and indeed the industry often advocates professionalism and expertise in the form of equipment, guidebooks, and so forth. In addition, advances in technology make it increasingly impossible to make "bad" recordings by leaving such matters as light settings, aperture control, and recording levels up to the inner workings of a "smart" machine.[3] Rawness becomes thus a matter of style, of a lack of aesthetic or formal knowledge, that marks a clear distinction between the overproduced representations of mainstream media and the hi-8 digital video shot on vacation and edited onto a DVD via Apple's i-Movie software. Indeed, in the case of amateur pornography, this rawness is an integral part of the self-document's fetishistic appeal. "The crude camera work, muddy sound, and harsh

lighting serve as earmarks of an authenticity that titillate the postmodern voyeur's appetite for an always already absent referent" (Tamblyn, 14).

The believers in the positively real do not take kindly to betrayal. To deliberately fabricate a form of self-documentation becomes at best a work of fiction but more likely a bad and unappreciated ruse. Such a lack of appreciation is potently represented in the world of online diary writing, which under the twin banners of community and sincerity place a high value on maintaining the "contract" of authentic expression and self-representation. A representative example is the story of "Ellie," who was betrayed by a regular visitor to her site, which includes a web-cam and a daily journal.[4] The incident started in a typical manner. A woman who also had a web-cam eventually formed a close friendship with Ellie on the basis of sharing "daily ups and downs" and the "turmoil in her life." By Ellie's account, the daily correspondence was deeply personal and often had considerable emotional impact. "Her husband was an abuser," writes Ellie, "she was seriously injured by him on numerous accounts [occasions] until she finally put him in jail. As our online friendship flourished, I was able to provide support and help her through her difficult times, as did others she got to know through me." After a period of time and some lengthy correspondence, Ellie's "online friend" revealed that she had come into some money and wanted to show her appreciation by taking both Ellie and her husband on "a trip to the sun." After a period of initial skepticism, the couple accepted the offer and began to make the necessary arrangements—babysitters, time off work, travel bookings, airport shuttles. However, as the day of departure approached, the threads began to unravel. A call to the airport to confirm the flights revealed that no reservations had been made. Confrontations with the "online friend" brought only excuses and another story of trauma—this time the death of her father. It was soon revealed that there was no truth to anything she had said. "We found out that she had made everything up, she had not come into any money, had not arranged this trip at all, and basically everything else in her life was a big LIE! We were taken in by a person who also had a web-cam, I saw her daily, and

her children, but never her 'husband,' who we still to this day don't know whether he was an abuser or not or if he even really existed."

Ellie's tale is not without precedence, and many such betrayals can be found in various accounts of social relationships on the web.[5] It should be noted as well that Ellie's situation is not purely an example of self-documentation in that the act of betrayal was primarily via direct and sustained correspondence, which is not the same thing as a diary or web-cam to which one makes regular visits. Yet given that the majority of online web-cams and diaries engage in regular interaction with others, the example remains a pertinent representation of the implied "contract of the real," to coin yet another phrase. A purer exemplar of a deliberately fictionalized diary and the betrayal created as a result occurred within the diary community opendiary.com. As in Ellie's experience, the incident involved the shared concern over the plight of an individual suffering unfortunate circumstances, in this case a teenage boy. And also like Ellie's case, it was revealed that the whole affair was a hoax from the very beginning.

> In this space, we recently asked a favor of our community members—to visit the diary of a teen boy who was sick and seemed to need help. We are sorry to say that this diary was, in fact, a hoax. Like many others on this site, we were fooled by this fake writer—fooled enough to feel that we might be able to do some good by showing him a little compassion. We are sorry that many people were misled by this person, and apologize for any hurt feelings that resulted from this.[6]

Such betrayals speak to the importance of what could be termed the "institutions" of self-documentation, which to follow an argument put forth by Michel de Certeau, determine the function of any particular document more than the content of the document itself (de Certeau). Thus, for example, it is the recognition of the "institution" of the home movie that spurs our initial willingness to accept the content as true or real. If after viewing the home movie it becomes apparent that it is "false," then the "institution" of the home movie, with its concomitant associations and conventions, is destabilized and potentially threatened. Paramount is thus what Erving Goffman

termed "the front," or "that part of the individual's performance which regularly functions in a general and fixed fashion to define the situation for those who observe the performance" (Goffman, 22). While Goffman is referring to far more general processes of establishing social identity, in this case the concept of the front offers a useful means of identifying the manner in which the self-document (such as a home movie) functions as a vehicle for the real and true. Audiences or readers are prompted to understand the represented individual or life story on the basis of a repertoire of reality cues, which include those of setting, appearance, and manner (27). On the other side of the page or lens, the self-documenter must adhere to the demands and codes of spontaneity and the creation of a front that does not appear to be deliberately (or at the very least consistently) scripted or planned. As a result of such performance, a "true" self is brought into focus that, to follow through with Goffman's analysis, reaffirms the societal codes of normative behavior and "real" life.

Consider also Michel Foucault: "the function of the author is to characterize the existence, circulation, and operation of certain discourses within a society" (Foucault, 1977, 123–24). Among such discourses is the actual act of self-documentation, which coupled with intention is key to creating and maintaining the positively real. In other words, the act of making a home movie combined with the intention to authentically capture Junior's first birthday party is what "makes" the resultant footage real, in terms of both its production and its reception. Indeed, sincere intention is assumed unless proven otherwise. When watching an old home movie we anticipate and expect by virtue of the institutional conventions signified by its form that what we are watching actually happened and is true. In this respect the primary cues for authenticity lie on the surface or in the form and material itself. The reception and evaluation of the content is based on this. For example, an entry into the livingroomcam, which advertises itself as "a family's home on the web," triggers the rather straightforward expectation of "real-life" media. The site discursively creates itself as real, and its format and aesthetic follows the conventions of real-life web-cams, as does the presentation of the content itself. Thus, we go into it expecting the real and experiencing

it as such. It is the entirety of the package that makes the experience possible. If it were to be exposed, say by members of the "living room," that everything was merely fabricated and that the living room was in fact a computer simulation, then collapse would ensue. The site would become unreal and thus disappear under its own virtuality.

Positive reality is a fragile state and can unravel at any time. It is important to keep the illusion intact, to not break the spell of authentic self-revelation. In this sense what is being emphasized is the "surface" of both truth and fiction. In other words, I am not interested in the actualities of truth or falsity or the manner in which all representations are arguably constructions of some sort (discursive, ideological), which continuously keep reality at bay. Instead, to follow a line of reasoning from de Certeau, the belief in and experience of reality comes down to what is seen and immediately available. "Today, fiction claims to presentify the real, to speak in the name of facts, and thus to cause the simulacrum it produces to be taken as a system of reference. Those to whom these legends are addressed (and who pay for them) are therefore no longer obliged to believe what they cannot see (the traditional position), but rather to believe what they do see (the contemporary position)" (de Certeau, 125). The readers/viewers of self-documents want to believe, so they must not be disappointed, at least if the category and system of self-documentation is to mean anything. Once again, the term *infrastructure* can be of use. For this is essentially what is being created by the practices of self-documentation—an infrastructure within which authentic and real experiences and expressions can be encoded and decoded. Along with this infrastructure are conventions, expectations, and norms that must be obeyed if the infrastructure is to remain intact. Of course deviations and games are permissible, mainly on the fringes of the system or as amusing distractions from the real business of serious self-documentation. Members of the discussion group diarynet, for example, enthusiastically discuss "hoax diaries" with the implied assumption that they are immediately recognized as such.[7] But within the core of online diary writing, purity must remain. This is, of

course, a purity of intention and not actuality, since wanting to believe is not the same thing as actually knowing. But then, this is obvious. We can never know, but we can certainly act as if we do. This is part of the pleasure and the norm of the positively real.

CHAPTER 11
Negative Reality

Sometime during the 1980s the real disappeared with a vengeance. Terms like *hyper-real*, *simulacrum*, and above all *virtual* began to make their way out of the academy and into everyday discourse. By the middle of the decade it seemed as if almost everything was hyphenated in some form: cyber-sex, hyper-reality, tele-commuting, virtual-life. The real was augmented, compromised, extended, or de-realized as never before. While precedents abound, it is the maturation of digital technology, under the general banner of "cyberspace," that serves as an obvious marker for such developments. For it is the concept and cultural expressions of cyberspace that most vividly represent an ethos and an aesthetic by which reality is consistently removed from its moorings, be they material or social. Within the realm of cyberspace everything becomes suddenly possible but in a manner that is neither a fabrication nor a "reality" in the conventional sense. More real than real but also less so, or as Sherry Turkle has observed in her studies of the fate of identity in digital environments—"in the real-time communities of cyberspace, we are dwellers on the threshold between the real and the virtual, unsure of our footing, inventing ourselves as we go along" (Turkle, 1995, 10).

The computer is often cited as being one of the primary vehicles for reconfiguring and expanding what we know and experience as reality. It stands behind the long list of concerns regarding "hyperreality, virtual worlds, cyberspace, interactive global communication, and beyond to artificial intelligence, neural networks, cyborg culture, an anxiety about the edges of the body and the limits of the machine, to nano-technology, genetic engineering and a dawning post-biological age" (Lister, 2). Furthermore,

advanced technology in general is frequently depicted as being a primary agent in the significant cultural shifts that have occurred over the past hundred years, particularly in terms of how it has affected the very nature of human subjectivity and being.

> In the culture more generally we see the changes manifest in the slow replacement of real persons with electronic impulses (for example in carrying out friendships on computer networks, being entertained or intrigued by television, or achieving sexual gratification through telephone services); the ready replacement of limbs, organs, skin and so on with technological devices; the avid enthusiasm for virtual realities, cyberpunk, and the chaotic flow of MTV images. (Gergen, 3)

Yet what does all this mean in the context of self-documentation? Among the most significant is the manner in which the virtual has become an increasingly ubiquitous experience within contemporary society either directly or indirectly. The need for original referents when it comes to creating or consuming representations is decreasing each day. Thus under the reign of the virtual order, one does not actually need a real-life "Amanda" or "Ellie" in order to experience a meaningful interaction or relationship. Distinctions between the authentic and the copy are even further apart than Walter Benjamin could have imagined. Indeed, if Lara Croft is any example, the virtual can today become a primary referent.

Thus for web-based forms of self-documentation, the real is gone in a number of ways. First, the resources required to produce a self-document are not as limited by material constraints, which means that the process of self-documentation can potentially be continuous. Once the initial conditions have been met, meaning the purchase of a computer and related equipment and services (or at least access to such equipment), one can write or record oneself into exhaustion or even in spite of it if one considers that a web-cam documents while you sleep. One obvious consequence is that of increased volume. While exact figures are difficult to come by, census data regarding the purchase and use of video and computer equipment makes it seem likely that an increasing amount of "content" is also being created and distributed.[1] This increase in "production," so to speak, has the

effect of expanding the field of self-documentation into equally expanding terrains of exchange and interaction. Quantity, in this case, matters, given that in the virtual world of the web "quantity" is subjected to what can be termed unreal economies of scale and duration. In other words, the act of producing and distributing web-based self-documents is not hindered by many of the constraints that plague "material media," namely media forms that rely on physical and limited resources such as film stock, paper, and geographically based distribution. The key element or consequence here is production, which as Robert Burnett and David P. Marshall discuss via their "cultural production thesis," distinguishes the web from previous media forms. "The Web provisions the user to eliminate the natural divisions between production, distribution, and exhibition as the network makes these divides meaningless" (Burnett and Marshall, 73). Thus the economics of the virtual—if by economics we mean the generic term for describing processes of production, distribution, and consumption—becomes unreal or immaterial in the sense of being able to function within an existential zone that is not exclusively formed within materially based realities.

Equally representative of how reality has "left the building" within the places of web-based self-documentation are a number of additional characteristics that have their basis within the concept of the unreal economies of the web. Among these is the general disconnection between original referents and representations, implying that reality can be created "from scratch" via the tools of digital media.[2] This is especially significant in the case of visual media, which are premised on the existence of a primary referent that, no matter how manipulated during or after the moment of actual documentation, still retains a strong connection to objective reality. As John Berger notes, "unlike any other visual image, a photograph is not a rendering, an imitation or an interpretation of its subject, but actually a trace of it. No painting or drawing, however naturalist, belongs to its subject in the way that a photograph does" (Berger, 50). In the case of digital image production, such "tracing" is not necessarily practiced, given that with the right imaging tools one can construct an image of an individual or place without ever having

been there. Thus the real is *not necessary* for representation to occur within the places of the virtual. In the case of self-documentation this presents at least two notable opportunities—deception and affirmative invention. In the first case, which has already been discussed earlier, the tools of virtual imaging (and the fact that one interacts with individuals on a virtual level) could be used to deliberately fabricate representations that have no basis in reality, with the aim being to fool users into believing that what they are seeing or reading is actually true or real. In the second instance, affirmative invention makes it possible for individuals to creatively play with their identity in a manner that frees them from the constraints of their specific life situations, whether geographical, physical, economic, or psychological. This allows for the by now familiar notion of the Internet in general as being a resource for creative self-expression and invention that, as Turkle notes (Turkle, 1991), allows for the creation of multiple selves without the danger of compromising the values associated with one's conception of a whole person. It is, however, important to note that such "self-creation" is potentially overstated in terms of being deemed exclusive to the experience of the web and is, as Kenneth Gergen has identified, indicative of far more general forces within the modern (and technologized) world (Gergen, 1996). Accordingly, self-invention, whether deceptive or inventive, is an important component of both analog and digital forms of self-documentation. However, what does make a difference in the case of digital media is again related to the notion of the unreal economy of the web, which gives rise to a dynamic of cultural production that is distinct from those available via material media—that is, media predicated on a combination of original referents, physical resources, and identifiable locations. Of course the web, especially in the case of self-documentation, can be similarly grounded within and by virtue of the physical and material world. But the point here is that it does not have to be. This is the important and essential difference that enables the real to disappear, if so desired.

CHAPTER 12
Returned Reality

Reality has returned with a vengeance. There is now more of it than ever before and often at prices and levels of convenience that are unparalleled in human history. It is there for the taking, ready to be experienced and lived to its fullest.

In this respect, the feud between the virtual and the real has dissipated to the point of being more of a minor irritation than a full-blown skirmish. Reality, as it turns out, has embraced the virtual and made it real. As a result, everything is now real or at least has the potential to be real, which in terms of effect amounts to the same thing. Thus, to champion one or to mourn the other is a waste of precious energy. Far more effective and necessary is the task of recognizing the potential reality of the virtual and treating it accordingly.

Indeed, I'm inclined to state that the aura has returned. The aura is back. After multiple decades of dormancy, the one-time aura of the unique masterpiece has snuck back into the scene, albeit in a somewhat altered fashion. This time around, the aura of authentic inscription or expression has lost a good portion of its transcendent quality. No longer are we carried away into some sublime plane of understanding or reunited with the "fabric of tradition" (Benjamin, 1969, 223); rather we are transported into the brute thrill of (un)adulterated reality, pure and simple and as direct as possible. Let's call this the "dirty aura."

The dirty aura is actually quite straightforward in its appeal and can be used to explain quite a number of phenomena. Reality television is one. Extreme sports is another. Reading someone's diary on the train also comes to mind, as does sneaking a peak at the Jennycam once in a while. Pornography seems like an obvious

follow-up. And then there is the drinking of Coca-Cola, at least if one is to believe their slogan. For the dirty aura is all about the Real Thing and the rush that can momentarily be experienced or even anticipated from getting close to a moment of authentic experience.

Self-documentation makes for a rather apt place for the realization of the dirty aura, especially on the part of the reader, audience, or user. For what self-documentation promises or at the very least pretends to be able to promise is a glimpse at Real Life, either past or present. In some cases this may lead to a sublime experience but more likely to moments of nostalgia, emotional "connection," or simple (fetishistic) desire.

But make no mistake. The dirty aura is not an aura that is offensive or morally dubious, at least by definition. Rather the concept of the dirty aura is being used here to signal the genuine appeal of the real in its most general and simplistically defined form.

> Real *(adj)*
> existing or happening as or in fact; actual, true, etc.; not merely seeming, pretended, imagined, fictitious, nominal, or ostensible a) authentic; genuine b) not pretended; sincere
> (Webster's New World Dictionary, 3rd college ed., s.v. "real time.")

In this sense the dirty aura could also be termed the primitive aura, since what is being emphasized here is a rather naive and simple form of "truth" that is not bound by comparative contextualization. The dirty (or primitive) aura is just the way it is. It is simply there, to be experienced and lived and not to be analyzed. The dirty aura does not bear well under scrutiny, as it thrives on the obscurity brought on by a lack of sustained reflection. The dirty aura requires faith.

One could say that so defined, the dirty aura has never gone out of style and that the real has not been as compromised as critics have had us believe. This is a matter of debate and not one that I will deal with directly in these pages. Rather, what is of specific interest is the manner in which recent developments in web-based self-documentation have contributed to a "revitalization of the real," in a manner that embraces, without paradox, both the virtual and the authentic. This is more than just Jean Baudrillard's infamous

simulacrum or a reworking of Hal Foster's comparable dictum (Baudrillard; Foster). The returned reality with its dirty aura is also counter to the common discursive tack that characterizes the Internet, and cyberspace in general, as something that privileges artifice and deliberate self-invention. Instead, what is to be probed and to some extent even celebrated in the course of this section is a recommitment to the efficacy of the real as a "belief system" among certain self-documenters that has genuine value in terms of generating modes of intimacy, emotion, community, and insight. To put this in another way, what is being pressed for here is a returned emphasis on embodied existence and its messy coterie of emotional baggage and relationships within the "virtual" place of the Internet. Or to say this in yet one more way: the real has returned to the virtual.

At this point, the question is how the places of web-based self-documentation become real. This is naturally a difficult question, capable of generating a multitude of responses and approaches. The one to be favored here is of a more formal or structural manner in the sense of conceptualizing how a given place of self-documentation is functionally constructed in such a way that it appears to be a separate world or reality, and thereby capable of generating its own "aura" of authenticity and existential distinctiveness. My thoughts here are linked to so-called possible-worlds theory, which has its roots in formal semantics but has been adapted to suit the purposes of narratologists, literary theorists, and, more recently, critical investigators of virtual reality. In the first instance, semantic theory utilizes the concept of possible worlds to characterize the manner in which the meaning of a sentence is constituted by the conditions under which that sentence is true. Thus to understand the meaning of a sentence such as "The Sahara Desert is almost completely covered in water due to recent climate changes," it is necessary to imagine or "know" what the world would be like if this sentence were in fact true. A "wet Sahara" becomes a possible but nonactual world that while far-fetched in terms of existing "facts" nevertheless retains its function as an alternative reality. Thus, to know how the world would be if a particular sentence were true does not require the knowledge of whether it is actually true. In the case of my Sahara

example, I do not actually need to know whether or not the Sahara is covered in water. I merely have to know what it would be like if it were covered in water. It is in this sense that it becomes possibly real. To cite a paraphrase of David Lewis:

> The concept of actual world is an indexical notion whose reference varies with the speaker. The "actual world" means the "world where I am located," where all possible worlds are actual from the point of view of their inhabitant. From an absolute point of view, what we call the real world has no privileged status in the modal universe. All possible worlds are equally real, but from a given point of view only one of them is actual. (Ryan, 1992, 2)

The recent work of Marie-Laure Ryan takes possible-worlds theory in a number of fruitful directions. Of primary interest here is her concept of "recentered fictional universes," which theorizes the relationship between actual and possible worlds. Her model, which is composed of three basic elements, is an adaptation of David Lewis's "indexical definition of reality," which conceives the difference between the actual and the possible in two ways: "absolutely, in terms of origin, or relatively, in terms of point of view" (Ryan, 2001, 101). From this basic distinction, Ryan constructs the model shown in figure 1.

The large sphere represents the "hypothetical real world," which exists independently of the human mind and our means of perception. Within this sphere are the representations of various individuals or cultures, which tend to overlap given that they are located within the same physical reality and are thus bound to reflect certain similarities regarding perceptions of reality. Outside of the main sphere are what Ryan terms "nonactual possible worlds," which as the term indicates are representative of worlds that exist only within the realm of possibility. In applying her model to works of fiction, Ryan makes the observation that the same tripartite structure also functions within mimetic texts and thereby creates the "recentered fictional universe" represented in the diagram. "Mimetic texts project not a single world but an entire modal system, or universe, centered around its own actual world" (103). In this respect,

fictional worlds function as "space-travel vehicles" in the sense that "consciousness relocates itself to another world and, taking advantage of the indexical definition of actuality, reorganizes the entire universe of being around this virtual reality" (103).

Figure 1: A Recenterable Possible-Worlds Model (Ryan, 1998, 163)

This reorganization or "recentering" has its application to some elements of self-documentation and, in particular, lends some insight into the nature of its online (that is, virtual) forms. At the most obvious level, it is possible to describe self-documents such as diaries, home movies, and photographs as "recentered universes" on the basis of how they transport the reader or viewer into another world, which is usually the mind or personal life of the self-documenter. In order for this world to be "real," it is important to maintain

connections to the "personal center" of the reader/viewer, which in most cases is the matrix of circumstances, experiences, and beliefs that constitute everyday, normative experience.

A notable example is the web-log of "Salam Pax" titled "Where Is Raed," which has achieved some notoriety for its detailed and often evocative description of daily life in Baghdad.[1] Salam Pax, whose name is obviously a pseudonym given that *salam* and *pax* both mean "peace" (the first in Arabic, the second in Latin), describes himself as a twenty-nine-year-old architect living in Baghdad. Celebrated by many, including those working in the media, as a welcome relief from the one-sided reporting of the mainstream press, Where Is Raed has become a rare moment of "reality" in the information war around the Iraq crisis. Journalist Charles Cooper, writing for CNET, goes even further by linking Salam's efforts to the overall democratic and anti-authoritarian potential of the Internet. "That a 'nobody' like Salam wound up providing a more nuanced view of his world—better than either the authoritarian inanities of the Iraqi information minister or the Geraldo-besotted dispatches of the commercial television networks—testifies both to the specific value of blogging as well as to the broader impact the Internet may yet have around the world" (Cooper).

However, equally central to the debates surrounding the "blog" is the question of whether or not Salam actually exists or if he (or she?) is even in Baghdad. "Other than what he tells us, we have no way of knowing if he's actually posting live from Baghdad or is running some elaborate hoax from the middle of Kansas," writes fellow "blogger" Jason Kottke.[2] CNN reporter Erica Hill expresses similar doubts about Salam's authenticity, and raises an even more fundamental question: "can blogs be trusted?" (Hill, 2003). In an effort to determine the truth, a type of grassroots investigation has been conducted by numerous members of the journaling (and/or blogging) community that range from technical attempts to trace the IP address to more direct methods such as asking Salam to answer a telephone in Baghdad. At the time of writing, the evidence of Salam's authenticity is inconclusive but the dominant position on the part of readers and fellow bloggers appears to be that it is *best to believe* that

Salam is whom he says he is. "In the end, it's still a matter of faith. Yes, I think he's really in Baghdad. And so far, he's still alive and well," writes Paul Boutin, a writer for the *New York Times*, *Wired*, and *Slate*. Similarly, "TJ Hooker" writes in his blog:

> Jordan or Iraq? Real or pen name? Which brings up the "so what?" question. I mean, what's more important about Raed? How "real" it is, or the fact that the reader is forced to imagine what it might be like to be a Raed, living in a city that is about to be bombed? In some respects, even if Raed were "unmasked" (a la Kaycee), the experience of reading the awful things Raed describes...*that* experience is real. There are things about the web that make it both real and unreal. Just like fiction, or history, or life.[3]

TJ's comment regarding how the blog forces the reader "to imagine what it might be like to be a Raed, living in a city that is about to be bombed" echoes Ryan's notion of a text or narrative serving as a "space-travel vehicle" that transports the reader to another world and its concomitant aura of authentic experience. The appeal and benefit of Where Is Raed can be attributed to its ability to offer a possible world of experience that readers, if they choose to believe, can temporarily access and experience *as actual*. In this respect, what is particularly notable about online or virtual forms of self-documentation is their success in functioning as increasingly independent units of meaning and experience that can be partially attributed to the peculiar dynamic between site creators and their "visitors" or users. This dynamic is in marked contrast to the "universes" of predigital forms, such as written diaries or home movies, which are often predicated on what could be termed a "truncated dynamic" between the native reality of the reader/viewer and the possible world of the self-documenter. This is particularly the case for self-documents that are experienced within the context of everyday life, such as family albums or home movies. Such forms of self-documentation are grounded in the native reality of both their creators and their audiences and thus create a very strong link between the mimetic representations and the "reality" of the actual world of the participants. As such, a member of the family takes the pictures or shoots the movie/video, which is then viewed by

members of that family or selected friends or acquaintances. The self-documents belong thus to the same universe of both the subjects and their viewers in the sense of having common geographical, temporal, or experiential contexts. The dynamic between the self-document and its respective creators and viewers is thus potentially truncated or at least surrounded by interpretive contexts that envelope both the production and reception within a type of shared experience that is coexistent with the lived realities of day-to-day family life. To return to Ryan's model, what is notable here is the manner in which the normative uses of non-web-based self-documentation are generally located within the "modal systems" or "universe" of a distinct and limited set of relationships, such as a family or a circle of friends.

The modal system of self-documents and the social units within which they are created are potentially expanded and destabilized when such self-documents are read or viewed by strangers, which tends to occur long after the initial moment of creation. In many cases, such outside access occurs within the contexts of either research or exchange, meaning that the self-documents are generally accessed via the archive or the marketplace. In either case it is arguable that what comes to the fore is the initial appeal of the dirty aura in the sense that the self-documents are made to bear the function of authentic (and often historical) artifacts of past reality. In the case of scholarly access, self-documents such as historical diaries are subjected to sustained scrutiny, with one potential result being that they are identified as inauthentic or fake. For self-documents that end up in the corner antique store, which is sometimes the case with old family albums, such critical probing is uncommon. What matters is often the literal appeal of the dirty aura in the sense of taking home a piece of history or, in some cases, instant ancestors that can be placed on the mantelpiece, next to the "real" photographs of Mom and Dad.

> In a local antiques store, I recently came across a curious, though charming, display of old photographs. The black and white images were carefully arranged on a small wooden table that had been covered with a hard-crafted doily....The pictures showed families who had lived long ago, the women in long dark dresses and shawls, the men in their best suits, children in bows

and buckled shoes, all gazing seriously at the camera. ... A hand-lettered sign next to the display listed prices, and offered a clever marketing slogan to entice potential buyers: 'Instant Ancestors!' it read. (Stokowski, 368)

The modal systems of online forms of self-documentation are, however, dispersed even further and thereby engender "recentered universes" that have a powerful sense of independence and self-replicating power. A good portion of this independence has to do with the fact that the primary mode of interacting with online forms of self-documentation is via virtual interactions that tend to be based on shared interests (or the perception thereof). In this respect, as identified by Barry Wellman "the Internet has continued the trend of technology fostering specialized relationships. Its structure supports a market approach to finding social resources in virtual communities." The existence of thousands of topic-oriented discussion groups, for example, points to "a technologically supported continuation of a long-term shift to communities organized by shared interests rather than by shared place" (Wellman, 336).

It is arguable that this organization around shared interests, however broadly defined, heightens the efficacy of a recentered universe, given the general lack of what could be termed embodied cues. In other words, there are usually no reference points external to the virtual presence represented on the screen to which the viewer or reader has any access. The reference point of the actual, objective reality of the person is assumed and implied, of course. However, one generally does not expect to meet this individual. It is not part of the initial equation. In this sense the reception of an online self-document encourages the construction of an external world that is surprisingly similar to mimetic texts, which, as Ryan has identified, project "an entire modal system or universe, centered around its own actual world" (103). Consider once again the example of Salam Pax. What is engendered by his blog is an actual world—in this case what we believe to be Baghdad—in which the reader, if she or he chooses to believe, can mimetically immerse her- or himself to the extent that Salam and his world become real and thereby project the aura of authentic and embodied existence.

Which brings me to an observation by Victor Burgin: "An identity implies not only a location but a duration, a history. A lost identity is lost not only in space, but in time. We might better say in space-time" (Burgin, 36). Burgin's evocative passage serves as a convenient means to highlight the manner in which web-based forms of self-documentation provide opportunities to foreground the reality of identities represented via the web, which, as discussed earlier, is often described as a technology that is anything but real. In this respect, web-based forms of self-documentation, such as web-cams, can be employed to *affirm* the presence of the fixed and singular identity as opposed to the abstract notions of the genderless and bodiless states of being so often championed in both academic and popular material on cyberspace or digital technology. Such an affirmation resonates with some of the concerns raised by Katherine Hayles, in her book *How We Became Posthuman: Virtual Bodies in Cybernetics, Literature, and Informatics*. Central to her critique is the idea that contemporary Western understandings of the human subject (or individual identity) are based on the notion that "embodiment is not essential to human being." This point can be made clearer by quoting Hayles at length:

> Indeed, one could argue that the erasure of embodiment is a feature common to both the liberal human subject and the cybernetic posthuman. Identified with the rational mind, the liberal subject possessed a body but was not usually represented as being a body. Only because the body is not identified with the self is it possible to claim for the liberal subject its notorious universality, a claim that depends on erasing markers of bodily difference, including sex, race, and ethnicity. (Hayles, 5)

What is striking to about Hayles's discussion of the posthuman subject is that it encapsulates very succinctly what is at stake in the characterization of the Internet and the web as being primarily places without bodies, places where identity is subject to the will or to information rather than in combination with the physical parameters of material conditions—conditions that include those of gender, sex, ethnicity, race, and health. For while such an unfixed, immaterial, and decentered state of being might well be our future, it is, for the

moment, not our present, especially not for those who do not have the benefit of technological access and the mobility made possible by economic stability. So, despite the hype, we are still bodies in space, place, and time—a fact that for the moment still determines the bulk of our individual and collective human destiny. At the same time, however, technologies such as the Internet are altering the equation somewhat and as a result new modes of existence are, at least for some, increasingly within reach. Yet one consequence of such a transitional state between the real and the virtual is a kind of uneasy tension that manifests itself, at the one end, as utopian excess and at the other, as glum paranoia.

Web-based self-documentation can be interpreted as one sign or manifestation of such a tension, such a negotiation between a life determined by material conditions and one in which these conditions no longer matter in the same way. Thus, the effect of such websites as Where Is Raed, the Livingroomcam, the Amandacam, Carlazone, and the thousands of other sites that exist, is to underscore the virtual environment of the World Wide Web with constant and persistent references to the real. In other words, web-based self-documentation has the effect of making the virtual real rather than making the real virtual, thus resisting the claim that virtuality and multiplicity are the only games in town, so to speak. Again, the point here is not to negate the claims that new ways of being are being fostered by new technology, but rather to emphasize that linear and grounded states of being and identity are *also* thriving within the various manifestations of cyberspace. Despite the fact that some domestic web-cams, blogs, or web-journals could be dismissed as self-absorbed ramblings or vain attempts to attain some measure of recognition or fame, I am inclined to cast the phenomenon of web-based self-documentation in a positive light because it indicates the reinsertion of the embodied human and its material ground into the "immaterial" place of the web. In other words, web-based self-documentation is significant because it privileges tropes and paradigms that are drawn more from embodied human experience rather than from abstract technological domains such as those of cybernetics and virtual reality.

Thus, the significance of web-based self-documentation is not that it represents the will to virtuality, as Arthur Kroker might say, but rather the will to will the virtual real. Such a distinction is far from minor, for it stresses the importance of cultivating the web in such a way that it becomes a place of lived, social spaces, realities, times, and identities rather than a fantasy world of commercialized and abstracted illusion.

PART FOUR
Time Place

CHAPTER 13
Posture Four

Time, as noted earlier, is of the essence. Much of contemporary society is subjected to its authority, and increasingly it is the measure of all things, including even money, as another cliché reminds us.

Yet the question "What is time?" is a tricky one. Intuitively we all know the answer, but any attempts to articulate such knowledge are routinely mired within complex abstractions. Is time a social construction? We need only look at the various versions of the calendar that have been constructed throughout human history to respond to that question. Or is time real in the sense of being independent from human actions and influence? A brief look in the mirror will provide a quick, if not terse, reply.

The question of time is central to the phenomenon of self-documentation as a whole. One might even say that self-documentation is all about time for both creators and consumers. A self-document, such as a diary, literally marks the passing of time in accordance with a specific format—daily entries, in this case. Indeed, for serious diary writers, the practice often becomes ritualized, in the sense that a specific time of the day or night is often earmarked as the "special time" in which to write in one's diary. Visual media, such as movie cameras, are equally time based and often function as implicit archives of daily life. As such, the act of taking snapshots or shooting a home movie becomes a deliberate act of accounting for or preserving the course of time, which as Andreas Huyssen identifies is increasingly necessary for contemporary humanity.

> The mnemonic convulsions of our culture seem chaotic, fragmentary, and free-floating. They do not seem to have a clear political or territorial focus, but they do express our society's need for temporal anchoring when in the wake of the information revolution, the relationship between past, present,

and future is being transformed. Temporal anchoring becomes even more important as the territorial and spatial coordinates of our late twentieth-century lives are blurred or even dissolved by increased mobility around the globe. (Huyssen, 7)

For the purposes of this volume, Huyssen's "temporal anchoring" can be extended beyond the period of the IT revolution via a trio of subdivisions, namely still time, future time, and real time. All of these "subanchorings" are based on temporal constructs that provide a mooring for certain experiential and material manifestations of "being in time," and the manner in which that "being" is manifested via an act of self-documentation. The conception of "temporal construct," however, is as problematic as it is useful. On the one hand, it serves as a necessary reminder of the discursive systems that to a large extent fashion or inform what we take to be "real" in the world. Yet on the other, to overemphasize the role of discourse is to ignore the material and experiential phenomena that are not based on language or tropes of representation. As discussed in earlier chapters, one way around this dilemma is to understand the use of "construct" as one that is not confined to human agency and thus includes what Jean François Lyotard terms the "inhuman" or the complex evolutionary forces to which both humanity and technology are contributing but not dominating factors. As such, my designations of still time, future time, and real time can be understood as three prominent temporal "anchors" that have attached to them a flotilla (to continue the nautical theme) of identifiable practices, physical artifacts, and, of course, discourses.

In this chapter, the question of time with respect to various practices of self-documentation will be probed via this trio of temporal anchors. The broad aim is to argue that the various forms of self-documentation engender identifiable and distinct time-space relationships that can be partly attributed to the material and experiential circumstances of the medium itself. The three anchors are intended to function as broad markers of the differences between the primary exemplars of self-documentation pursued throughout this volume—the page, the camera, and the network. Again, I must remind the reader that these categories are not mutually exclusive or

locked into any kind of linear or determinist trajectory. Everything and anything always overlaps and any attempt to create order out of complexity is just that—an attempt to create order. As in the previous chapters, the attempt is motivated by the desire to identify a few prominent trajectories, a few notable lines of flight.

CHAPTER 14
Still Time

For most of us, to imagine a writer is to imagine solitude. The writer writes alone, in silence and with a stillness of body, but not necessarily of spirit. In the case of the written diary, this image is doubled in intensity, for not only does the writer write alone but also in secret and dedicated silent fervor. Readers are cast in a similar role in that they are also engulfed in the stillness that the written word seems to encourage or demand.

Central to such representations of the immobile writer/reader is the role of the individual conscious subject engaged in the task of self-reflection and expression. As has been discussed in previous chapters, the emergence of the individual subject is an integral component of the modern condition, with autobiographical forms of expression serving as primary examples. Of particular interest here is the role of what I am calling still time, which is meant to indicate how temporal conditions are deployed and experienced within self-reflective and interiorized forms of self-documentation. Still time also references the manner in which the endless flow of eternal, premodern time is effectively encapsulated within the perspectives afforded by the modern self-aware and self-made individual. In this case both space and time are "separated from living practice and from each other and so become ready to be theorized as distinct and mutually independent categories of strategy and action" (Bauman, 9). In other words, time can be counted, it can be made into history and thus carried and altered by acts of "human ingenuity, imagination and resourcefulness" (9).

Still time, as associated with the advent of the Enlightenment and the modern era, can also be differentiated by its implied opposite, "moving time," or better yet "nomadic time." The force of

civilization, with modernity being among its vectors, entails the consistent and systematic assault of the settled against the nomadic peoples and their style of life. The "prequantified" and unbounded condition of the nomad, whose identity was stabilized by tradition, myth, and religion, gave way to a quantified and defined life in which identity is determined via allegiances to nationality, ideology, and the willingness (or necessity) to follow the regulatory forces of the market, the bureaucracy, the church and the state. Among the consequences is the cultural imperative of "taking stock," a process of personal accountability and reflection of which self-documentation is but one example.

Autonomy, self-empowerment, and liberation: these are but some of the concepts that define what it means to be enlightened and modern and thus integral to my conception of still time. The modern individual is someone who is said to inhabit the world in a manner significantly different from that of the premodern subject who, as many critics have informed us, was bound to the organic rhythms of tradition, myth, and nature. As Douglas Kellner has succinctly noted, premodern identity was "fixed, solid and stable." Social roles and daily practices were largely defined by a system of myths and religious teachings that served as powerful regulatory forces for both the mind and the body. "One was born and died a member of one's clan, of a fixed kinship system, and of one's tribe or group with one's life trajectory fixed in advance" (Kellner, 231). Such fixity is also noted by Anthony Giddens, who argues that for premodern culture conceptions of time and space were bound together by their strong link to a particular place. "'When' markers were connected not just to the 'where' of social conduct, but to the substance of that conduct itself" (Giddens, 16). Furthermore, the strong role of tradition in most premodern culture means that the past serves as a vital linchpin for all present and future concerns (49). Premodern time is thus eternal time, a time far beyond that of the single individual who was but one minor element among the many inaccessible mysteries of the universe. This is the time of the sunrise and sunset, the time of the harvest, the time of seasons and the unspoken regularity of plants and animals. This is also the time of God, or gods or even demons,

devils, trolls, and goblins—the whole hodgepodge of eternal beings that look down upon and meddle with the state of humanity.

However, despite being both compelling and convincing, it must be acknowledged that such representations of the premodern are more indicative of a resolutely "modern" take on the world than an empirical description of what life was really like "back then." In other words, the premodern is a notion of the modern and thus speaks of sentiments and cultural preferences that are more representative of the modern than of the premodern. Yet, as Michel Foucault has pointed out, such circular sentiments and constructs "matter" in the sense of establishing regimes of knowledge that help construct our contemporary realities (Flynn, 28). In the present context, then, what matters is precisely the artifacts produced under the premise or construct of the time *before* still time, the time of the premodern restlessness that drew no distinctions among the Self, the World, and the Heavens.

To be modern, in contrast, is to become mobile, uprooted, or "liquid," to use Zygmunt Bauman's terminology. It is to replace natural and divine rhythms with those constructed by logic, science, rationalism, and, above all, the machine. Giddens terms it "post-traditional," where the question "how shall I live has to be answered in day-to-day decisions about how to behave, what to wear and what to eat—and many other things—as well as interpreted within the temporal unfolding of self-identity" (14). Identity becomes a far more personal or individual affair and instead of being forged by the demands of tradition, lineage, or caste it is subject to the fickle requirements of industry, fashion, work, and negotiations of class and economic status. For the truly modern individual, there is no authority higher than that brought upon by personal experience and elaboration. Within the modern condition, time has been emptied out and the relationship between time, space, and place has been severed. The "when" and "where" are still connected, but not necessarily through the "mediation of place" (17).

The pursuit of "my time," in which time is framed within the perspectives afforded by the construct of the modern individual, can be witnessed most readily in the context of diary writing.

Contemporary guides to the art of the diary are especially telling in terms of their emphasis on proclaiming the individual as the primary essence, the pinnacle, if you will, from which to view everything and anything. Among the benefits of such a standpoint is a raw form of authenticity that, as Marlene Schiwy affirms in *A Voice of Her Own*, effectively "strips away the layers of social niceties that obscure our true feelings and lays bare the powerful impulse to reveal ourselves as we really are" (30). So revealed, this "real me" experiences and represents the passage of time to the beat of a personal chronometer, a personal series of moments that are regulated by the temporal rhythms of everyday life. Among the most commonly stated goals of the diary-writing experience, at least according to the many "self-help" books that are published on the subject every year, are those of personal growth, development, and self-understanding. Often described as a journey, the practice of diary or journal writing (the terms are used interchangeably) affords one the ability to observe the self as it unfolds. "We hear the mind think," write Christina Baldwin and Susan Boulet, "we observe our own behavior. Consciousness is our life's companion, the company we keep inside ourselves" (7). Similarly, Tristine Rainer describes the diary as an "active, purposeful communication with the self" (16) and as a place to "enjoy and profit from solitude" (18).

Stuart Sherman, in his book *Telling Time: Clocks, Diaries, and the English Diurnal Form, 1660-1785*, explicitly connects the popularization of clocks and watches to the development of regular diary writing. By virtue of the clock's ability to create a "new temporality," in which time was broken down into increasingly small and regular units, Sherman contends, the actual experience of time began to be understood as a series of empty moments in constant need of "filling up." "The particular forms of time proffered by the clocks, watches and memorandum books so new and conspicuous in the period seemed to many serial autobiographers to limn a new temporality... durations that might serve as 'blanks' in which each person might inscribe a sequence of individual actions in an individual style" (18). The practice of regular diary entries ideally suited this "new temporality" in the sense of offering a place in which

to fill in the blanks, so to speak, "to write about time, locate the self within it, inhabit it fully and attentively" (24). Drawing from Raymond Williams's concept of "structures of feeling," Sherman argues further that "the diary, written in solitude, conceiving itself as private, idiosyncratic and even isolating, but abounding in forms and conventions it draws from the culture would seem…to offer an especially responsive instrument for articulating many emergent structures of feeling, but particularly structures of feeling about time" (25–26).

In other words, clocks and watches effectively structure a feeling about time, a feeling that can be represented in part by concepts such as efficiency, precision, punctuality, wasting time, making good use of time, taking time off, and so forth. Time must be used and used well. Furthermore, the experience of time itself becomes acutely personalized in the sense of becoming something that the self needs to literally occupy. Again, the diary serves as a powerful tool with which to achieve such an occupation and the "discipline" required to maintain its boundaries.

> Time Writing
> Choose a set time to write, 5–7 minutes serves well
> Set a timer, watch the clock
> Stop writing when the time is up, even in the middle of a sentence. (Baldwin and Boulet, 22)

The diary writer, as an occupant of still time, takes on the classic pose of the self-aware and self-analyzing subject for whom the dynamics of the past, present, and future become equal with respect to serving as items for contemplation. As a temporal anchor, still time continues to serve an important function in the practice of online diary and journal writing, despite some notable differences that will be discussed below. "My favorite type of entry to read," writes "John," "involves self revelation. Moments in the past are connected to the present and change is discovered."[1] Similarly, "x ribbon" writes about how her diary serves as a means to explore and "experiment" with herself in Teen Open Diary (TOD): "The thought of people I

didn't know reading my diary had some kind of sick appeal to me, and I signed up and wrote my first entry. I like writing, and I like trying to describe feelings in words, which I do find hard, and so I enjoyed using TOD to experiment, write about myself and what I'd been up to, as well as what I thought about things going on in life."[2]

Maurice Blanchot writes the following: "What must the writer remember? Himself: who he is when he isn't writing, when he lives daily life, when he is alive and true, not dying and bereft of truth" (29). What matters is authenticity engendered by the force of the concentrated individual, who through the force of will and intensified consciousness can stop the temporal flow and momentarily render his being into words.

To successfully still time, a degree of control, persistence, and dedication is required. One must be able to concentrate, to exercise the powers of selection and observation. One must be able to say (or better yet write), "Here I am. I am alone and this is what I am thinking. This is my time—my still time."

CHAPTER 15
Future Time

Future time is prime time, the time of the next best thing, the time to greet that which is just around the corner, almost here but not quite. Future time is time in motion, specifically a forward motion that is driven by the tireless rhythms of progress, innovation, and the modernist conceit of change through the powers of originality and individual agency. "The modern world is distinguished from the old by the fact that it opens itself to the future, the epochal new beginning is rendered constant with each moment that gives birth to the new" (Habermas, 6).

The message of the future is common one. We hear it, we have heard it, in fact, every day for years, centuries. It constitutes the discursive heart of modernity itself and fuels the basic dichotomy that keeps the whole thing intact—the distinction between the premodern and the modern and, by extension, the difference between the West and the Other. There are a number of additional dualisms, which resolutely place the likes of tradition, the past, the nomad, the slow against those of revolution, the future, the professional, the settler, the fast, and, of course, progress. That the entire narrative is a construction is obvious enough. But as I have maintained throughout this volume, constructions matter and *are*, in many ways, matter—namely real, physical, and experiential zones in which we, as mortal human beings, spend our lives.

If the Enlightenment and the emergence of what is conceptualized as the modern condition is predicated on possessive individualism and the stilling of time for purposes of self-reflection and definition, then modernity as accelerated by the forces of industrialism put time and the individual into motion. Introspection is accordingly brought out into the open—out into the marketplace and out into the zones of

display, consumption, and spectacle. This is where the camera comes in. As a medium it is ideally suited to the dynamism of future time in that it wastes no time in recording its impressions and converting them into spectacles that are suited for both public and private consumption. It is in this sense that future time "belongs" most ideally to the place of the camera. In the pages to follow, the dynamic of future time will be probed mainly through the lens of the home movie camera and through shifts in the temporal ground of self-documentation. Again, future time is not limited to only camera-based forms of self-documentation and can certainly be identified in other practices such as the written diary. However, for the purposes of articulating the concept, the camera in general and the home movie camera in particular serve as utilitarian exemplars and will thus be the major focal points of this section.

As an anchor, to continue with Huyssen's metaphor, future time takes on a rather paradoxical role with respect to self-documentation, especially in terms of memory. On a literal level, Western culture's obsession with the future is one that routinely deprivileges the past as a form of vital living knowledge and often reduces it to artifacts designed to serve the needs of the immediate present. The modern construction of the museum is a telling case in point. "We must remember that, like the discovery of history itself in its emphatic sense with Voltaire, Vico, and Herder, the museum is a direct effect of modernization rather than somehow standing on its edge or even outside it" (Huyssen, 15). Traditional (premodern) societies do not require museums, given that their notion of the past is contained within the eternal present of myth, religion, and tradition. Modern cultures (and postmodern ones), on the other hand, need what Huyssen terms the "museal gesture," for reasons that are as diverse as they are contradictory.

> If you think of the historicizing restoration of old urban centers, whole museum villages and landscapes, the boom of flea markets, retro fashions, and nostalgia waves, the obsessive self-musealization per video recorder, memoir writing and confessional literature, and if you add to that the electronic totalization of the world on data banks, then the museum can indeed no longer be described as a single institution with stable and well-

drawn boundaries. The museum in this broad amorphous sense has become a key paradigm of contemporary cultural activities. (14)

The "museal gesture" is driven by the logic of future time. For only in a society that is driven by the belief that progress and change are inevitable does it become necessary to institutionalize and commodify nodes of preservation and memory. The past, as such, becomes rearticulated in terms of continuous availability and thereby subjected to the temporal rhythms of progress.

The camera can be described as another form of the "museal gesture" and perhaps even as one of the primary "memory agents" of modernity itself. Among the camera's peculiar attributes is the implied certainty of its representations. Roland Barthes writes of the photograph's uncanny ability to objectively render all that stands before it. "Until this day no representation could assure me of the past of a thing except by intermediaries; but with the Photograph, my certainty is immediate: no one in the world can undeceive me" (115). Such immediate certainty can be attributed to the manner in which the camera "produces a trace rather than an index or symbol," meaning that the camera "does not imitate; it reproduces" (Trachtenberg, 187).

> Their [photographs'] physical peculiarities only heighten the photographic experience, rendering it in a mode which served as an extraordinary initiation for modern culture into one of its fundamentally new conditions: the instant convertibility of experience into image, the potentiality of endless and continuous doubling of all tangible surfaces, and the reification of the eye as the leading instrument of everyday knowledge. (Trachtenberg, 187)

The relationship between the eye and knowledge is a theme cogently explored by Jonathan Crary, who, in his well-known *Techniques of the Observer*, documents the manner in which vision was reconfigured in the nineteenth century by way of changes in the social and technical landscape. For Crary, the nineteenth century heralds the start of "the visual culture of modernity" (96) in which the "persistence of vision" effectively altered not only the nature of visual culture but also

fundamental relationships among the human subject, the body, and social power.

> The break with classical models of vision in the early nineteenth century was far more than simply a shift in the appearance of images and art works, or in systems of representational conventions. Instead, it was inseparable from a massive reorganization of knowledge and social practices that modified in myriad ways the productive, cognitive, and desiring capacities of the human subject. (3)

Time is among such massive reorganizations. As noted above, conceptions and practices of time have changed dramatically over the course of human history, with the nineteenth century and the maturation of modernity having had a particularly resonant impact. Technology is frequently at the epicenter not only in terms of the impact that a particular innovation may (or may not) have, but also in terms of what Lorenzo Simpson identifies as technology's anthropological origins. For Simpson, technology is directly related to human needs and desires that generate technical knowledge, applications, and artifacts that become autonomous and thus capable of altering the course of human nature and history (13). Time is particularly at stake, given that "technology, through its emphasis upon efficiency and control," effects a "domestication of time, a reduction of time to manipulable, dispensable units geared toward future goals" (4). A world so engendered by the technological imperative is a world that is, according to Simpson, an instrumental one where domination and order are the primary engines of social and cultural change and production.

Modern technological time is thus reconfigured as instrumental linear time that, according to Simpson, naturally leads us to the "notion of progress" (53).

> The idea of progress presupposes an understanding of the future as the locus of that which does or can differ in some essential respect from that which now is or which has been. The idea of progress contributes a basic instability to the worldview of modernity, in that it implies that the world is never "settled." This instability or lack of closure is tied to the expectation of

change, and both give rise to an experience or existential understanding of time as linear. (53)

Technology, then, is "essentially oriented toward the future, a future which is understood as an open horizon" (54) that must not only be domesticated, to use Simpson's term, but also filled and accounted for. Paradoxically, however, the future also becomes something to fear, given its proximity to uncertainty and unpredictability. To remedy such a situation, the future must be controlled so that uncertainty, while never nonexistent, is at least preempted via the tools of prediction and risk assessment. In Simpson's formulation, technology allows one to bring the future into the present, thereby domesticating and tempering it via carefully constructed forms of novelty and "newness." In this sense the future time of modernity takes on a curiously regulated quality, at least if one thinks in terms of a generalized definition of control that, according to James R. Beniger, involves a "continual comparison of current states to future goals" (8). The future becomes thus the future that can be accessed now and in accordance with the norms and values of the present. In this respect, future time banishes both the past and what one might call the "real future"—the future that defies prior knowledge and prediction—to the same temporal dustbin that is occupied by history.

The camera would appear to be right on target with respect to Simpson's views. For Scott McGuire, the fact that the camera was developed during the emergence of modern, industrial culture is consistent with general historical directions. In addition to being dependent on industrial culture for its production and distribution, the camera also relies on industrial paradigms for its social conditions of existence. "The camera corresponded perfectly to the demands of a society which found itself in the flux of rapid industrial transformation. It offered a talisman for memory in an era in which the past was under threat and time itself seemed to be accelerating" (124).

It is perhaps then of little surprise that the camera became such a fixture in nineteenth-century households across the economic

spectrum (Berger, 48). McGuire makes a connection between the rapid popularization of photography and what he terms a "looming memory crisis." Drawing from Siegfried Kracauer's notion that "good history demands a balance between the particular and the general," McGuire argues that the camera renders the past too visible in terms of being constantly open for reassessment and reinterpretation. "When historical evidence multiplies exponentially, the line of time no longer coheres. Both the concept of the archive and the model of historical understanding with which it has been associated threaten to decompose" (143). For my part, I attribute a portion of this "decomposition" to the relentless character of future time, which is arguably predicated on constant reassessment and reinterpretation. In order to avoid obsolescence, both the past and present must be framed within a context of a relentless update. A change in direction therefore occurs. Instead of asking "What can the past teach us?" one asks, "Does the past still matter and, more important, will it matter tomorrow?"

As a tool for self-documentation, the camera provides an ideal response to such a question, at least from the bias of future time, which can be conceptually linked to augmentation, extension, and prosthesis. Contained within the logic of future time is the notion that humanity is capable of going beyond itself, of being able to overcome present conditions and constraints via the powers of technology and knowledge. Equally pertinent is a form of agency over the self itself—the power to alter the course of one's identity and future by virtue of sheer willpower and self-directed destiny. Celia Lury employs the phrase "prosthetic culture" to identify how the contemporary subject has become a self-initiated site of experimentation and flexibility, noting that

> The primary capacity of the individual with a flexible body (an about face!) is the ability to be disembodied and then re-embodied at will, that is, to be disembedded from specific social relations, to be deracinated, without gender, class, sexuality or age, and then to display a combination of such natural and social characteristics as required through an assertion of a claim to the significance of their effects: to turn the substitutability of the

customized individual in a postplural society into the individual art of coloring by numbers. (26)

Such flexibility is particularly accelerated in the context of digital technology, which, as will be explored more specifically in the final section, on real time, engenders a peculiar and "appropriate paradox" that defies normative categories of time, place, and identity. In terms of its relevance to the concept of future time, Lury's observation brings to the fore the important notion of how the course of the possessive individual has been altered or enhanced via its relationship to technological infrastructures, in this case the photographic apparatus. Lury, following similar assertions by Don Ihde and Crary, asserts that photography "taught us different ways of seeing," and thus altered the paths and processes of self-understanding and, I might add, self-construction (Lury, 3).

The home movie camera is one such "different way of seeing" that generates a temporal field that is in accordance with the conditions of future time. Among these conditions is the camera's absorption into the realm of leisure culture, which arguably synchronizes it with the temporal rhythms of modern capitalism and the cult of progress. Such synchronization gives rise to a curious mix of often-conflicting obsessions: the desire for mastery and control, the cultivation of the novice expert, and the automation of creativity. This generates a temporal signature of expectation, uncertainty, and anxiety inasmuch as the user is constantly reminded that there are standards to be met, that the results could be better, and that time, above all, is running out and therefore must be properly documented. Last, there is the motion picture camera's ability to fuse the particular with the general in a manner that allows detail to reign supreme, meaning that the past is constantly visible, "open for reassessment and reinterpretation" and thereby constantly held within the grasp of *future* acts of interpretation, analysis, and judgment (McGuire, 143).

Associated primarily with the late 1940s and 1950s, the popularization of home movies coincided with the postwar boom and the maturation of consumer society, although amateur film production was considered a consumer item as early as 1920, with

Bell and Howell and Eastman Kodak leading the industry. For Patricia Zimmermann, amateur film is best seen as a discursive construct and a category of production that has been subjected to a number of historical, ideological, and technological forces since 1897. From the very onset of the industry, a sharp distinction was made between professional and amateur movie production, with the latter associated with cheaper cameras, specific types of film stock (16mm and then later 8mm), and a lack of technical expertise. By the 1950s, home movie production was almost entirely associated with recreation and leisure, which effectively reinforced the notion of two temporal environments—the time of work and the time of leisure. This basic distinction can be seen as being instrumental not only to modern capitalism but also as a reinforcement of the cultural and economic imperatives of future time. Richard Dienst's analysis of television offers some valuable insight. He writes,

> Television, in its fundamental commercial function, socializes time by sending images of quantifiable duration, range, and according to its own cultural coordinates. By generating a realm of collective, shared time, and by setting standards for the valorization of this time, television advances capitalism's temporal rule: everybody is free to spend time in their own way only because, on another level, that time is gathered elsewhere, no longer figured as individual....Television, by delimiting and monopolizing the time of imagination, allows us to offer up our social lives as free contributions to capitalist power. (61–62)

Dienst's observation is useful for the present inquiry in terms of directing attention to the manner in which the experience of time is rendered within the domains of advanced capitalism. As he notes, time is "no longer figured as individual," from which we could extrapolate that time is also no longer figured as belonging primarily to zones defined by tradition, culture, or social collectivity. All time, including the time of individuals and groups, is contained within the temporal trajectories of capitalism, which are oriented toward the future. Home movies figure as prototypical figures of the televisual with respect to Dienst's analysis in terms of how they signal the "monopolizing of the time of imagination." In addition, home movies

are also representative of subjecting domestic time to the time of a machine, which as Zimmermann has identified, is regulated by the codes of professionalism and the filling of "spare time" with consumer goods and services, especially those preferred by the rapidly expanding entertainment industry.

Among the more readily available examples of such "temporal subjugation" are the various marketing campaigns that were run by manufacturers of home movie equipment and supplies. One persistent theme employed by both Kodak and Bell and Howell is the need to guard against the failure of human memory by making the movie camera a constant companion to all meaningful events, encouraging in many cases the cultivation of what could be termed an anxiety of loss. The ad "An American Tradition—Home Movies on Christmas Night" run by Kodak toward the end of World War II, for example, draws from such anxiety by evoking the very real fear that one's son might not make it home for Christmas. The ad pictures four individuals clustered around a movie projector—a woman and her young daughter, a grandmother, and a grandfather. The grandfather is lovingly holding a spool of film, which one would assume contains the image of the notably absent husband of the young woman. The text beneath the main headline, which is presumably spoken by the grandfather, ominously intones, "first, the ones we made when Bob was home on leave." The gaze of the three female figures are directed toward the grandfather and his spool of film, their faces rapt with expectation and, in the case of the young mother, a hint of stoic resignation to the very real possibility of sacrifice in the name of patriotism. Before getting to the technical merits of Kodak equipment, the text of the advertisement reads, "THE EVENING BEGINS, and ends, with the movies they made when their boy was home on leave last Christmas. It's good to have him smiling out at them from the screen...wonderful to reflect, with a lift of the heart, that *perhaps* next Christmas he'll be home again."[1]

In a similar campaign, a Bell and Howell advertisement during the same wartime period also played upon the fallibility of memory and anxiety of losing those "precious moments" to the inevitable accidents of time and fate. "You'll have a grand time Christmas,

won't you? But every day that passes afterward will make the fun harder to remember...unless you capture those precious moments in memory-preserving movies that you can screen again and again whenever you want."[2] What is telling about such marketing campaigns within the context of the present discussion is the characterization of the movie camera as a kind of prosthetic memory. "Life is a movie," proclaims an early Kodak campaign, and "with a movie camera you can keep it all."[3] No longer is "untechnologized" memory sufficient for the rigors of contemporary life, nor can it quite keep up with the cultural practices of acquisition and spectacle that constitute the backbone of consumerism. The experiences of the present must be properly encoded if they are to be accessible and meaningful in the future. To extrapolate from the arguments of Guy Debord, memories must be converted into spectacles if they are to have a meaningful place within contemporary consumer society. "The relation to the commodity is not only visible, but one no longer sees anything but it: the world one sees is its world. Modern economic production extends its dictatorship extensively and intensively" (Debord, 42). The role of the home movie camera in this sense frames (or at least attempts to frame) everyday life within the regime of cinematic representation as sanctioned and discursively rendered by the numerous engines of consumer capitalism. Thus memories must be made into artifacts that lend themselves to future consumption and revisitation.

> FROM THE "GREAT EVENT" that we often experience, to the precious moment a baby comes toddling to meet us...there are endless times to use a movie camera. Endless times when it saves us a living record that we won't want to be without. That is why more than one million men and women are now making movies. Filming them—seeing them—showing them—is a year-round hobby too fine to miss.[4]

The second point of interest in this section is with regard to the ability to master the technical demands of the medium itself in a manner that allows the user to gain control not only over the technology but also over the temporal and spatial dynamics of the people or events that are about to be captured on film. Opportunities,

let alone film, should not be "wasted," implying the need for vigilance and discretion while filming. In this respect, many ads and advice books emphasize a backdrop of professionalism behind their projects in the sense of providing consumers with an infrastructure of technical competence from which they can draw in order to make the best use out of the technology. An ad for the Filmo, manufactured by Bell and Howell, stresses that its cameras are "built by the makers of Hollywood's preferred studio equipment to give *professional results with amateur ease*."[5] After "you have mastered the easy fundamentals" you can "rejoice in having a camera that imposes no restrictions upon your ever increasing ability." Another Bell and Howell ad employs the endorsement of a "famous Hollywood Producer and Director" to reassure its customers that "Filmos are so easy to use that even beginners can get superior results, right from the first."[6] While also congruent with the culture of professionalization that Zimmermann discusses in her research on home movies, the continued emphasis on ease of use, efficiency, control, superior results, good technique, quality, and entertainment value all point to what I would define as the anxiety of expectation. In other words, is the present good enough to film? Is what I am filming *now* worth keeping for *tomorrow*? Are my techniques of an acceptable enough standard to ensure the value of my film for future generations? In order to respond affirmatively to such questions, one must be able to keep up to date, to keep informed of the latest development, and to maintain existing equipment within acceptable parameters. Purchase the Cine-Kodak K-100, for instance, and you can make the "kind of travel movies that people usually *pay* to see."[7] The Cine-Kodak Magazine 8, on the other hand, is "so wonderfully easy" that even the most unprepared beginner (as implied by the young woman pictured in the advertisement) can record the magic of everyday life with ease and certainty.[8] The Kodak Signet 80, which is actually a still camera, goes one step further by having "the skill built in," which might explain why the ad has no humans in it at all.[9] Only the camera, with its built-in expertise, remains. That is all that is necessary.

Yet properly equipped with both camera and knowledge (or better yet a camera that has the knowledge "built in"), one can

breathe a sigh of relief and get down to the business of capturing the "precious moments" of the present for anticipated future moments of revisitation and remembering. History, in this case personal history, can be made continuous and engender what Foucault describes as "the certainty that time will disperse nothing without restoring it in a reconstituted unity" (Foucault, 1972, 12). Should we falter in our confidence, the ads are always there to remind us that unblemished preservation is indeed possible, that the past can be maintained indefinitely for the future. "Old friends—and new friends, too—you're together whenever you wish. Movies capture all the reality of life itself."[10]

The ability to revisit the past in the future via the images provided by the movie screen is a peculiar thing. For one, it breeds a certain type of obsessive concern for the detail that, if taken to its logical extreme, destabilizes memory and history by virtue of their being constantly submitted to reinterpretation and reevaluation. Part of this has to do with what Barthes describes as "infra-knowledge," which identifies the manner in which the camera can document historical details at a much higher "resolution" than could previous modes of documentation, such as writing or painting (30). We can literally see how people wore their hair in the 1920s or see "for ourselves" the construction process of the Eiffel Tower, or, closer to home, the expressions of our parents when that first birthday cake was brought to the table. Such level of detail and the ability to revisit that detail has no historical precedent, especially if one considers issues of availability (Sontag, 165).

The detail, as such, "refuses to lie down" (McGuire, 143). It refuses in other words, to let the past remain as told but rather infuses the historical record with a "narrative fecundity" that consistently qualifies the past (and thus the present as well) by virtue of interpretations that are *to come*. "Under pressure of photographic scrutiny, the past remains all too visible, open for reassessment and reinterpretation" (McGuire, 143). The camera, especially the movie camera, encourages a "cultural preoccupation with the 'decisive moment'" (144). McGuire's particular example in this case is the infamous Zapruder film, which through unparalleled scrutiny and

reviewing has turned the historical event of the Kennedy assassination into a continuous narrative of conspiracy, rumor, and speculation. The details, as such, refuse to stabilize, refuse the impulse of generalization of which the narratives of history are actually composed. The story is never complete, never finished, never "generalizable." Its time of definitive interpretation, definitive meaning, is always in the future, always about to be revealed, thanks to the sharp eyes that will eventually notice that which has been previously unnoticed, either by design or by fault.

In the case of the lowly home movie, the kind that features babies instead of dead presidents, such claims of destabilized history might seem a bit overblown. Yet personal histories are as much a part of history as anything else and, as the exemplars of Anne Frank and Rodney King have demonstrated, historical significance can crop up at any moment. A distinction needs to be made here, I think, between the act of creating a home movie and the act of watching one. The former is a literal encapsulation of time (a time capsule) and thus a potential future artifact. Yet the latter could be seen as literally making the past present, a form of replication and simulation that is contained within the cloak of objectivity and reality. What we are seeing right now is the past as it really was. Furthermore, this past can be transmitted; it can be continuously replayed in an endless filmic loop. Thus the past is always with us as we move consistently into the future. Introspection thus gives way to "extrospection"—the continual look outward that renders each perceived moment anew.

Part of the significance of what I am terming future time is that it identifies a type of "temporal posture" that, in the case of self-documentation, renders the personal archive into a literal memory machine that receives its energy from the implied objectivity and timelessness of the audiovisual detail. The detail never goes away. The detail is not an impression, which means that its interpretation can always start afresh. Such is the implication of the cliché "a picture is worth a thousand words." I would venture that this is a rather conservative estimate. A picture contains words into infinity. A picture invites the reinvention of words. A picture can always be something else in the future, which means that the filmed self-

document—the home movie—is less a window into the past than an extension of the past into the future. The past, as such, becomes a prosthetic, a continuation, an elongation of a lived moment into the ever-forward motion of future time.

Of course future time is not a distinction exclusive to the camera, nor is future time a pure state in and of itself. Other temporal postures and technologies coexist with that of future time. As already stated, my aim here is not to construct definitive categories but rather to identify tendencies that flow between the various media and practices of self-documentation. Such a process of identification lends itself to the artifice of categorization and the illusive consistency of the well-crafted term.

At this juncture, however, a word of caution and restraint is in order. The above observations run the danger of representing the activity of home movies as empty gestures of consumption or mechanical automation that are devoid of personal meaning or relevance. Nothing could be further from the truth. As forms of self-documentation, home movies, like diaries, function as important emotional and cultural artifacts that while potentially less introspective and "spontaneous" than diaries nevertheless represent the individuals and families that have created them. In a review of Zimmermann's book, Janine Marchessault comments that home movies "cannot be reduced to discourse" by virtue of the fact that they "belong to people—just like memories." As such, their production and reception is a complicated process that involves not only the dynamics of individuals and their families but also the larger contexts of cultural and economic capital (Marchessault, 423). Such complexity needs to be acknowledged and, accordingly, left to its own accord. That said, however, it is possible to identify relatively stable or consistent temporal postures that function within technological environments, such as those predicated by various forms of self-documentation. Crary notes that "spectacle is not primarily concerned with a looking at images but rather with the construction of conditions that individuate, immobilize, and separate subjects, even within a world in which mobility and circulation are ubiquitous" (Crary, 2001, 74). The emphasis is then on the particular

strategies of the individual with respect to, in this case, the temporal conditions of self-documentation.

CHAPTER 16
Real Time

There is something odd about the term *real time*. For one, it implies its opposite, namely unreal time, or fake, inauthentic time. This raises an inevitable question. What would unreal time be like? What are its major properties and how would one be able to recognize it? Furthermore, does unreal time have any ill effects? Is it dangerous? Can it lead one in the wrong direction, such as toward vice, recklessness, or delusion?

The formal definition of real time acknowledges few of such concerns. "Real time: time in which the occurrence of an event and the reporting or recording of it are almost simultaneous" (*Webster's New World Dictionary*, 3rd college ed., s.v. "real time.")

In the context of media and communications, real time is often used to designate the condition of simultaneity between an event and its transmission. The early days of radio heralded the arrival of real-time media with such events as Herb Morrison's live coverage of the Hindenburg tragedy or Orson Wells's "War of the Worlds" serving as markers of simultaneity's power and basic appeal.

Real time, the time of immediacy, signifies a preoccupation with the "now," and, as such, is often directly associated with the concept and practice of telepresence, with the television being, of course, the primary conduit for real time. "To switch on the TV," writes Scott McGuire, "is to plug the self into an optical-electronic field of immediacy, a zone of accelerated perceptions generating the aura of instant availability so crucial in defining the world today" (251). This is as much a recognized academic observation as it is a familiar day-to-day experience (Sconce). We all turn on the TV to find out what is going on, since television is literally plugged into the present. That this present is constructed, framed, edited, curtailed, restricted,

embellished, falsified, or fed to us through the likes of "embedded journalists" fails to take away from the magic of immediacy that television still seems to be able to supply. The inevitable question thus arises: Why do we believe? Because, like Fox Mulder, we want to? Or because we can't help ourselves given that resistance is futile. Television is an all-occupying force that is temporally, materially, and discursively enveloping. It takes up our time, fills our home, and provides us with things to say and think about (Kellner).

Curiously (or perhaps not), the conceptual potpourri represented by the likes of real time, immediacy, postmodernism, and the network are often employed to indicate a rather profound *lack* of substance and reality. Real time, like MTV's *Real World*, is not quite the Real Thing. That distinction belongs to Coca-Cola, which along with other bastions of our postmodern culture actually create the realities that we occupy on a day-to-day basis. In his characterization of the shopping mall as a "temple of consumption," Zygmunt Bauman notes, via Foucault, how the contemporary shopping experience "is a floating piece of space, a place without a place, that exists by itself, that is closed in on itself and at the same time is given over to the infinity of the sea" (Bauman, 99). In other words, it is nothing and everything at the same time. The Gulf War didn't take place either, or at least the TV version didn't (Virilio, 1995).

Yet here's the rub. Real time is real and the Gulf War did take place and the twin towers did fall (only once in New York but several thousand times on TV). Which brings us to a bit of an impasse. The real time offered through telepresent media such as television manages to both deliver and renege on its promise to connect us to pure immediacy. On the one hand we are plugged in, yet on the other we are completely disconnected.

> This is the crux of our ambivalence to the screen. As much as television watching is experience as pleasure, keeping us in touch, up to date and informed, distilling the particular and the transient with uncanny clarity and endless fascination, its other visage is boredom: the sensation that time has ceased, the world is absent, the chattering, smiling faces are masks, the viewer is alone, adrift in a lost zone which belongs only to television. (McGuire, 257)

Which brings us to the Internet.

For the various practices of self-documentation, the incorporation of real time into the temporal horizon has had a significant impact on the total experience for both creators and observers. The World Wide Web and the increasing availability of high-speed networks have been particularly significant in terms of engendering forms of self-documentation that directly negotiate with the "reality" of real time. Web-cams are perhaps the most notorious of such phenomena, especially in terms of fostering debates around themes of voyeurism, self-degradation, and exploitation (Calvert).

With respect to the nature of temporal experience, web-based forms of self-documentation raise a number of important questions regarding the impact of technology and material practice.[1] Among them is the manner in which the web reframes self-documentation within a context of *continuous* dialogue and exchange, at least potentially. The emphasis on continuity is important here in terms of how it privileges real time as the temporal space within which self-expression and the reception thereof occurs. If compared to previous media places, such as the written diary, the photograph, or the home movie, what becomes clear is the manner in which there is a relatively clear separation between the time of inscription and the time of reception. Such separation creates a type of temporal barrier between content creators and their audiences. In other words, first there is composition and production and then later, sometimes much later if at all, there is distribution, reception, and commentary. One need only think of generic situations such as the discovery of an old diary at the back of an antique desk or viewing home movies after the death of a parent or even picking up a set of photographs from the developers. In all such cases there is a significant temporal and material distance between the producers and receivers of self-documents. It is my contention that such a distance matters.

To explore the significance of this distance, consider the following, if rather banal, example, supplied by "Rick," who is part of the diary community diaryland.com.

2002-04-15—12:18pm. Don't tell my boss. I'm writing from work. He'll be back soon. Bye bye.

2002-04-24—08:35 pm. I'm tired. Someone wake me up. Please.[2]

What is notable here is that the experience, despite its declared banality, becomes performative and oriented in the continuous present for which there is always a potential audience.[3] Such continuity or immediacy indicates what could be termed a complexification of the act and experience of self-documentation. One key element is the inclusion and attachment to an overall communication infrastructure, which by its very nature is grounded in an interactive present that is beyond summary or description given its constant real-time growth and expansion. Among the consequences, at least in the case of web-diaries, are discursive constructions that are dialogical in the extreme. In other words, dialogue, or more accurately "multilogue," is the preferred mode of discourse. Web diarists write for themselves and for others who also write for themselves and others, often forming web-rings that encourage and enable nearly constant interchange and interaction. Such a discursive environment clearly privileges the present as the mode within which material is created and exchanged. In this sense the crucial act becomes that of "putting it online," as "Paulineee" states below, or more precisely, the act of injecting one's self into the real-time matrix of the web and its *potential* (and not necessarily actuality) for instant readership. "The journal has gotten me through so much in the past 3 years. I don't know what I did before. Ranted to friends I suppose...and broke out in a rash, stuff like that. When I need to I go to various stages of anonymous, and even though nobody might ever find it, it helps to have it up there. Putting it online is part of the process, not just the writing."[4]

The experience of real time, as constructed by normative web practice, also creates what could be called an anticipatory temporal climate in which constant readiness, connection, and availability become the key organizational and motivational paradigms. As a result, one must not only be connected at all times, but also capable of immediate discursive or expressive response. Web-diaries thus

become conduits for a kind of globalized immediacy in which the thoughts of individual writers are "channeled" by way of current events, suggested topics, and the discursive tide of particular web communities or web-rings. This is not to imply, however, that topics are limited as a result or that web diarists are compelled to structure their content according to externalized structures or standards. The influence is much less direct, which is why I prefer the term *anticipation*. Anticipation expresses a kind of "plane of organization or development," to make use of Gilles Deleuze and Felix Guattari once again, which "concerns the development of forms and the formation of subjects" (Deleuze and Guattari, 265). "The development or organizational principles does not appear in itself, in a direct relation with that which develops or is organized....Forms and their developments, and subjects and their formations, relate to a plan(e) that operates as a transcendent unity of hidden principle. The plan(e) can always be described, but as a part aside, as ungiven in that to which it gives rise" (266). Similarly, temporal anticipation, as I term it, functions as a kind of "hidden principle," whose lurking presence can only be inferred from the "forms it develops and the subjects it forms, since it is for these forms and these subjects" (266).

The diary discussion list Journal-L is a telling case in point. Described as a discussion list for "journallers to talk about journaling," Journal-L is an administered list whose content is shaped by the moderator Al Schroeder.[5] Every day, Schroeder attempts to initiate discussions via a few direct questions, such as:

> Do you have any comments from your readers, why they read you? (February 13, 2003)
>
> How did you pick the title for your journal? (February 19, 2003)
>
> We all have targets we can't resist. What do you like to mock...and have you ever regretted doing so? (February 18, 2003)
>
> What is your biggest fault as a journaller? What do you wish you could do better? (September 16, 2002)
>
> What, in your life, do you most need escape from? Work? A relationship? Responsibility for children? (April 26, 2002)

The various members of the list respond, either directly or via tangents that may or may not be related to the initial question. What is notable about Journal-L is that most, if not all, of the active members have their own online diaries, which, judging from the exchanges on the list, are also read by the list members. As is often the case, both the questions and diary entries are influenced by current events, and in some cases by experiences of individual list members. In and of itself, this is hardly remarkable, as nonweb diaries are equally related to the topics of their times. However, what is different in the case of web-diaries is the intensity of the interconnection and the synergies thereby created among list members. Everyone is literally plugged in, not only to other members of the list but also to the "structuring plane" of the web itself, which functions as the precondition for the entire array of activities. It thus becomes necessary to adopt a posture of anticipation, of readiness and heightened awareness. For without this posture, this positioning in time and space, the act of self-documentation (in this case online diary writing) would become too internalized, static, and unresponsive, at least by the standards of a fully connected sensibility. The website aplaceforpeace.com, created by Journal-L member "Katherine," offers a particularly striking example. Intended as a parallel site to her online journal, aplaceforpeace.com is both a highly personalized representation of the thoughts and impressions of a young woman and her struggle with the aftermath of sexual assault and a connection point for others, both male and female, who may have experienced similar trauma.

> Welcome to my small corner of cyber space! I originally began this site as a way to reach out to sexual assault survivors and their loved ones. To offer them support and hope of healing. It's grown however, into a virtual reality extension of myself. I've included pages on my spiritual path of Paganism and Dianic Witchcraft, as well as writings on my thoughts about several issues such as how sexual assault and rape survivors are treated in our society, and about how we each need to be free to find our own spiritual path....The site changes as quickly as I do. As I'm always changing, evolving, and growing as a person, so do the pages found here. I hope that you find something that interests you. As with all other webmaster/mistresses, I like to know what others think of my thoughts and

of my site. So feedback is always welcome. Feel free to drop me an Email, I'll respond.

Or...sign my Guest Book! I just today (March 24, 2000) finally added a Guest Book to my site for you to talk about your experiences, vent about something, or just tell me what you think of my site or to say hello![6]

On an arguably more frivolous but equally significant level are sites that draw their energy from the combined appeal of voyeurism, exhibitionism, and performance, such as the now defunct weliveinpublic.com, which was a particularly elaborate attempt to connect a private home to the real-time matrix of the web.

The level of self-imposed surveillance rivals that of the kind employed in the television series *Big Brother* in the sense of leaving no corner of the stylish Soho loft undocumented, including the *inside* of the toilet bowl. In addition to thirty-two web-cams, some of which were programmed to follow any movement in a room, the site incorporated phone taps, full audio, diaries, archives (image and text), and a "schedule" of important events such as parties or daily routines. Described as an "experiment" by the creators, Josh Harris and Tanya Corrin, the site's stated goal was to archive "daily life at the dawn of a new era of man." "Similar to the television show Big Brother, Tanya and I have placed cameras, microphones and phone taps all over our loft in order to capture the detailed moments of daily life. You can watch us fight, make love, eat meals and use the bathroom as well as see how our many guests react with this modern living style."[7] It is unclear what this "new era" constitutes, or for that matter whether in the case of Josh and Tanya it can fulfill its implied utopian prospects. To live within real time at a constant level requires a total commitment to connection and availability that potentially sacrifices or at least challenges normative ideas of self-control, agency, and privacy.

"I believed but believe no more," writes Tanya in her diary, "that living in public is fundamentally a good thing....Maybe it is in small doses, but somehow I crossed the line and can't go back. Now I'm a rumpled mess of bathrobe crouching in the dark. I am a sacrifice. No, no one sacrificed me. I put my name on the paper. They let me go. I went. I'm gone."[8] As Tanya's diary within weliveinpublic.com also

documents, the strain of actually living in public took its toll psychologically and on the relationship between the couple, who in short order split up. Corrin herself reported on the breakup in the *New York Observer* (Corrin, 15). It is, of course, such discord and revelations of high emotions that provide so-called reality-cams or reality TV with its dramatic (and narrative) power. On television and by extension on the web as well, "the private sphere of intimate relations, personal problems, illicit and illegal acts, embarrassing behavior, and confidential activities remain magically open to the viewer" (Abelman, 97). It is this magic that keeps us watching. It is also this same magic—the magic of potentially continuous connection—that makes the experience of Internet-based communication so seductive and meaningful, as characterized evocatively by Tanya once again:

> So what's next? Catch a plane to the next big thing? Wherever I run to, there is always the "World Wide Web." It's full of beautiful people, don't you know. Used to be full of strangers. Now it's full of friends.
> Connection is only a chatroom away. Love is right around the corner. It's hard to imagine but I believe it is true.[9]

To return to an earlier point, this magic could be also described as the magic of anticipation that real time is so capable of conjuring. By virtue of the connection, anything could happen—nudity, sex, trauma, breakdowns, honesty, intimacy, whatever (and wherever). Often this anticipation is without expectation, at least in terms of outcome. The only expectation is that of potential events, of possible happenings and interruptions of the routine, the banal. One could also attribute the appeal of anticipation to what Espen Aarseth identifies as the ergodic experience of navigating hypertextual space. Aarseth defines *ergodic* as the "non-trivial effort" that is "required to allow the reader to traverse a text" (Aarseth, 1). Marie Laure Ryan develops Aarseth's concept more specifically by breaking the ergodic into eight categories, one of which is "electronic, ergodic, interactive texts" (Ryan, 2001, 210). This is the category that the web as a whole belongs to due to its ability to transform itself by virtue of reader input. Anticipation can thus be attributed in part to the ergodic

nature of the web in terms of making the "non-trivial effort" a primary component of the entire experience. A form of restlessness is thereby engendered, driven by the pursuit of pure anticipation.

Such deliberate and well-structured connections between the internal world of personal experience and a defined but potentially limitless community or network requires not only the ability to attain a balance between the private and the public but also what I am calling a posture of anticipation and readiness. In other words, a portion of the meaning, relevance, and significance of sites such as aplaceforpeace.com or weliveinpublic.com rests in the ability and interest in maintaining an active link with actual and potential readers via a complex interplay of personal reflection, unstructured dialogue, and the identification of and active interaction with an interest group. Added to that is the logic of the web paradigm itself, which is predicated on the condition of linking or surfing, which as Brian Massumi notes is an activity that maintains a curious balance between engagement and boredom. "Given the meagerness of the constituent links on the level of formal inventiveness or uniqueness of content, what makes surfing the Web compelling can only be attributed to an accumulation of effect, or transductive momentum, continuing across the linkages" (Massumi, *Parables*, 2002, 141).

Identifying this accumulation of effect as "potentialization," Massumi further characterizes surfing as a "felt moreness to ongoing experience," which implies, among other things, a programmatic form of restlessness or flow in which a current encounter is constantly mediated by the expectation, however undefined and submerged, that something "more" is just one click away. The necessary mindset, if one could call it that, is an anticipatory one in the sense that users must be continuously open to the potential of the unexpected, the meaningful, and the interesting while negotiating with the medium itself. In other words, it is the "click" that matters, for the click is potential and, to a large degree, the medium itself. As such one must be prepared to click. One must anticipate the click.

Self-documentation's immersion and realization in the real time of the web also engenders a reframing of archival space and its role as a "piece" of history, an artifact of experience and expression. What is

significant here is the manner in which online diaries and web-cams are affected by the conditions of constant availability and interconnection in a manner that corresponds in part to the fate of the literary text under the conditions of hypertext technology. As theorists of hypermedia have noted for a number of years now, hypertext destabilizes the rigidity of linear print media and, by extension, the normative forms of visual narrative media such as film and television (Bolter, 2001). Among the consequences is the displacement of hypermedia's authority, at least in terms of being formed by a singular authorial voice. Equally significant is the manner in which the content is said to exist within a dynamic state that can potentially be constantly influenced and transformed by author/reader/viewer input. Hypermedia thus become living texts that, to follow the visions of hypermedia pioneer Theodor Nelson, can potentially represent "the true content and structure of human thought" (326). Media and mind, in this sense, become one.

Such factors yield some interesting observations in the case of online forms of self-documentation. In particular, web-cams embrace the ethos of hypermedia by way of their persistent dynamism. Web-cams are always "on," always connected, and thus representative of the evolving present rather than the static past. This is in marked contrast to home movies, whether film or video, which are generally conceived of as stable documents of the past. Indeed, home movies and snapshots very often induce nostalgia or become sites for reconstructing and revisiting the past. Richard Chalfen has noted how many individuals perceive home movies, videos, snapshots, and family albums as the deliberate creation of "memory banks." "This metaphor is quite telling—a bank is locked up, it prevents loss, it preserves value, and in a sense it disallows change" (Chalfen, 1998, 162).

The transient and ever-changing nature of web-cam documentation is in contrast to normative conventions of memory banks, which privilege a certain measure of stability, at least in terms of regular increases in the sheer *volume* of content. Of course, many sites do offer selected archives of web-cam footage, some of which are selected by dedicated viewers and highlighted or assigned "awards,"

as in the case of camcentral.com. Yet one does not visit a web-cam site, nor construct one for that matter, in order to view the past. As forms of self-documentation, web-cams exist for the purpose of documenting the "real time" of the present.

Web-diaries, as the other major form of web-based self-documentation, however, do not have such a straightforward relationship to real time. As noted above, web-diaries bear many similarities to their nondigital predecessors, including that of serving as stable archives of personal and familial life. The instance of consuming web-diaries, however, appears to have a greater connection to the temporal space of real time, especially with respect to the construction of communities and web-rings. Again, as discussed above, web-diaries function as vehicles for interpersonal interaction, support, and community building in the sense of providing a means for people to share their personal lives with other, like-minded individuals. The act of reading other people's diaries, especially in the case of strangers as opposed to family members or close friends, is arguably akin to a generalized ergodic function of pursuing content and experience. Again, it is real time that matters here because it is the continuous activity of exploration and discovery that engenders the web with meaning and significance.

Recent technological developments and their accompanying marketing campaigns cultivate the expectation that all media should be in a symbiotic relationship with the real world of lived time. Consider, for example, the combinatory nature of the current generation of digital technology that allows the cell phone, the desktop computer, the television, the Palm Pilot, the automobile, the refrigerator, and any number of devices to be in a constant state of connected readiness.[10] Everything is connected, everything communicates in a present that is increasingly localized. Such is the state of the "Network Society," as Manuel Castells has termed it, where a new technological paradigm is at work.

> New information technologies by transforming the processes of information processing act upon all domains of human activity, and make it possible to establish endless connections between different domains, as well as between elements and agents of such activities. A networked, deeply interdependent

economy emerges that becomes increasingly able to apply its progress in technology, knowledge, and management to technology, knowledge, and management themselves. (Castells, "Materials," 2001, 78)

The communities of web diarists and other contemporary self-documenters are arguably participants in such deep networking and thus draw from many of the same impulses and material/cultural infrastructures that drive the ambitions of the largest firms and the most celebratory enthusiasts of the global network economy. The question of time is, of course, of central importance and, as in the previous eras of capitalism, has undergone significant revision under the aegis of the network. Castells, once again, employs the phrase "timeless time" to describe the manner in which the network society radically alters the experience of temporality in a manner that creates a form of "undifferentiated time, which is tantamount to eternity" (Castells, 2000, *Network Society*, 494). Thus all is subjugated to the *premise* of the constantly connected present—a present with which all past and future nodes inevitably connect.[11] In this respect the temporal attitude is not driven by a linear conception of the future or progress. Rather, innovation and change merely "appears" as a new node or link to be accessed or followed. Instead of any kind of destiny-driven pursuit, one instead follows the flow, linking as one goes.

Under the ethos of constant connection, web-based forms of self-documentation generally contribute to the strength of the network paradigm and its infusion into everyday social and cultural practice. Parallels can be made here to earlier observations regarding the influence of Hollywood production models and the paradigms of professionalism on home movie practice. It is arguable that like the home moviemakers of the 1940s and 1950s, contemporary web-cammers and online diarists are similarly influenced by the economic imperatives of the technological and entertainment industries. In making such a statement, however, it is important to keep in mind that the nature of this influence is often indirect and difficult to plot on any kind of definitive trajectory. More appropriate is to consider once again Deleuze and Guattari's notion of "planes of development and production," which as stated above refers to a "hidden principle"

behind which and through which "forms and subjects" are developed and practiced.

Keeping to the present theme of "real time," what then are some of the identifiable practices and tendencies of web-based forms of self-documentation that point toward the "hidden principle" of the network as an organizing force? Perhaps the most obvious is that of constant availability, especially in terms of reception. The simple act of posting a diary or web-camera stream on the web makes it universally available on a constant 24/7 basis. Access is no longer restricted to a singular physical location, such as in the case of a written diary or even the viewing of a home movie. The time of access or reception thus becomes "timeless" in Castells's meaning of the term, and furthermore "placeless" in the sense of no longer being contained within a particular material environment or context (Auge). In other words, a web-diary can be read by anyone at anytime, anywhere, and on an increasingly diverse array of devices such as desktop computers, laptops, mobile phones, and communication devices such as the much-touted "third-generation" technology.[12] The market is naturally only too willing to accommodate the material and infrastructural demands of such timeless availability, as is evidenced by specific marketing campaigns and the discursive environments of the web itself. The advertising campaign for the aforementioned "3G" mobile phone technology in Sweden offers a strangely evocative example. In both print and television ads, the campaign features individuals expressing or being in situations that demand one to express certain primal emotions—anger, fear, love, sadness. There is little in terms of a direct sales pitch, nor are any forms of technology actually featured. Instead there is the simple and vital message of connection—a connection between people for the most basic and most human reasons. One television ad, for example, depicts a mother and her teenage daughter sitting across from one another in a stylish restaurant. By way of expressions and body language the viewer is made to understand that the two have had an argument and that the daughter refuses to speak to her mother. The mother looks intently at her daughter, who tries her best to avert her gaze. Gradually a small smile emerges on

her lips, signaling that the argument is on its way to being resolved. At that point, the company slogan appears: "I see you, I feel you, I three you." Despite the total absence of any 3G telephone, the message is clear. It was 3G that brought the two together.[13]

Equally pervasive and far less poetic than the "3G culture" is what one might term a surveillance-entertainment culture, in the sense that the distinctions among surveillance (for purposes of security and control), individual expression, and entertainment have been rendered rather fuzzy, to say the least. Again, market forces have been quick to capitalize on such developments, with the ever-increasing portfolio of reality TV serving as a primary and perhaps increasingly irritating example.[14]

The surveillance-entertainment culture creates a temporal environment that collapses immediacy into saleable content that knows no limits other than those imposed by market demand. Thus everything is potentially timely and thereby marketable, however brief the appeal or profitability may be. In the case of noncommercial forms of self-documentation, such "timeliness" is evident in the perceivable sense of anxiety regarding relevance, audience awareness, control of site access and linking, the economy of recognition identified above, the ability to keep up with web community trends, and technical and design literacy. Web self-documenters create their projects within a developmental plane that is deeply and subtly informed by the flows and ebbs of network capitalism and the surveillance-entertainment complex. A repertoire of anxiety is thus spawned, including: the anxiety of connectedness, the anxiety of obscurity, and the anxiety of oblivion. Consider Castells's observation that "being disconnected, or superficially connected, to the Internet is tantamount to marginalization in the global, networked system" (Castells, 2001, 269). The primary threat of the networked citizen is thus disconnection and the irrelevance and powerlessness that automatically accompany it.

The real time of the network is of course a paradoxical misnomer in that it casts the distinction between the real and the unreal or virtual into a tumult of irresolvable contradictions and apparent affirmations. As must be acknowledged, "the real" was a

questionable construction long before the arrival of the computer and the Internet and is indeed a mainstay of philosophical and critical discourse. But that is another set of arguments altogether. For now, as a means to conclude this chapter, I would like to suggest that the real time of the network, especially as evidenced by self-documentation, is a time of the in-between, a "third time" that creates a type of material continuity in which the distinctions between the real and the unreal matter less than those of connection and disconnection. This third time—let's call it network time—mitigates a set of temporal conditions that are both familiar in terms of the responses that it appears to elicit and yet unlike anything that human beings have experienced before. The emerging practices and patterns within the worlds of online self-documentation offer some insight into the way in which individual subjects—that is, people like you and me—are negotiating and expressing themselves in a material and dare I say "real" way.

EPILOGUE
Last Place

Imagine that it is a decade later and that you are on the subway again. As usual you have forgotten to bring along any reading material and the batteries on your personal digital assistant (PDA) are too low on power to make connecting to the web much of an option. The holographic advertisements that buzz near the top of the subway car are no more enlightening than they were in the days of simple print advertisements, although an ad for disposable prosthetics catches your eye for a moment. Time passes at a rate much slower than the stations zipping past the window and again, with a sigh of boredom you scan the empty seats around you. What you find surprises you. It is a fifth-generation PDA with integrated video and audio recording and production capabilities. Naturally you pick it up. It has already been switched on, meaning that the password has been entered and that the contents are available to you without restriction. You make the instinctual and cursory glances to ensure that no one has seen you and then you plunge in. How can you resist? This is much better than the diary you encountered years ago. It contains nearly everything that represents the identity of an individual—journal entries, daily schedules, archives of family photographs and videos, shopping lists, web links, notes, work records, birthday greetings, insurance policies, identification protocols, a driver's license, a marriage certificate, live video links to the family home, the summer cottage, the daycare center, traffic tickets, MP3s, Christmas lists, future plans, doctor appointments. The list could go on and on, as there is little that cannot be contained, linked, or referenced via the stylish unit that covers little more than the palm of your hand. Had you nothing better to do, no life of your own, you could make it your project to immerse yourself within the

172 Saved from Oblivion

life of the individual represented on the PDA. You could know everything, see everything, feel everything. But unfortunately the owner of the device must have discovered his loss, as the screen suddenly goes dead. An automatic security protocol has gone into effect, rendering the PDA a disconnected and thus utterly useless portal. It now contains nothing except a handful of electronic components.

With some relief you notice your stop and manage to get off in time. On your way out of the station you toss the PDA into a trashcan and continue with the day that awaits you above ground.

As imaginary as this scenario may be, the notion of electronic devices as being intimate links to one's identity is not a fantasy, at least judging by the often-breathless rhetoric of current industry leaders. For example: "At Nokia we want to make life simpler, more efficient, and more fun. We want to offer increased freedom to our customers, and we believe that mobile phones and other communication devices are the keys that will open doors to exciting and liberating futures."[1] Equally convinced of the transformative potential of wireless communications, Hans Roger Snook, CEO of Orange, anticipates a future in which one's wireless device will become an "intimate utility that allows them [users] to create their own world, to control their own world," to become in a sense "a remote control for life" (Morely). As part of the web-based marketing campaign, Palm runs a "day in the life" series that offers scenarios for "personal solutions" to the information hassles of everyday life. One such sequence, "A Day in the Life of a Mom," narrates the use of a "Zire 21 handheld" by "a busy Mom" making her way through a regime of exercise classes, doctor's visits, and dinner party menus.

> 7:00 a.m. HotSync® Cable
> Synchronizes to her Outlook calendar to see both her office and home schedules for the day.
> 8:30 a.m. Pocket Workout Wizard
> Records her morning jog and tracks her monthly exercise goals.
> 10:30 a.m. IR Access Point
> Making a trip to the mall, she visits a Bluefish infrared access point to download the mall directory and valuable coupons.

11:45 a.m. Zire Essentials Kit
Carries her Zire 21 handheld in the protective flap case that came in the kit. Three extra styli and screen protectors are essential extras to have on hand.

12:45 p.m. Address Book
Looks up her pediatrician's phone number to see if he can see her son, who's running a fever at school.

1:30 p.m. Palm Reader
Reads *David Copperfield*, by Charles Dickens, for her book club meeting while waiting in the pediatrician's office.

3:00 p.m. Date Book
Her alarm sounds fifteen minutes before she is to pick up her daughter from softball practice.

4:00 p.m. Handmark Mobile DB
Adds this database to her handheld for tracking special information like birthdays, anniversaries, automobile maintenance, personal passwords and more.

7:30 p.m. Pocket Recipes
Looks up a recipe for Chicken Cacciatore for her dinner party tomorrow night.[2]

Similar scenarios are created for numerous other lifestyles, including those of a student, marketing manager, art director, attorney, and police officer. One testimonial from a young Palm user speaks particularly to the future of self-documentation in the wireless age. "Being a kid is a demanding job. Homework. Little league. Baseball card collections. Along with being a pretty decent surfer, Cody is perhaps the most organized 12-year old in Singapore. He documents everything he does with his Palm handheld's digital camera."[3]

Clearly, what industry developers are encouraging here is the concept of communication technology becoming more than just a means for information transfer. Instead it is to become a kind of identity conduit that incorporates as inclusively as possible the entirety of *representable* life and experience. As such, convergence is taken to an entirely new level in the sense that human agents are now part of the "remediating" mix, thereby extending the place of media into the actual flesh and minds of human beings. Such a statement

brings to mind the cyborg, with its constant merging of categories, forms, and states of being. Yet it also implies something else, something more than just a symbiosis of dualisms and the creation of a dynamic hybrid of blurred boundaries. One perplexing and thereby useful alternative or addition is that of *quasi corporeality*, which Brian Massumi employs to contemplate "the superposition of the sum total of the relative perspectives in which the body has been implicated, as object or subject, plus the passages between them: in other words, as an interlocking of overlaid perspectives that nevertheless remain distinct" (Massumi, *Parables*, 2002, 58). The notion of "overlaid perspectives" that manage to remain distinct takes on a special resonance when applied to the emerging practices of wireless self-documentation. For not only are the perspectives overlaid, they are also embedded and extracted, included and excised in a relentless ontological mélange of constant yet incomplete documentation. "Quasi corporeality," writes Massumi, "is an abstract map of transformation. Its additive subtraction simultaneously constitutes the spatiality of the body without an image and translates it into another kind of time" (58). In the context of wireless self-documentation, this "another kind of time" is a time simultaneously located within the time of a body made absent by virtue of being an object of consumption (or contemplation) and present by virtue of encoding lived experience into a particular apparatus, such as a Palm Pilot. An individual thus stands in one corner, let's say in Kitchener, Ontario, and encodes into his Blackberry the thought that he is feeling crappy and that the world has turned against him and that the streets are lightly coated with a fine, gray dust. Somewhere else, let's say in Karlstad, Sweden, someone else browses through his list of links and comes to learn of the crappy world and dusty streets in a town that he knows only via isolated snapshots of previous entries. Presences and absences merge into one another, rendering the Kitchener body into an unsteady yet persistent presence to the Karlstad body within a temporal space that belongs to neither. Not there but *there*. Not here but *here*. Not now but *now*. Presence thus becomes an exercise of constant translation and movement.

Another and final advertisement comes to mind. It is for the Samsung E700 Moment, a "stylish Camera phone" that is first and foremost coded and sold as a fashion accessory.[4] The point of it being an actual communications device seems secondary, marginal, and almost irrelevant. As one enters the Flash-driven website, one is greeted with a loop of ubiquitous lounge music and a gently merging collage of messages and stylized images of contemporary retro chic. Five categories that speak to various features of the phone eventually merge: "Memory of Multiple Eyes, Momentary Self-Portrait, Addictive Night Power, Framed by Finger Moment, Maximal Pleasure of Minimalism." The categories are reminiscent of titles that one might find in contemporary crime fiction, or perhaps even soft porn. There is an air of deliberately contrived mystery, voyeurism, and controlled excess.

The sequence for "Momentary Self Portrait" begins by explaining that thanks to the "dual color screens, you can take a photo of yourself without even opening the phone." What follows is perplexing and eerily prophetic. A stylized drawing of a woman softly emerges, as does the text "Self Portrait: I will never open my mind." The image shifts, and the same woman, shown only in profile, is holding the E700 and wearing a frilly nightgown. In the background a male figure reclines in confidence on an unmade bed. The text continues: "I will never open my mind. Sometimes I feel like talking to an electronic doll. Then start whispering to myself 'one, two, three...' hoping that this moment could be adorable." The scene shifts. An airbrushed photo of a young female sophisticate with the requisite black turtleneck and a deliberately unkempt coiffure is positioned next to a reproduction of Van Gogh's *Self Portrait with Straw Hat*. The woman has a blank but carefully poised look about her. Van Gogh, on the other hand, appears pensive, nervous, and uncertain. The text reads: "Vincent van Gogh produced about thirty self portraits in the five years from the end of the Brabant period (1885) to the last year of his life at St Remy an Auvers. These self-images of the painter show a mastery of control and power of observation, a mind perfectly capable of integrating the elements of

its chosen activity. How about you? Picture yourself. What do you see...?"

Indeed, picture yourself, picture ourselves. What do we see? With the E700, two possibilities are suggested. The first is the closed mind of the woman in the nightgown who relies on a small camera phone for her powers of observation and reflection. The other is the controlled mastery of practiced observation and the ability to transcend surface appearances and get down to the very core of the human psyche and soul.

Taken together rather than as contradictions of one another, the two alternatives provide some indication of the future of self-documentation in terms of the influence of new technology. In conjunction with the current rage for all things "real and live," as indicated by the popularity of programs such as *Survivor*, *Big Brother*, *Temptation Island*, and scores of others, technological advances herald an increased mediatization of self-expression itself. Increasingly, throughout the latter half of the twentieth century (and into the twenty-first), the media has proven to be a major form of socialization and arena for cultural legitimacy (Kellner). Thus, it is perhaps no great leap to suggest that self-documentation will become a highly mediated, technological, and public activity. As such, the future of self-documentation will be a paradoxical mix of self-knowledge through studied solitude and introspection and the predominately unreflective approach of contemporary media practice, with its emphasis on self-promotion, continuous change, and the relentless pursuit of an audience. One could think of this as a form of expressive cryogenics. In other words, gaining immortality and perhaps even transcendence by literally transcribing the self into a continuous and ultimately self-perpetuating media space.

Such possibilities, which are as exciting as they are disturbing, resonate with Richard Dienst's observations regarding the impact of media technology on the temporal and material experience.

> The more we live with new technologies of communication and information cyber-spaces, the more our sense of temporality will be affected. Thus the waning of historical consciousness is itself a historically explainable phenomenon. The memory book, however, is a potentially healthy sign of

> contestation: a contestation of the informational hyperspace and an expression of the basic human need to live in extended structures of temporality, however they many be organized. It is also a reaction formation of mortal bodies that want to hold on to their temporality against a media world spinning into a cocoon of timeless claustrophobia and nightmarish phantasms and simulations. In that dystopian vision of a high-tech future, amnesia would no longer be part of the dialectic of memory and forgetting. It will be its radical other. It will have sealed the very forgetting of memory itself: nothing to remember, nothing to forget. (Dienst, 9)

Dienst's comments here offer a number of thoughts with which to close this volume. At the forefront is the ever-present need to stave off oblivion—as predicated either by the conditions of mortality or by the fragility of human memory. Death, in this respect, is akin to being forgotten and thus part of the drive to continuously create new "representation engines" that could be attributed to our natural desire for longevity both biologically and conceptually. Self-documentation becomes in this sense an attempt to hold on to one's temporality, as Dienst suggests, and moreover to continuously enact extensions of the self into the material and, for lack of a better term, psychosocial environments of place, society, and culture. In the twentieth and twenty-first centuries, which have been the focus of this volume, this need has been especially urgent given the historical, cultural, and technological forces that have been steadily altering the experience of time in ways that are almost unimaginable. The page, the camera, and the network serve as key historical-technical markers of this process, not only in terms of time but also in terms of *lived* place and experience. In this respect, the phenomena of photographs, home movies, and web-diaries serve as vivid testimonies of the human desire and ability to hold on to time, experience, and memory. They speak of potential hybrids of the human-technological matrix that may very well keep oblivion at bay.

NOTES

INTRODUCTION

1. Cornelius Holtorf, "Prospective Memory," Monumental Past: The Life-Histories of Megalithic Monuments in Mecklenburg-Vorpommern (Germany), http://citd.scar.utoronto.ca/CITDPress/holtorf/0.1.html (November 3, 2003).
2. The work of George Grant comes to mind here, particularly in terms of his contention that technology actively mediates human relations and, as well, forms the basis for values and ontological positions. See *Technology and Justice* (Toronto: House of Anansi, 1986) and *Philosophy in the Mass Age* (Toronto: University of Toronto Press, 1995).
3. The work of Katherine Hayles offers much in the way of exploring the nature of nondiscursive or prerepresentationalist paradigms in what could be understood as an attempt to forge a path between semiotic and phenomenological explorations of technology. In addition to her *How We Became Posthuman* (Chicago: University of Chicago Press, 1999), see also "Constrained Constructivism: Locating Scientific Inquiry in the Theatre of Representation," *New Orleans Review* 18, no. 1 (1991): 76–85, and "The Materiality of Informatics," *Configurations* 1, no. 1 (1993): 147–70.
4. A note on terminology here: the terms web-diary, web-journal, and web-log (or blog) are used interchangeably in this volume. It is arguable that such a merging of categories undermines the distinctive nature of each of these "genres." To some extent this may be true; however, given the fluid nature of the web in terms of mixing and fusing categories and boundaries, rigid definitions are neither possible nor useful. For more specific details on the "blogging" phenomenon see Rebecca Blood's *We've Got Blog: How Web Logs Are Changing Our Culture* (New York: Perseus Publishing, 2002).
5. Jeffrey Sconce's *Haunted Media: Electronic Presence from Telegraphy to Television* (Durham, N.C.: Duke University Press, 2000), for example, explores how themes of transcendence, disembodiment, and electronic presence have been a major cultural preoccupation since the days of the telegraph.
6. "Think different" is part of the Apple Computer Corporation's effort to brand its stylish line of personal computers and accessories. "Go create" is

Sony's attempt to correlate its product line with tropes of originality, creativity, and expressive agency. See http://www.apple.com and http://www.sony.com.

PART ONE: MEDIA PLACE
1. POSTURE ONE

1. Michael Benedikt's *Cyberspace: First Steps* (Cambridge, MA.: MIT Press, 1992) is a canonical volume regarding the spatial nature of digital technology. For a less celebratory but arguably more "mystical" account of cyberspace see Paul Virilio's *Open Sky* (New York: Verso, 1995).
2. See also Jennifer Gonzalez's "Autotopographies," in *Prosthetic Territories: Politics and Hypertechnologies*, ed. Gabriel Brahm and Marc Driscoll (San Francisco: Westview Press, 1995), 133–50.

2. PLACE OF THE PAGE

1. Innis's well-known distinction between time-bound and space-bound societies similarly posits the notion that oral societies exist within a continuity of time, thought, and expression where individual experience and thought are submerged within the overall directions of collective experience and the common good. See Harold Innis, *Empire and Communications* (Toronto: University of Toronto Press, 1972), 10, 44, 127.

3. PLACE OF THE CAMERA

1. For more details regarding the litigious side of photography's historical development see chapters 3–5 in Pollack.
2. Kevin Warwick, "FAQ,": http://www.rdg.ac.uk/KevinWarwick/html/faq.html (June 30, 2003).
3. Kodak's Cine Kodak cost $335. By comparison, the Model T Ford could be purchased for $550. Kodak Company, home page, "Super 8mm Film

Products," http://www.kodak.com/US/en/motion/ super8/history.shtml (June 26, 2003).
4. Biromsoft Corporation, home page, http://www..biromsoft.com (June 30, 2003).
5. The Casio wrist-cam is billed as the world's first wearable web-cam. Among its features is the ability to transfer images between other wearers of the wrist-cam via an infrared link and, naturally, to upload stored images to a computer. See http://www.casio.com for more details. Steve Mann is a pioneer of wearable computing and is currently a faculty member of the University of Toronto's Department of Electrical and Computer Engineering. See http://wearcam.org/steve.html.

4. PLACE OF THE NETWORK

1. The Digital Divide Network, "Digital Divide Basics Fact Sheet," http://www.digitaldividenetwork.org/contents/sections/index.cfm (June 30, 2003).
2. For an incisive discussion of the tension between the material and the immaterial as rendered by information technology, see Katherine Hayles's *How We Became Posthuman* and *Virtual Bodies in Cybernetics, Literature, and Informatics* (Chicago: University of Chicago Press, 1999).
3. See http://www.cybergeography.org.

PART TWO: PRIVATE PLACE
5. POSTURE TWO

1. A brief explanation of Sweden's public access policy can be obtained from Sweden's Official Website (in English), at http://www.sweden.se/templates/Article____2252.asp.
2. Cyberspace provides many opportunities for augmenting, creating, or inventing versions of the self that provide means of escape or fantasy, as Sherry Turkle describes in *Life on the Screen: Identity in the Age of the Internet*

(New York: Simon and Schuster, 1999). The subject of such creative augmentation will be explored more fully in part 3 of this volume.

6. PURE PRIVACY

1. For example, *The Wonder Years*, a coming-of-age television series that ran from 1988 to 1993, employed the use of home movie sequences in its title and credit sequences in a manner that heightened the program's obvious nostalgic appeal as well as corresponded with the program's premise of an older man remembering his childhood. The constructed sequence had the requisite shaky camera style, the grainy film stock, and the unscripted behaviors that signal authentic moments of a past life and experience. Accordingly, the viewers are transported via aesthetic and formal markers to the "possible world" of a not-too-distant past, which in the case of *The Wonder Years* serves as the platform for the authenticity of the program's fictional universe.

2. The livingroomcam, which is still in operation at the time of this writing, can be viewed at http://www.livingroomcam.cx (June 30, 2003).

3. Popular consensus attributes the Trojan Room Coffee Pot as one of the world's first publicly available web-cam sites. It was set up in 1991 by a several computer engineers working at the University of Cambridge Computer Laboratory in order to alert them to the presence of a fresh pot of coffee. While no longer in operation, a website created by its "inventors" still exists at http://www.cl.cam.ac.uk/coffee/qsf/coffee.html. Equally a pioneer is Jennifer Ringley, whose Jennicam stands as one of the first to gain a global audience of eager voyeurs. The web-cam went online on April 1996 during Ringley's college years. Today, the Jennicam has grown to seven cameras around her home and the site itself has become a commercial enterprise. See http://www.jennicam.org/.

4. The livingroomcam home page, http://www.livingroomcam.cx (June 30, 2003)

7. PUBLIC PRIVACY

1. Carla, e-mail to author, February 19, 2001.
2. Rick, e-mail to author, March 19, 2002.
3. The "covers" are assembled from those archived at Amanda's site, http://www.amandacam.com.
4. Derived from "The Diarist Awards," http://diarist.net (May 30, 2001).

8. CONNECTED PRIVACY

1. Open Diary, home page, http://www.opendiary.com (October 15, 2001). The current version of Open Diary no longer contains this introductory text.
2. "Link Collection: Community," http://www.diarist.net/links/community.html (November 26, 2003).
3. "FAQ#56," http://www.livejournal.com/support/faqbrowse.bml?faqid=56 (November 26, 2003).
4. From http://www.hedgehog.net/op/ (June 30, 2003).
5. From http://C.webring.com/hub?ring=thediaries (June 30, 2003).
6. "Diarist Net Awards," http://www.diarist.net/awards/ (April 18, 2003).
7. See http://www.journalcon.com.

PART THREE: REAL PLACE
9. POSITIVE REALITY

1. See http://www.annefrank.ch/content/default.htm.
2. The Ordinary Life, home page, http://www.geocities.com/Athens/1589/index.html (June 19, 2003); emphasis mine.
3. See the discussion of cameras such as the Kodak Signet 80 with "skill built in" on page 151.
4. Ellie's story is derived from a private e-mail exchange with the author, February 7, 2001. Her web-cam can be found at http://www.members.shaw.ca/motaboy/.

184 *Saved from Oblivion*

5. See the infamous "Rape in Cyberspace," by Julian Dibbel, originally published in the *Village Voice* (Dibbel) and later anthologized in Mark Dery's *Flame Wars: The Discourse of Cyberculture* (Durham, NC: Duke University Press, 1994). An interesting case that attracted a modicum of media interest is that of "Kaycee Nicole Svenson," who captured the hearts and support of thousands via her online diary that detailed her fight against leukemia. It was eventually revealed that Debbie Swenson, a thirty-five-year-old mother, had fabricated the entire diary. What is particularly odd is that Debbie's daughter Kelli, as a rather short-lived web experiment that made no reference to illness or other traumatic events, had actually invented "Kaycee." Kelli and her friends eventually abandoned the web-diary. For reasons unknown, Debbie took over the web-diary and began turning Kaycee into a leukemia victim (Dunne).

6. Open Diary, home page, http://www.opendiary.com (November 30, 2000).

7. The thread on "fake journals" was discussed in journals@lists.yeehaw.net from March 25 to April 17, 2003. "Fozzy O" comments on the appeal of constructing a fake journal while at the same time noting that he has never been tempted to write one nor, to his knowledge, has he ever read one. Fozzy O notes further that "It is an interesting idea, creating your lead character, a home for them, a job, what is their background—what is the story. What is going to happen to them." Fozzy O, journals@lists.yeehaw.net, (March 25, 2003).

10. NEGATIVE REALITY

1. U.S. census data, for example, indicates that in 2000 some 51 percent of American households had at least one computer, compared to 22.8 percent in 1993. Internet access was calculated at 41.5 percent in the year 2000 (U.S. Census Bureau). In 2000 some 62 percent of all Canadian households had computer access. Internet access by Canadians was calculated at 49 percent of all households (Industry Canada).

2. Lev Manovich notes that one of the properties of digital media is its ability to render media objects via "numerical representations," meaning that media becomes programmable and can be manipulated in ways that are impossible in the world of materially based media (Manovich, 27–47).

11. RETURNED REALITY

1. Salam Pax, Where Is Raed, http://dear_raed.blogspot.com (June 30, 2003). The contents of Salam's blog have been recently published in book form. See *Salam Pax: The Clandestine Diary of an Ordinary Iraqi* (New York: Grove Press, 2003).
2. Jason Kottke, http://www.kottke.org/03/03/030320nowseriousl.html (June 30, 2003).
3. TJ Hooker, diary entry for March 2, 2003, http://paulboutin.weblogger.com/2003/03/2.

PART FOUR: TIME PLACE
12. STILL TIME

1. John, e-mail to author, January, 15, 2003.
2. x-ribbon, "x I am beautiful," diary entry for May 13, 2001, http://www.teenopendiary.com/entryview.asp?authorcode=B113021&entry=10750.

13. FUTURE TIME

1. Kodak, "American Tradition," c. 1940, emphasis mine. This advertisement was found in the digital archive Adflip. Exact bibliographic information is not available. See http://www.adflip.com for more information.
2. Bell and Howell, c. 1940, Adflip.
3. Kodak, "Life Is a Movie," c. 1950, Adflip.
4. Kodak, "Life Is a Movie."
5. Bell and Howell, "Filmo," c. 1940, Adflip.
6. Bell and Howell, "Finer Home Movie," c. 1940, Adflip.
7. Kodak, "K-100," c. 1950, Adflip
8. Kodak, "Mag 8," c. 1950, Adflip.

186 Saved from Oblivion

9. Kodak, "Signet 80," c. 1949, Adflip.
10. Kodak, "Brownie," c. 1940, Adflip.

14. REAL TIME

1. The case of digital photography is particularly notable in this regard. Virilio comments that digital photography makes "time newly visible...and newly productive" and thus engenders a temporal-material relationship that is radically different from analog (chemical) photography (Virilio, 1994, 61). Celia Lury notes that this changed relationship is predicated on the fact that the "observer's moment of exposure is no longer in synch, no longer integrated into the time of exposure" (Lury, 176).
2. Edgylemon, diary entry for April 15 and April 24, 2002, http://www.diaryland.com.
3. The role of performance in online self-documentation, particularly via web-cams, is an important element that will not be explored here. For a detailed analysis of performance within the web-cam community, see Senft.
4. Paulineee, "Ranting and relief," e-mail message posted on journals@lists.yeehaw.net (March 17, 2003).
5. Derived from http://lists.yeehaw.net/mailman/listinfo/journals.
6. A Place for Peace, home page, http://aplaceforpeace.com (July 2, 2003).
7. We Live in Public, http://weliveinpublic.com (December 20, 2000). This website is no longer active.
8. Diary entry for December 30, 2000, http://www.weliveinpublic.com.
9. Diary entry for December 4, 2000, http://weliveinpublic.com.
10. The buzzword convergence, which has currency in both academic and corporate circles, is often used to denote the union of previously distinct media forms (radio, TV, etc.) within a single media place, such as the World Wide Web. For a balanced study of the nature and impact of convergence see Baldwin, Thomas et al, *Convergence: Integrating Media, Information, and Communication* (Thousand Oaks, CA: Sage Publications, 1996).
11. Andreas Huyssen makes the valid and necessary point that "all representation—whether in language, narrative, image, or recorded sound—is based on memory. Re-presentation always comes after, even

though some media will try to provide us with the delusion of pure presence" (Huyssen, 2). Yet such delusions matter and have in fact become a paradigm with which to understand and increasingly construct (mediated) reality, as indicated by Castells.

12. Third-generation mobile technology combines "high speed mobile access with Internet Protocol (IP)-based services." According to the 3G Newsroom, this will provide "whole new ways to communicate, access information, conduct business, learn and be entertained—liberated from slow, cumbersome equipment and immovable points of access." "Introduction into 3G," http://www.3gnewsroom.com/html/about_3g/intro_3g.shtml (June 19, 2003).

13. The website for the 3G campaign, which is in Swedish and English, is available at http://www.tre.se.

14. Reality TV is a growth industry that appears to have no limits both in terms of popularity and the extremes at which networks are willing to go in an effort to capture their share of the market. Miles Dale, a producer for the CBS series *Top Cops*, believes that "the success of reality-based shows is a product of all-news networks like CNN or Newsworld. By recycling news as entertainment, current affairs programs have created an appetite for reality shows. Human tragedy has become a commodity that is bought and sold in a competitive market place" (Mazurkewich, 5).

EPILOGUE

1. Nokia, "The Wireless Future," http://www.nokia.com/nokia /0,8764,3447, 00.html (November 7, 2003).
2. Palm One, "A Day in the Life of a Mom," http://www.palmOne.com/us/solutions/personal/dayinthelife/mom.html (November 7, 2003).
3. Palm One, "A Day in the Life of a Student," http://www.palmOne.com/us/solutions/personal/dayinthelife/mom.html (November 7, 2003).

4. Samsung, home page, http://www.samsung.com/ (November 12, 2003). To view the flash animation for the E700, click on the link "Stylish Camera Phone."

WORKS CITED

For reasons of clarity, all web sources with the exception of scholarly journals or news publications are listed in the endnotes.

Aarons, Jules. *Vacation and Travel Photography*. New York: Grosset and Dunlap, 1964.
Aarseth, Espen. *Cybertext: Perspectives on Ergodic Literature*. Baltimore: Johns Hopkins University Press, 1997.
Abelman, Robert. *Reading a Critical Mass: A Critical Analysis of Television Entertainment*. Mahwah, NJ: Lawrence Erlbaum, 1998.
Anderson, Michael. *Approaches to the History of the Western Family, 1500–1914*. Cambridge: Cambridge University Press, 1995.
Aries, Philippe. *Centuries of childhood*. Trans. Robert Baldick. London: Pimlico, 1996.
Auer, Michel. *The Illustrated History of the Camera: From 1839 to the Present*. Boston: New York Graphic Society, 1975.
Aufderheide, P. "Public Television and the Public Sphere." *Critical Studies in Mass Communications* 8 (1991): 168–83.
Auge, Marc. *Non-places: Introduction to an Anthropology of Supermodernity*. London: Verso, 1995.
Bakardjieva, Maria, and Andrew Feenberg. "Community, Technology, and Democratic Rationalization." *The Information Society* 18 (2002): 181–192.
Baldwin, Christina, and Susan Boulet. *Life's Companion: Journal Writing as a Spiritual Quest*. New York: Bantam Doubleday Dell Publishers, 1991.
Barlow, W. "Community Radio in the US: The Struggle for a Democratic Medium." *Media, Culture, and Society* 10 (1988): 81–105.
Barthes, Roland. *Camera Lucida*, trans. Richard Howard. New York: Hill and Wang, 1981.
Baudrillard, Jean. *Simulations*. New York: Semiotext(e), 1983.

———. *The Gulf War Did Not Take Place*. Bloomington: Indiana University Press, 1995.
Bauman, Zygmunt. *Liquid Modernity*. Cambridge: Polity Press, 2000.
Bellah, Robert. Ed. *Habits of the Heart: Individualism and Commitment in American Life*. Berkeley: University of California Press, 1985.
Benedikt, Michael. *Cyberspace: First Steps*. Cambridge, MA: MIT Press, 1992.
Beniger, James R. *The Control Revolution: Technological and Economic Origins of the Information Society*. Cambridge, MA: Harvard University Press, 1986.
Benjamin, Walter. *Illuminations: Essays and Reflections*. New York: Schocken Books, 1969.
———. *Selected Writings: Volume 1, 1913–1926*, ed. M. Bullock and M. Jennings. Cambridge, MA: Harvard University Press, 1996.
Ben-Ze'ev, Aaron. "Privacy, Emotional Closeness, and Openness in Cyberspace." *Computers in Human Behaviour* 19, no. 4 (July 2003): 451–67.
Berger, John. *About Looking*. New York: Pantheon Books, 1980.
Blanchot, Maurice. *The Space of Literature*. Trans. Ann Smoch. Lincoln: University of Nebraska Press, 1982.
Boling, Patricia. *Privacy and the Politics of Intimate Life*. Ithaca, NY: Cornell University Press, 1996.
Bolter, J. David. *Writing Space: Computers, Hypertext, and the Remediation of Print*. London: Lawrence Erlbaum, 2001.
Bolter, J. David, and Richard Grusin. *Remediation: Understanding New Media*. Cambridge, MA: MIT Press, 1999.
Braudy, Leo. *The Frenzy of Renown: Fame and Its History*. New York: Oxford University Press, 1986.
Braverman, Harry. *Labor and Monopoly Capital: The Degradation of Work in the Twentieth Century*. New York: Monthly Review Press, 1974.
Buck-Morrs, Susan. *The Dialectics of Seeing: Walter Benjamin and the Arcades Project*. Cambridge, MA: MIT Press, 1989.
———. *Dreamworld and Catastrophe: The Passing of Mass Utopia in East and West*. Cambridge, MA: MIT Press, 2000.
Bunkers, Suzanne, ed. *Diaries of Girls and Women: A Midwestern American Sampler*. Madison: University of Wisconsin Press, 2001.

Bunkers, Suzanne, and Cynthia Huff. *Inscribing the Daily: Critical Essays on Women's Diaries*. Amherst: University of Massachusetts Press, 1996.

Burgin, Victor. *In/Different Spaces: Place and Memory in Visual Culture*. Berkeley: University of California Press, 1996.

Burnett, Robert, and David P. Marshall. *Web Theory: An Introduction*. New York: Routledge, 2003.

Buss, Helen M. "Pioneer Women's Diaries and Journals: Letters Home/Letters to the Future." In *Mapping Our Selves: Canadian Women's Autobiography in English*. Montreal: McGill-Queen's University Press, 1993.

Calvert, Clay. *Voyeur Nation: Media, Privacy, and Peering in Modern Culture*. Boulder, CO: Westview Press, 2000.

Camper, Fred. "Some Notes on the Home Movie." *Journal of Film and Video* 38 (Summer–Fall 1986): 9–14.

Carey, J. W. *Communication as Culture: Essays on Media and Society*. Boston: Unwin Hyman, 1989.

Casey, Edward S. *The Fate of Place: A Historical History*. London: University of California Press, 1997.

Castells, Manuel. "Materials for an Exploratory Theory of the Network Society." *British Journal of Sociology* 51, no. 1 (January–March 2000): 5–24.

———. *The Rise of the Network Society*. Oxford: Blackwell Publishers, 2000.

———. *The Internet Galaxy: Reflections on the Internet, Business, and Society*. New York: Oxford University Press, 2001.

Cavell, Richard. "McLuhan and Spatial Communication." *Western Journal of Communication* 63, no. 3 (Summer 1999): 348–64.

Chalfen, Richard. *Shapshot Versions of Life*. Bowling Green, OH: Bowling Green State University Press, 1987.

———. "Family Photograph Appreciation: Dynamics of Medium, Interpretation, and Memory." *Communication and Cognition* 31, no. 23 (1998): 161–78.

Citron, Michele. *Home Movies and Other Necessary Fictions*. London: University of Minnesota Press, 1999.

Cooper, Charles. "Salam Pax Is Still Alive." *CNET*, May 9, 2003. Available at: http://news.com.com/2010-1071_3-1000666.html.

Coover, Robert. "The End of Books." *New York Times Book Review*, June 21, 1992, 1ff.

Corrin, Tanya. "The Harris Experiment." *New York Observer*, June 27, 2003, 15.

Craib, Ian. *Experiencing Identity*. London: Sage Publications, 1998.

Crary, Jonathan. *Techniques of the Observer: On Vision and Modernity in the Nineteenth Century*. Cambridge, MA: MIT Press, 1990.

——. *Suspensions of Perception: Attention, Spectacle, and Modern Culture*. Cambridge, Mass.: MIT Press, 2001.

Cubitt, Sean. *Timeshift: On Video Culture*. London: Routledge, 1991.

Danius, Sara. *The Senses of Modernism: Technology, Perception, and Aesthetics*. Ithaca, NY: Cornell University Press, 2002.

de Certeau, Michel. "Believing and Making People Believe." In *The Certeau Reader*, ed. Graham Ward. Oxford: Blackwell, 2000.

de Kerckhove, Derrick. *Connected Intelligence: The Arrival of the Web Society*. London: Kogan Page, 1998.

Debord, Guy. *The Society of the Spectacle*. New York: Zone Books, 1994.

Delanda, Manuel. *A Thousand Years of Nonlinear History*. New York: Zone Books, 1997.

Deleuze, Gilles, and Felix Guattari. *A Thousand Plateaus: Capitalism and Schizophrenia*. Trans. Brian Massumi. London: Athlone Press, 1988.

Derrida, Jacques. *Of Grammatology*. Trans. Gayatri Chakravorty Spivak. Baltimore: Johns Hopkins University Press, 1974.

Dibbel, Julian. "A Rape in Cyberspace: How an Evil Clown, a Haitian Trickster Spirit, Two Wizards, and a Cast of Dozens Turned a Database into a Society." In *Flame Wars: The Discourse of Cyberculture*, ed. Mark Dery. Durham, NC: Duke University Press, 1994.

Dienst, Richard. *Still Life in Real Time: Theory after Television*. Durham, NC: Duke University Press, 1994.

Dos Passos, John. *The Big Money: Volume Three of the U.S.A. Trilogy*. New York: Houghton Mifflin, 2000.

Dunne, Steve. "The Short Life of Kaycee Nicole." *The Guardian*, May 28, 2001. Available at: http://www.guardian.co.uk/.

Duval, Jean-Luc. *Photography: History of an Art*. New York: Rizzoli, 1982.
Eakin, Paul. *Fictions in Autobiography: Studies in the Art of Self Invention*. Princeton, NJ: Princeton University Press, 1985.
Elias, Norbert. *The Society of Individuals*. Trans. Edmund Jephcott. New York: Continuum, 2001.
Flynn, Thomas. "Foucault's Mapping of History." In *The Cambridge Companion to Foucault*, ed. Gary Gutting. Cambridge: Cambridge University Press, 1994.
Foster, Hal. *The Return of the Real: The Avant-Garde at the End of the Century*. Cambridge, MA: MIT Press, 1996.
Foucault, Michel. *The Archaeology of Knowledge*. New York: Pantheon Books, 1972.
———. *Language, Counter-Memory, Practice: Selected Essays and Interviews*. Ed. Donald F. Bouchard. Ithaca, NY: Cornell University Press, 1977.
Frank, Anne. *The Diary of a Young Girl: The Definitive Edition*. New York: Doubleday, 1995.
Gabler, Neal. *Life the Movie: How Entertainment Conquered Reality*. New York: Knopf, 1998.
Gergen, Kenneth J. *The Saturated Self: Dilemmas of Identity in Contemporary Life*. New York: Basic Books, 1991.
Gernsheim, Helmut, with Alison Gernsheim. *The History of Photography: From the Earliest Use of the Camera Obscura in the Eleventh Century up to 1914*. Toronto: Oxford University Press, 1955.
Giddens, Anthony. *Modernity and Self-identity: Self and Society in the Late Modern Age*. Cambridge: Polity Press, 1991.
Gobetti, Daniela. *Politic in Locke and Hutcheson*. London: Routledge, 1992.
Goffman, Erving. *The Presentation of Self in Everyday Life*. Garden City, NY: Doubleday, 1959
Guarino, Lois. *Writing Your Authentic Life*. New York: Dell Publishing, 1999.
Habermas, Jürgen. *The Philosophical Discourse of Modernity: Twelve Lectures*. Cambridge, MA: MIT Press, 1987.

Hansen, Mark. *Embodying Technesis: Technology beyond Writing.* Ann Arbor: University of Michigan Press, 2000.

Haraway, Donna J. *Modest Witness@Second Millennium ©MeetsOnco Mouse ™: Feminism and Technoscience.* New York: Routledge, 1997.

Hayles, Katherine. *How We Became Posthuman: Virtual Bodies in Cybernetics, Literature, and Informatics.* Chicago: University of Chicago Press, 1999.

Heddon, Deirdre. "Autotopraphy: Graffiti, Landscapes, and Selves." *Reconstruction: An Interdisciplinary Culture and Studies Community* 2, no. 3 (Summer 2002). Available at: http://www.reconstructionws/023/heddon.htm.

Hill, Erica. "Blogging for a Better View." *CNN.com.* March 26, 2003. Available at:: http://www.cnn.com/2003/TECH/03/26/hln.wire hln.wired.blog/index.html

Holmes, Edward. *An Age of Cameras.* London: Foundation Press, 1974.

Holtorf, Cornelius. "Towards a Chronology of Megaliths: Understanding Monumental Time and Cultural Memory." *Journal of European Archaeology* 4 (1996): 119–52.

———. *Monumental Past: The Life-Histories of Megalithic Monuments in Mecklenburg-Vorpommern (Germany).* Available at: http://citd.scar.utoronto.ca/CITDPress/holtorf/0.1.html (November 3, 2003).

Huyssen, Andreas. *Twilight Memories: Marking Time in a Culture of Amnesia.* New York: Routledge, 1995.

Jagodzinski, Cecile M. *Privacy and Print: Reading and Writing in Seventeenth Century England.* Charlottesville: University of Virginia Press, 1999.

Jobey, Liz. "Keeping Aunty out of the Picture: Ruthless Cut and Paste in the English Family Album." *New Statesman and Society,* June 28, 1996, 38–39.

Jones, Steve, ed. *CyberSociety: Computer-Mediated Communication and Community.* Thousand Oaks, CA: Sage Publications, 1994.

Joyce, Michael. *Of Two Minds: Hypertext, Pedagogy, and Poetics.* Ann Arbor: University of Michigan Press, 1995.

———. *Othermindedness: The Emergence of Network Culture.* Ann Arbor: University of Michigan Press, 2000.

Kahney, Leander. "The Walls Have Eyes." *The Guardian*, July 2, 1998, 2.
Katz, John Stuart, ed. *Autobiography: Film/Video/Photography*. Toronto: Art Gallery of Ontario, 1978.
Katz, Jon. "The Netizen: The Birth of a Digital Nation." *Wired*, Issue 5.0.4, April 1997. Available at: http://www.wired.com/wired/5.04/netizen_pr.html.
Kellner, Douglas. *Media Culture: Cultural Studies, Identity, and Politics between the Modern and the Postmodern*. London and New York: Routledge, 1995.
Kelly, Kevin. *New Rules for the New Economy: Ten Radical Strategies for a Connected World*. New York: Viking, 1998.
Kittler, Friedrich. *Grammophon, Film, Typewriter*. Stanford, CA: Stanford University Press, 1999.
Kodak (the editors of Eastman Kodak Company). *How to Make Good Home Movies*. New York: Random House, 1958.
———. *How to Make Good Sound Movies*. New York: Eastman Kodak Company, 1973.
Kroker, Arthur, and David Cook. *The Postmodern Scene: Excremental Culture and Hyper-Aesthetics*. Montreal: New World Perspectives, 1986.
Kuhn. Annette. *Family Secrets: Acts of Memory and Imagination*. New York: Verso, 1995.
Lalavani, Suren. *Photography, Vision, and the Production of Modern Bodies*. New York: State University of New York Press, 1996.
Landow, George. *Hypertext: The Convergence of Contemporary Critical Theory and Technology*. Baltimore: Johns Hopkins University Press, 1992.
Latour, Bruno. *We Have Never Been Modern*. Cambridge, MA: Harvard University Press, 1993.
Lejeune, Philippe. *On Autobiography*. Minneapolis: University of Minnesota Press, 1989.
Levy, Pierre. *Becoming Virtual: Reality in the Digital Age*. Trans. Robert Bononno. New York: Plenum, 1998.
Lister, Martin. *The Photographic Image in Digital Culture*. Routledge: New York, 1995.

Lothrop, Eaton. *A Century of Cameras: From the Collection of the International Museum of Photography at George Eastman House.* New York: Morgan and Morgan, 1973.

Lury, Celia. *Prosthetic Culture: Photography, Memory, and Identity.* London: Routledge, 1998.

Lyon, David. *Surveillance Society: Monitoring Everyday Life.* London: Open University Press, 2001.

Maffesoli, Michel. *The Time of the Tribes: The Decline of Individualism in Mass Society.* Trans. Don Smith. New York: Sage Publications, 1996.

Manovich, Lev. *The Language of New Media.* Cambridge, MA: MIT Press, 2001.

Marchessault, Janine. Rev. of *Reel Families: A Social History of Amateur Film* by Patricia Zimmermann. *Screen* 37, no. 4 (Winter 1996): 419–23.

Martin-Fusier, Anne. "Bourgeois Rituals." In *A History of Private Life IV: From the Fires of Revolution to the Great War*, ed. Michelle Perrot, trans. Arthur Goldhammer. London: Harvard University Press, 1990.

Mascuch, Michael. *Origins of the Individualist Self: Autobiography and Self-Identity in England, 1591–1791.* Stanford, CA: Stanford University Press, 1998.

Massey, D. *Space, Place, and Gender.* Cambridge: Polity Press, 1994.

Massumi, Brian. *Parables for the Virtual: Movement, Affect, Sensation.* Durham, NC: Duke University Press, 2002.

———. Ed. *A Shock to Thought: Expressions after Deleuze and Guatarri.* London: Routledge, 2002.

Mazurkewich, Karen. "Snuff-TV." *Canadian Dimension* 26, no. 5 (July–August 1992): 5.

McCauley, Elizabeth Anne. *A. A E. Disderi and the Carte de Visite Portrait Photography.* New Haven, CT: Yale University Press, 1985.

McDermott, Irene E. "Running Rings around the Web." *Searcher: The Magazine for Database Professionals* 7, no. 4 (April 1999): 67.

McGuire, Scott. *Visions of Modernity: Representation, Memory, Time, and Space in the Age of the Camera.* London: Sage Publications, 1998.

McLuhan, Marshall. "Playboy Interview: A Candid Conversation with the High Priest of Popcult and Metaphysician of Media." In *Essential McLuhan*, ed. Eric McLuhan and Frank Zingrone. Toronto: Anansi Press, 1995.

Moravec, Hans. *Mind Children: The Future of Robot and Human Intelligence.* Cambridge, MA: Harvard University Press, 1988.

Morely, Lynd. "Foreword: A Truly Wireless Future." *The Most Effective Applications and Service Infrastructure.* March 1, 2001. Available at http://www.eurocomms.co.uk/features/storyshtml?Features.REF=7.

Munon, Bryon. *Changing Community Dimensions.* Columbus: Ohio State University Press, 1968.

Murphy, Burt. *Baby and Child Photography.* New York: Verlan Books, 1960.

Muther, Christopher. "All the Web's a Stage." *Boston Globe*, July 24, 1998, City ed., E1.

Negroponte, Nicholas. *Being Digital.* New York: Vintage, 1996.

Nelson, Theodor. "Computer Lib/Dream Machines." In *The New Media Reader*, ed. Noah Wardrip-Fruin and Nick Montfort. Cambridge, MA: MIT Press, 2003.

Nora, Pierre. "Between Memory and History, Les Lieux de Mémoire (1984)." *Representations* 26, Spring 1989, 7–25.

Olney, James. *Memory and Narrative: The Weave of Life-Writing.* London: University of Chicago Press, 1998.

Ong, Walter. *Orality and Literacy: The Technologizing of the Word.* London: Methuen, 1982.

Pax, Salam. *Salam Pax: The Clandestine Diary of an Ordinary Iraqi.* New York: Grove Press, 2003.

Pollack, Peter. *The Picture History of Photography: From the Earliest Beginnings to the Present Day.* New York: Harry Abrams, 1969.

Ponsonby, Arthur. *English Diaries: A Review of English Diaries from the Sixteenth to the Twentieth Century with an Introduction on Diary Writing by AP.* London: Methuen, 1923.

Poster, Mark. *The Mode of Information: Poststructuralism and Social Context.* Chicago: University of Chicago Press, 1990.

———. *What's the Matter with the Internet?* Minneapolis: University of Minnesota Press, 2001.

Postman, Neil. *Amusing Ourselves to Death: Public Discourse in the Age of Show Business*. London: Methuen, 1987.

Putnam, Robert. *Bowling Alone: The Collapse and Revival of American Community*. New York: Simon and Schuster, 2000.

Rainer, Tristine. *The New Diary: How to Use a Journal for Self-Guidance and Expanded Creativity*. Los Angeles: J. P. Tarcher, 1979.

Robinson, N. "Bring the Internet to Zambia." In *Bridge Builders: African Experiences with Information and Communication Technology*, ed. Office of International Affairs National Research Council. Washington, DC: National Academy Press, 1996.

Rojek, Chris. *Decentering Leisure: Rethinking Leisure Theory*. London: Sage Publications, 1995.

Ryan, Marie Laure. "Possible Worlds in Recent Literary Theory." *Style* 26, no. 4 (Winter 1992): 528–53.

———. "The Text as World Versus the Text as Game: Possible Worlds Semantics and Postmodern Theory." *Journal of Literary Semantics* 27, no. 3 (1998): 137–163.

———. *Narrative as Virtual Reality: Immersion and Interactivity in Literature and Electronic Media*. Baltimore: Johns Hopkins University Press, 2001.

Schiwy, Marlene. *A Voice of Her Own: Women and the Journal Writing Journey*. New York: Simon and Schuster, 1996

Schoeman, David, Ferdinand. *Philosophical Dimensions of Privacy: An Anthology*. Cambridge: Cambridge University Press, 1984.

Sconce, Jeffrey. *Haunted Media: Electronic Presence from Telegraphy to Television*. Durham, NC: Duke University Press, 2000.

Seiberling, Grace. *Amateurs, Photography, and the Mid-Victorian Imagination*. Chicago: University of Chicago Press, 1986.

Senft, Theresa. *Homecam Heroines: Gender, Celebrity, and Auto-Performance on the World Wide Web*. New York: Peter Lang Publishing Group, forthcoming.

Sherman, Stuart. *Telling Time: Clocks, Diaries, and the English Diurnal Form, 1660–1785*. Chicago: University of Chicago Press, 1996.

Simpson, Lorenzo. *Technology, Time, and the Conversations of Modernity.* New York: Routledge, 1995.

Slater, Don. "Domestic Photography and Digital Culture." In *The Photographic Image in Digital Culture,* ed. Martin Lister. New York: Routledge, 1995.

Slevin, James. *The Internet and Society.* Malden, MA: Blackwell, 2000.

Sobchack, Vivian. "The Scene of the Screen: Envisioning Cinematic and Electronic Presence." In *Electronic Media and Technoculture,* ed. John T. Caldwell. New Brunswick, NJ: Rutgers University Press, 2000.

Sontag, Susan. *On Photography.* New York: Farrar, Straus, and Giroux, 1977.

Stokowski, Patricia A. "Languages of Place and Discourses of Power: Constructing New Senses of Place." *Journal of Leisure Research* 34, no. 4 (2002): 368–82.

Sunden, Jenny. *Material Virtualities: Approaching Online Textual Embodiment.* PhD diss., Department of Communication Studies, Lindköping University, 2002.

Tamblyn, Christine. "Qualifying the Quotidian: Artist's Video and the Production of Social Space." In *Resolutions: Contemporary Video Practices,* ed. Michael Renov and Erika Suderburg. London: University of Minnesota Press, 1996.

Temple, Judy Nolte. "They Shut Me Up in Prose: A Cautionary Tale of Two Emilys." *Frontiers,* March 2001, 150–73.

Trachtenberg, Alan. *Classic Essays on Photography.* New Haven, CT: Leete's Island Books, 1980.

Turkle, Sherry. *The Second Self: Computers and the Human Spirit.* New York: Simon and Schuster, 1984.

———. *Life on the Screen: Identity in the Age of the Internet.* New York: Simon and Schuster, 1995.

United Nations Development Program. *Human Development Report 2001: Today's Technological Transformations—Creating the Network Age.* Available at: http://www.undp.org.np/publications7hdr/2001/.

U.S. Census Bureau. *Home Computers and Internet Use in the United States*. Available at: http://www.census.gov/population/www/socdemo/computer.html (September 2001).

Virilio, Paul. *The Vision Machine*. Bloomington: Indiana University Press, 1994.

———. *Open Sky*. London: Verso, 1997.

Weintraub, Jeffrey. "The Theory and Politics of the Public/Private Distinction." In *Public and Private in Thought and Practice: Perspectives on a Grand Dichotomy*, ed. Jeffery Weintraub and Krishan Kumar. Chicago: University of Chicago Press, 1997.

Wellman, Barry. *Networks in The Global Village: Life in Contemporary Communities*. Boulder, CO.: Westview Press, 1999.

Zaretsky, Eli. *Capitalism, the Family, and Personal Life*. New York: Harper and Row, 1976.

Zimmermann, Patricia. *Reel Families: A Social History of Amateur Film*. Bloomington: Indiana University Press, 1995.

Zizek, Slavoj. *The Plague of the Fantasies*. New York: Verso, 1997.

INDEX

A

actual world, 118, 121, 123
amateur, 38, 43, 104, 145, 149
anticipation, 159, 160, 162, 163
anxiety, 111, 145, 147, 149, 168
archive, 50, 122, 144, 151, 161
artifice, 7, 101, 117, 152
augmentation, 144
aura, 75, 115–117, 121–123, 155
authentic, 3, 13, 14, 72, 99, 103, 105, 108, 112, 115, 116, 121–123
authenticity, 12, 89, 101–104, 107, 117, 120, 136, 138
authorship, 101
autobiography, 7, 12, 27, 28, 32, 101, 103
autonomy, 65, 73

B

Bachelard, Gaston, 7
Barthes, Roland, 141, 150
Benjamin, Walter, 36, 41, 96, 112, 115
betrayal, 105, 106
blogs, 120, 125

C

camera, 1, 2, 8–11, 13, 23, 24, 35, 37, 39, 41–44, 46, 48–52, 58, 73, 74, 76, 80, 81, 82, 84, 99, 104, 123, 130, 140, 141, 143–145, 147–150, 152, 167, 172, 174, 176
camera phone, 173
candid, 41, 74, 101
capitalism, 44, 46, 69, 79, 80, 85, 145, 146, 148, 166, 168
cartes de visite, 36
Castells, Manuel, 53, 56, 165–168
celebrity, 80, 87
commodity, 40, 74, 75, 79, 81, 148
complexification, 23, 36, 158
complexity, 9, 49, 131, 152
computer, 1, 4, 24, 35, 44, 45, 47, 55, 108, 111, 112, 165, 169
confession, 9, 33
connected privacy, 67, 90, 91, 93, 96
consumer, 12, 14, 43, 45, 48, 49, 51, 82, 86, 101, 145, 147, 148
consumerism, 75, 79, 148
creativity, 15, 145, 179
cyberspace, 53, 111, 117, 124, 125

D

daguerre, 35, 36
daguerreotype, 37
Derrida, Jacques, 30
detective camera, 42, 43
diary writing, 28, 31, 67, 71, 105, 108, 135, 136, 160
digital divide, 54
digital media, 13, 14, 53, 113
disconnection, 113, 168, 169
discourse, 24, 29, 33, 66, 85, 90, 91, 100, 111, 130, 152, 158, 169
discursive, 4, 5, 7, 10, 11, 13, 14, 24, 36, 56, 83, 85, 95, 99, 108, 117, 130, 139, 146, 158, 167

E

Eastman, George, 42, 146
embodied, 4, 9, 24, 27, 41, 117, 123, 125, 144
Enlightenment, 133, 139
entertainment, 15, 46, 50, 51, 84, 147, 149, 166, 168
everyday life, 1, 5, 42, 44, 49, 50, 74, 79, 121, 136, 148, 149, 171
exhibitionism, 91, 161

F

fake, 106, 122, 155
fame, 80, 125
family, 40, 43, 44, 49, 51, 58, 65, 66, 69, 71–73, 76, 77, 80, 83, 84, 86, 101, 102, 104, 107, 121, 122, 164, 165, 170
family album, 43
fetish, 14, 74, 75, 77
fiction, 12, 73, 74, 101, 105, 108, 118, 121, 173
film, 2, 6, 41, 43, 46, 48, 49, 74, 84, 113, 145, 147, 148, 150, 164
future, 3, 16, 57, 85, 124, 130, 134, 137, 139, 140–146, 148–152, 166, 170–172, 174, 175
future time, 16, 139

H

Hansen, Mark, 4, 5, 24, 36, 41
Heidegger, Martin, 10
hoax, 106, 108, 120
Hollywood, 12, 84, 87, 149, 166
holodeck, 17
home movie, 2, 3, 9, 23, 48, 49, 74, 83, 84, 106, 107, 129, 140, 145–148, 151, 152, 157, 166, 167
hypermedia, 164
hyper-real, 13, 14, 111
hypertext, 15, 28, 57, 164

I

identity, 2, 4, 10, 28–30, 32, 65, 95, 101, 107, 111, 114, 124, 125, 134, 135, 144, 145, 170, 172
immediacy, 16, 55, 56, 59, 155, 156, 158, 159, 168
individual, 2, 10, 23, 27, 28, 31–33, 40, 45, 47, 56, 57–59, 64, 65, 67, 69, 70, 71, 73, 80, 83, 85–87, 93, 106, 107, 113, 119, 123–125, 133–136, 138, 139, 144–146, 153, 159, 160, 168–170, 173
industrial culture, 79, 143

extension, 22, 42, 53, 55, 56, 58, 59, 70, 139, 144, 152, 160, 162, 164

industrialism, 139
information age, 4
interaction, 4, 14, 24, 40, 41, 47, 50, 55, 58, 92, 95, 96, 106, 112, 113, 158, 163, 165
interactive, 93, 94, 111, 158, 162
interactivity, 54, 58
Internet, 12, 52–55, 57, 58, 66, 76, 90–92, 96, 114, 117, 120, 123, 124, 157, 162, 168, 169
intimacy, 67, 69, 72, 73, 76, 77, 89, 91, 117, 162
introspection, 9, 15, 27, 70, 71, 101, 175
isolation, 27, 30, 67, 69, 71, 91

J

Joyce, Michael, 57, 79

K

Kodak, 42, 48, 82–84, 146, 147, 148, 149

L

leisure, 38, 43–45, 49, 70, 145, 146
Lejeune, Philippe, 12, 101
liberation, 134
life-writing, 7, 28
literacy, 29, 30, 70, 75, 168

M

Maffesoli, Michel, 46
mass production, 79, 81
Massumi, Brian, 163, 172
McLuhan, Marshall, 2, 22, 30, 80
mediatization, 15, 50, 174
memoir, 101, 140
memory, 3, 28–30, 140, 141, 143, 144, 147, 150, 151, 164, 175
mimesis, 24, 41
mimetic texts, 118, 123
modern, 3, 10, 16, 27–29, 32, 33, 40, 47, 67, 69, 70, 79, 81, 82, 85, 90, 114, 133–135, 139, 140, 141, 143, 145, 146, 161

modernity, 16, 43, 46, 67, 80, 134, 139, 141–143
Moravec, Hans, 47
museum, 140
myth, 134, 140

N

Negroponte, Nicholas, 4, 54
neo-tribalism, 46, 47
network, 8–11, 13, 45, 53, 54, 55–59, 67, 90, 92, 94–96, 99, 113, 130, 156, 163, 166–168, 176
new media, 4
nomadic time, 133
Nora, Pierre, 3
nostalgia, 72, 89, 116, 140, 164

O

oral, 28–30
orality, 28, 29

P

page, 2, 3, 8–11, 15, 23, 24, 27, 28, 30–33, 58, 71, 86, 87, 99, 101, 107, 130, 176
perception, 10, 13, 16, 32, 42, 48, 79, 118, 123
phonograph, 80
photography, 14, 23, 35–38, 40, 42, 48, 79, 82–84, 86, 104, 144, 145
portrait, 35, 39, 40, 82
portrait photography, 82
premodern, 69, 133–135, 139, 140
primary referent, 112, 113
print, 9, 13, 15, 28, 85, 164, 167, 169
privacy, 11, 69, 70, 79, 89, 95
private place, 8, 11, 12, 61
private property, 69, 71, 80
professionalism, 104, 147, 149, 166
prosthesis, 144
public, 11, 12, 29, 33, 38, 40, 43, 48, 59, 63–65, 67, 69, 71, 72, 74, 77, 79, 80 87, 89 91, 95, 96, 140, 161, 163, 175
pure privacy, 67, 71, 74, 75, 77, 89, 91, 96

R

reader, 5, 7, 11, 23, 27, 29, 33, 75, 95, 104, 116, 119, 121, 123, 130, 133, 162, 164
reading, 1, 12, 22, 23, 27, 57, 70, 114, 121, 138, 165, 169
real place, 8, 12, 97
real time, 1, 16, 17, 56, 116, 130, 145, 155–158, 161–163, 165, 167, 168
reality TV, 46, 162, 168
representation, 2, 4, 9, 10, 13, 15, 16, 17, 21, 24, 27, 29, 31, 39, 43, 49, 51, 55, 75, 77, 80, 82, 101, 105, 106, 114, 130, 141, 148, 160, 175

S

Saint Augustine, 32
Salam Pax, 120, 123
science, 135
self-definition, 73
self-documentation, 2, 5, 7, 8, 10–17, 21, 23, 24, 27, 30, 32, 45, 48, 54, 58, 59, 67, 70, 71, 77, 79, 82, 89, 91, 93, 96, 99, 100, 102, 103, 105, 106, 108, 112, 113, 116, 119, 121–126
self-invention, 114, 117
simulacrum, 108, 111, 117
simulated, 13, 14
snapshot, 43
solitude, 2, 15, 70, 133, 136, 137, 175
Sony, 45, 46, 49, 179
spectacle, 45, 46, 77, 81, 89, 140, 148, 152
spontaneity, 103, 107
still time, 15, 133
subjectivity, 10, 29, 32, 55, 58, 70, 112
Super-8, 2, 15, 74
surveillance, 50, 51, 64, 91, 161, 168

T

Talbot, Fox, 36
technology, 2, 4, 5, 8, 12, 14, 15, 16, 35–39, 41–44, 46, 48, 49, 50, 54, 55, 56, 66, 72–74, 79, 86, 90, 92, 96, 104, 111, 123–125, 130, 142–145, 148, 157, 164–167, 172, 174, 175, 179

timeless time, 56, 166
transparency, 16
typewriter, 80

U

United Nations, 54, 56

V

video, 6, 15, 48–51, 67, 74, 76, 104, 112, 121, 140, 164, 170
video camera, 49, 50, 74
Virilio, Paul, 56, 156
virtual, 4, 6, 13, 14, 17, 22, 51, 53, 55, 58, 59, 92, 111–117, 119, 121, 123, 125, 126, 160, 168
virtual reality, 14, 125

W

web-cam, 1, 3, 5, 8, 12, 14, 17, 35, 36, 48, 50–52, 59, 73–77, 87, 89, 91, 101, 105, 106, 112, 164
web-ring, 94
wireless, 171, 172
World Wide Web, 4, 6, 12, 15, 24, 45, 53, 58, 86, 90, 125, 157, 162
writer, 1, 23, 27–29, 67, 71, 87, 103, 104, 106, 121, 133, 137, 138
writing, 2, 6, 10, 12, 13, 16, 23, 27, 29, 30, 32, 33, 71, 86, 102–104, 120, 136–138, 140, 150, 158

Z

Zapruder, 150